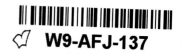

FOR DEAR LIFE

FOR DEAR LIFE

CAROL JACOBSEN

Foreword by Lucy R. Lippard

WITH ESSAYS BY:

Amanda Alexander
Regina Austin
Sally Berger
Lynn D'Orio
Nina Felshin
Marjorie Heins

Betti-Sue Hertz
Rebecca Jordan-Young
Wendy Kozol
Caitlin Mitchell
Kay Schaffer
Sidonie Smith

Ruby Tapia
Carole S. Vance
Maryann Wilkinson
Patricia Zimmerman

University of Michigan Press • Ann Arbor

WOMEN'S DECRIMINALIZATION
AND HUMAN RIGHTS IN FOCUS

WITH LETTERS, NARRATIONS, AND CONTRIBUTIONS BY:

Anonymous
Violet Allen
Barbara Anderson
Angela
Anita Alcorta
Stacy Barker
Minnie Boose
Cassie
Doreen
Tonya Carson
Melissa Chapman
Edie Clark
Joyce Cousins
Angela Y. Davis
Donna Debruin

Diane Engleman
Towanda Eppenger
Susan Fair
Susan Farrell
Goldie
Geraldean Gordon
Serena Gordon
Jennifer Granholm
Linda Hamilton
Connie Hanes
Jean
Jo
Karen Kantzler
Delores Kapuscinski
Kinnari

Linda J.
Linda K.
Carol Leigh
Lorraine
Kim Lundgren
Maria
Mary
Sharee Miller
Christy Neff
Melanise Patterson
Machelle Pearson
Millie Perry
Anita Posey
Tammy Ramos
Levonne Roberts

Carlene Roache
Sherry Savage
Sherrie
Nancy Seaman
Mary Suchy
Sugar
Melissa Swiney
Luanne Szenay
Tonyia
Theresa
Juanita Thomas
Sharleen Wabindato
Doreen Washington
Jamie Whitcomb

All revenue from sales of this book goes to the Michigan Women's Justice & Clemency Project.

Special thanks to the University of Michigan for funding toward publication of this book: the Office of Research; the Penny Stamps School of Art & Design; the Institute for Research on Women & Gender; the Institute for the Humanities, and the ADVANCE Program.

Published in the United States of America by the
University of Michigan Press
Manufactured in China
Printed on acid-free paper
First published January 2019

A CIP catalog record for this book is available from the British Library.

Library of Congress Cataloging-in-Publication data has been applied for.
ISBN 978-0-472-07392-4 (hardcover : alk. paper)
ISBN 978-0-472-05392-6 (paper : alk. paper)
ISBN 978-0-472-12418-3 (e-book)

Design: Shaun E. Bangert

This book is dedicated with love
to all the fabulous feminists who have participated in
the Michigan Women's Justice & Clemency Project
on both sides of the fence.

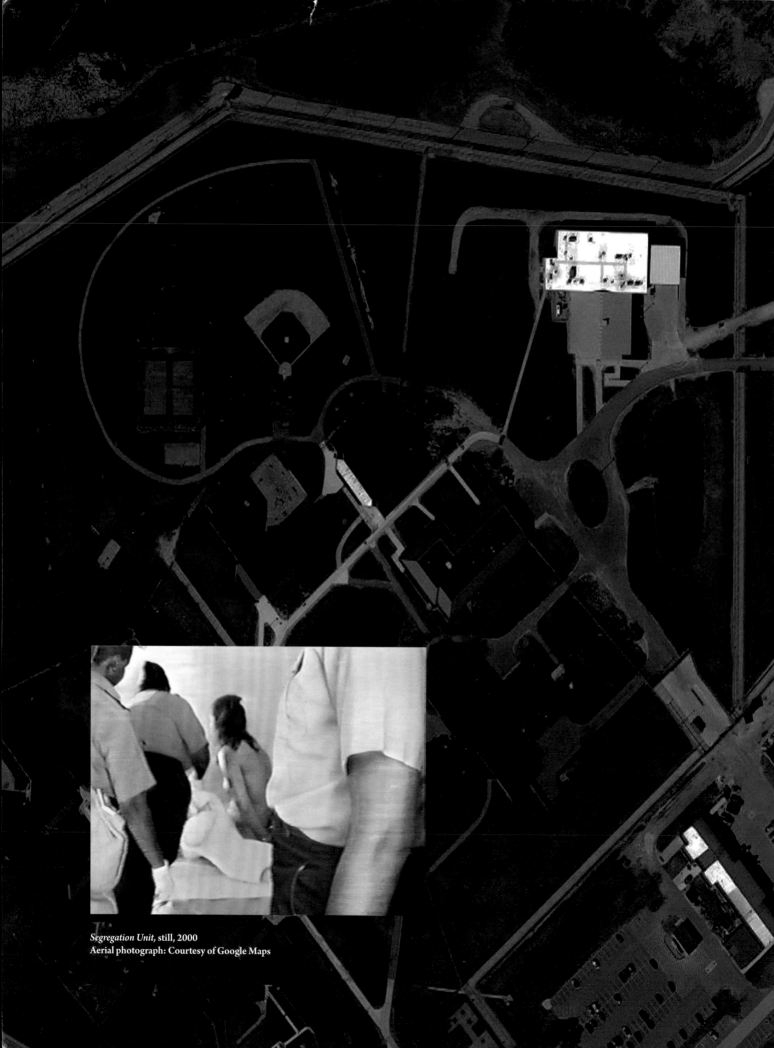

Segregation Unit, still, 2000
Aerial photograph: Courtesy of Google Maps

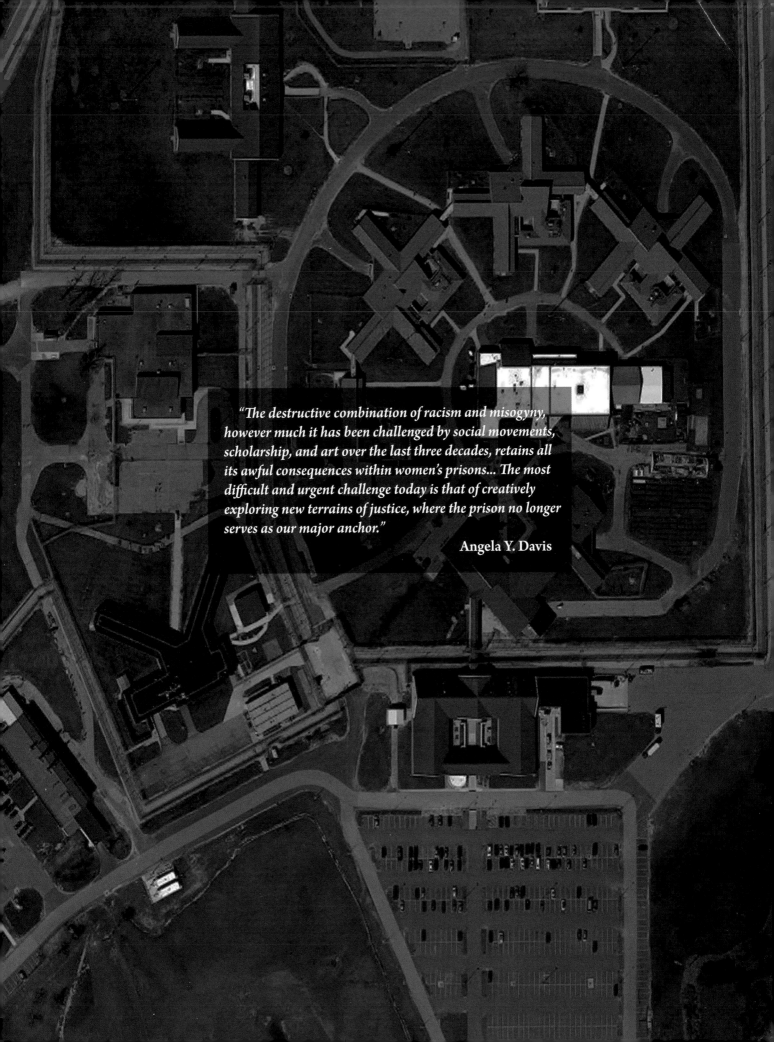

"*The destructive combination of racism and misogyny, however much it has been challenged by social movements, scholarship, and art over the last three decades, retains all its awful consequences within women's prisons... The most difficult and urgent challenge today is that of creatively exploring new terrains of justice, where the prison no longer serves as our major anchor.*"

Angela Y. Davis

Contents

TWELVE WOMEN FREED FROM LIFE SENTENCES

Opposite: Twelve women freed from life sentences in prison through efforts of the Michigan Women's Justice & Clemency Project (MWJCP):

First row: Levonne Roberts (freed 2009, through clemency granted by Governor Granholm based on MWJCP clemency petition, testimony, and support); Violet Allen (freed 1999, based on a motion in court filed by MWJCP legal director Lynn D'Orio); Minnie Boose (freed 2008, through clemency granted by Governor Granholm based on MWJCP clemency petition, testimony and support).

Second row: Joyce Cousins (freed 2013, through MWJCP testimony and support); Doreen Washington (freed 2008, through clemency granted by Governor Jennifer Granholm based on MWJCP clemency petition, testimony, and support); Linda Hamilton (freed 2009, through clemency granted by Governor Granholm based on MWJCP clemency petition, testimony, and support).

Third row: Barbara Anderson (freed 2009, through MWJCP clemency petition, testimony, and support); Mildred Perry (freed 2009, through MWJCP clemency petition, testimony, and support); Melanise Patterson (freed 2017, through MWJCP clemency petition, testimony, and support).

Fourth row: Tonya Carson (freed 2018, through MWJCP assistance on clemency petition, testimony and support); Juanita Thomas (freed 1998, based on a motion filed in court by MWJCP volunteer attorney Andrea Lyon, with evidence developed by Susan Fair and University of Michigan law students); Karen Kantzler (freed 2017, through MWJCP clemency petition, testimony and support).

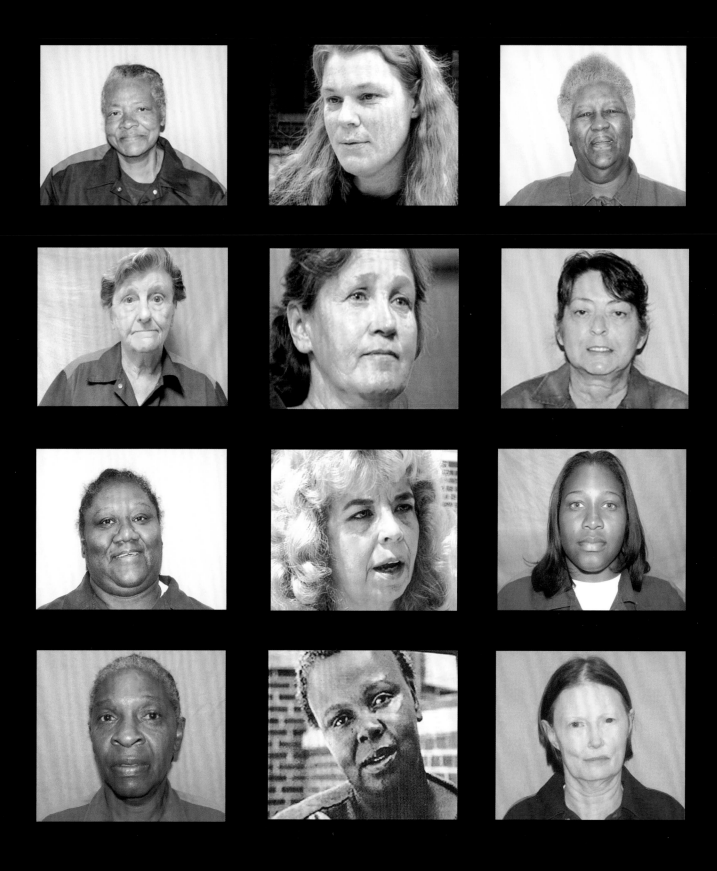

FOREWORD

Not for Art's Sake: Carol Jacobsen's Activism
Lucy R. Lippard

Activist art has cut a broad (and sometimes shallow) swath since the late l960s, becoming a catch-all for a wide variety of often impressive social practices and oppositional arts. I know of no more successful combination of these conventionally incompatible obsessions than Carol Jacobsen's work. And work it is–hard, uncompensated, often unappreciated labor. Dealing with the real world's bureaucracies and legalities is not included in art education. The commercial artworld can pay admiring lip service to those operating beyond its boundaries, but the farther out an artist acts, the less attention the center pays. The good news is that more and more artists are entering the broader field, which includes community-based arts and social or public practice as well as outright political oppositional imagery. So this book is a boon not only for the artist but for those who will take her model to heart, and run with it.

It is a brutal book. And we should all grit our teeth and tackle it. The flood of horrendous, evidence-backed tales of social control over women from state prisons, ranging from rape to starvation to torture, racism, misogyny and homophobia, mental illness and suicide, are hard to read and harder still to ignore. And there is no happy ending. Although "her works reframe Michigan," according to Patricia Zimmerman, in 2005, Jacobsen documented that 59 women were murdered by male partners and the 2015 statistics (and racist demographics) were even worse.

Passionate is the word consistently employed to describe Jacobsen's deep commitment to human rights and to justice for women who have survived and resisted violent abuse (against them and sometimes against their children, especially their daughters). They have been severely punished for their courage and forgotten by society until someone like Carol and her admirable colleagues on the Clemency Project come along. Passion is presumed to be an element of

any art, but a passion for justice by those who aspire to be art activists in the truest sense of the word exist on a different level than a passion for aesthetic or commercial triumphs. It is extremely rare that an artist can have as much effect on an issue as Jacobsen and her cohort has had: twelve incarcerated women serving life sentences have been freed by the project over the years and many more remain in the clogged pipeline.

Equally rare is an artist willing to sacrifice so much "studio time" to social justice. "Often I wished I had studied law formally… yet I would not have given up art for law since law is based on limits and art is fundamentally about freedom," says Jacobsen. Legal work may have taken time and energy away from Jacobsen's conventional art time but it has also illuminated it. Her films, videos, installations, and photographic grids carry a message more powerfully than any dry or spectacular journalistic account could. Feminist artists have long used the grid as a formal device in which to subvert the masculine rigidity it implies. As Betti-Sue Hertz observes, Jacobsen "steals the grid away from its institutional authority with the intent of inversion." Her works range from individual portraits to images drawn from an archive of records of women convicted of "justifiable homicide" in a nineteenth-century prison archive (*For Dear Life*, 2012–17) and another trove of images and documents from the 1920s and '30s (*Files on the History of Justifiable Homicide*, 2005–12). In the latter, each archival record is joined to the present by a metal plaque with an all too similar quote from a current case. In *Violet and Judith,* 1995, a current case is intensified by historical juxtaposition of Artemisia Gentileschi's famous seventeenth-century painting of Judith with the severed head of Holofernes.

In this eye-opening book, Nina Felshin points out that Jacobsen's work is a fusion of art and politics. (I'd emphasize fusion, not an overlay, not a collage, not

a borrowing, not an aestheticization of facts, but more significantly, a fusion of art and life.) Maryann Wilkinson writes of Jacobsen's videos that they "suggest a transparency allowing the viewer a largely unmediated view into another's reality." And Regina Austin remarks that artists like Jacobsen "educate the mind's eye." The next step may be to educate those who control the public minds' eyes.

There have been innumerable obstacles, including a ban on visits, photography, and reporters in the Michigan prisons, and, of course, censorship. Jacobsen's 1991 video installation, *Street Sex*, was closed down after a few hours on exhibition by the University of Michigan Law School (of all places); thanks to the ACLU, it was reinstalled. (Similar backlash has been leveled at other work on sex workers and women prisoners by feminist artists, among them *Carnival Knowledge*, Susan Meiselas, and Laurie Jo Reynolds. It should be said that there has been opposition within the movement over the years on "moral" grounds concerning pornography and prostitution—another long story.)

I'm proud to say that Jacobsen and I both worked with *Heresies* and PAD/D in the 1980s. Her original inspiration to become an activist as well as an artist was the famous women's action against nukes at Greenham Common Women's Peace Camp in England (1981–87). After years of this work she writes that "it is still the spirit of Greenham that I carry as I struggle to raise hell and havoc against the state's injustice to women." But there was another, darker inspiration—"there but for the grace of God go I." The artist grew up in the shadow of a prison she never entered. But at age seventeen, she had fallen into an abusive marriage which she escaped only by an illegal abortion that nearly killed her. (She never regretted it.) So when she first actually entered a prison in 1989 to make a film, she was uniquely equipped to temper her fury with a deeper empathy that led her to identify with the heartbreaking, blistering testimonies of those who have been doubly punished: first by domestic violence and then by a heartless prison system.

Jacobsen's relationships with inmates are long-term. Their trust in her and her colleagues and the mutual respect for their dignity despite the intimacy of public information about their cases that is displayed in their letters is extremely moving. This is what real feminism looks like. I am often told by younger women that they might not call themselves feminists but they are strong, they stand up for themselves. My definition of a feminist is someone who stands up for other women, all women.

I have long claimed that artists cannot change the world alone but with the right allies they can make a difference. Jacobsen has created her own allies, and her activism endows her art with a strength that can't be faked.

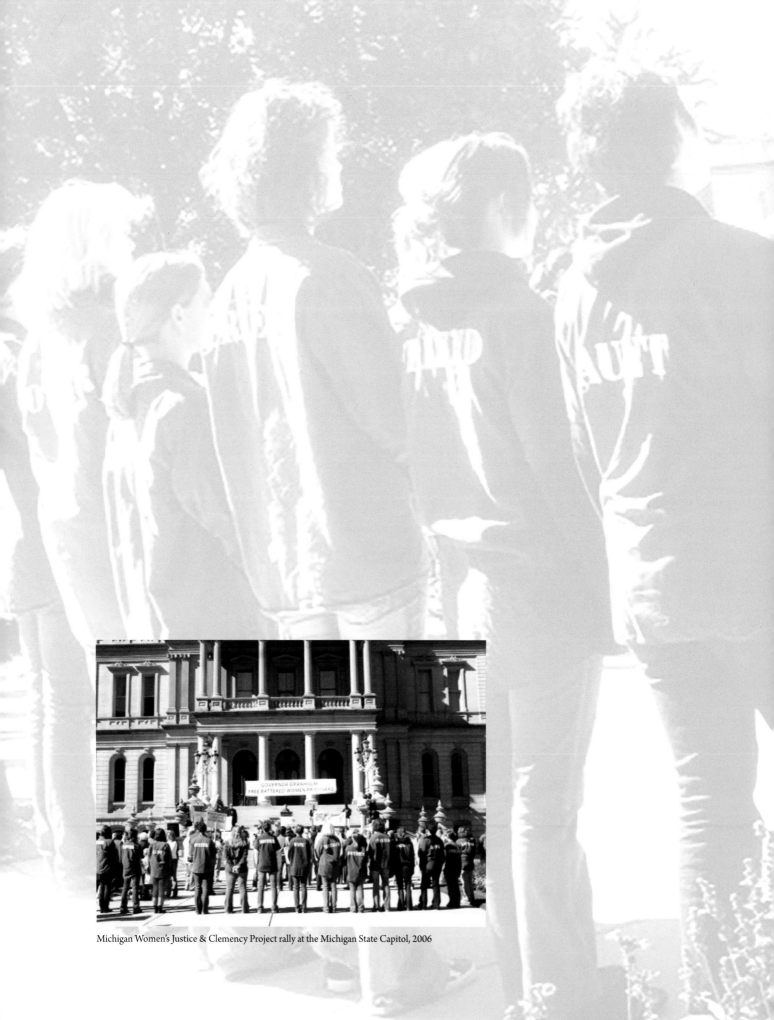

Michigan Women's Justice & Clemency Project rally at the Michigan State Capitol, 2006

INTRODUCTION

Confronting Women's Criminalization

Like many feminists past and present, I began to question issues of women's criminalization when I recognized the deeply political interconnections of our specific gendered experiences with rape, battering, abortion rights, lesbian identity, and sex work that were all stigmatized by social norms and punished by the state. As I began to focus the lens of feminist theory on my own painful past in graduate school in the 1970s, it was ridicule and warnings from male professors that convinced me to back off from creating political imagery to get my degree. But soon afterward while living in Europe, I encountered feminist activism linked to women's criminalization on an international scale, and I was electrified. I read about Greenham Common Women's Peace Camp near London, and my friend, Connie Samaras, and I decided to go there. As we trudged around the huge NATO base where the campgrounds were located, we met women from around the world. During the years they occupied the perimeter of the base, Greenham women tunneled under, crawled over and cut through the fence. They blocked convoys and painted peace messages on airplanes. They wrote articles and published books. It was an enormous, collective, activist art project on a global scale. For their efforts, many of the women were arrested and charged with crimes of "disturbing the peace" or "disorderly conduct." I followed some of the protestors to court in London where I witnessed jaw-dropping scenes. The courtroom was filled with women shrieking with laughter, singing songs and mocking the British court, white wigs and all. I was struck by their fearless confrontations with the law and reminded of Virginia Woolf's literary challenge to "educated men, the public fathers brought to power by the sacrifices of their sisters and mothers in the all-women Out-siders Society," whose creed was "As a woman, I have no country. As a woman, my country is the whole world."[1]

When I returned to the United States in 1984, I joined several political art groups where my work could contribute to feminist and social justice conversations. In New York, it was Political Artists Documentation and Distribution (PAD/D), Ceres Co-op Gallery and the feminist art journal, *Heresies*. My work of that period was inspired by and paid homage to Greenham women. In Michigan, I organized actions

and exhibitions with Connie Samaras, Pi Benio, Marilyn Zimmerman, Joanne Leonard, Kathy Constantinides and other feminist artists. As I kept wondering who was "disturbing the peace" in the United States, I decided to return to court, this time in Detroit. I discovered it was prostitutes.

My investigation into sex work on the streets and in and out of the courtrooms in Detroit spanned the period from 1985 to 1989 and produced several video installations, activism and other works (*Street Sex*, 1989; *International Detroit Pro Press*, 1990; *Night Voices*, 1992). I spoke with women who were released from jail, watched questionable behavior by police officers and encountered unfriendly judges. The women gave scathing critiques of the revolving doors of their criminalization process and the abuse by not only predators on the streets, but also officers of the law, the courts, and the jails. All of the women were punished with jail or prison sentences in a systematic process that served to inflate arrest records for police and conviction rates for prosecutors at the women's, the city's and the public's expense. At one point during this project, the adjacent city of Ypsilanti passed an ordinance outlawing women from waving on the street, a move that further increased female arrests. Kathy Constantinides and I went to an American Civil Liberties Union (ACLU) meeting in our community to find an attorney who would challenge the new law. Lore Rogers took the case and succeeded in getting it struck down. [2]

When I began to exhibit the work on prostitutes' rights, I was not expecting the unrelenting censorship it would provoke: a printer refused to print my announcements, art writers refused to review the work, and galleries removed it or covered it over, with the exception of nonprofit artist spaces in New York City, where it was shown without objection. The most widely publicized of these censorship incidents occurred in 1992 at the University of Michigan Law School when an exhibition of my video installation (*Street Sex*, 1989) and the films and photography of six other artists on the subject of prostitutes' rights was banned as soon as it opened. The ACLU represented the artists, and our yearlong battle finally forced the law school to reinstall the entire show. In 2005, I co-produced *Censorious*, with Shaun Bangert and Marilyn Zimmerman, a film narrated by feminist

artists who had all fought censors, especially during the height of the culture wars, a tumultuous period from the late 1980s to the early 1990s when artists were under attack for performing and exhibiting artworks that publicly confronted issues of sexism, racism, homophobia and religious bigotry.

In 1989, my documentaries on sex workers caught the attention of a prisoner rights activist who invited me to go into Huron Valley Women's Prison to make a short film with the women about their children's visitation program. I felt both eager and apprehensive to go inside the women's prison. I had grown up in the shadow of the world's largest walled prison, in Jackson, Michigan, where I'd always felt a mixture of curiosity and fear toward that monstrosity at the edge of town. My Sunday school teacher was married to the warden. A boy I went to high school with was sent there. A boy I dated went to work there. By 1989, we were all living in the shadow of a prison in the world's most incarcerated country.

Once inside the women's prison, I was stunned. These were the "criminals," especially the "murderers," in our women's prisons? Their stories decried both the human and civil rights abuses they'd survived at the hands of individual abusers as well as of the criminal-legal-penal system. I met women who were serving drug sentences for their boyfriends, women who killed their rapists and batterers in self-defense, women who were serving time for the most inane reasons but were not parolable because they had mental illness, and women whose physical as well as mental disabilities were compounded because of this disastrous system.

The oppressive control that extends from the domestic to the penal sphere, from individual violent men to the gendered violence of the prison was starkly visible inside the barbed wire. The women were spoken to like infants or idiots, generally treated with contempt and prodded like cattle. As I sat and talked with one after another, each woman's words were like shards of my own story.

At seventeen, I married my violent boyfriend. Within weeks, I regretted it. On the day I realized he would surely kill me, I left. My parents hid me with friends and relatives until the stalking ended. When my father asked me if I was pregnant, I said yes. When he asked what I wanted to do, I said, "I'm not having it." Within days, both parents drove me to an abandoned theater building in Detroit where

I had a then illegal abortion. Although I almost died, I never regretted it. I survived and I was free.

The women I met in prison were not so lucky. Like me, they'd saved their own lives. Like me, they'd called police but officers either did nothing or did not show up at all. Unlike me, they did not have the shelter or support they needed to get free. Once they fought back and defended themselves, they faced prosecutors who trotted out every myth and stereotype to prove they were liars, judges who denounced them for failing to leave, and attorneys who neglected to defend them. I became determined to make a film that would bring them close up, face-to-face, with public audiences who would see them as I did and hear their critiques of a criminal-legal system that failed them—and that fails us all.

In December 1990, at the end of my first year of filming inside the women's prison, Governor Richard Celeste of Ohio granted clemency (commutation of sentence) to twenty-five women who had killed their abusers. [3] I was thrilled by this seismic event and what it could mean for the future of the women I was filming. Governor Celeste's act generated a wave of public and media excitement across the country as well as a grassroots clemency movement for battered women prisoners in many states. Although a large number of governors followed suit and released battered women, others resisted out of political fear for their careers and clemencies in the United States generally declined. As a result, thousands of women have remained unjustly sentenced for murder because of abusive men, unfair trials, and governors' cowardice.

After I finished the film for the women on their children's program in 1990, I began work on a new film (*From One Prison…*, 1995). At the same time, two attorneys and I approached the ACLU, who granted us a small amount of funding the first few years to reorganize a grassroots project that had folded. The Michigan Women's Justice & Clemency Project (The Clemency Project) was an effort to free battered women prisoners who did not receive fair trials. As an artist, it represented an opportunity to expand my research and visual work on an issue I was now deeply committed to, opening up territories of law and justice, documentary journalism, political organizing and public protest.

The History of Women's Incarceration

My research on the history of women's incarceration has raised many questions in my mind about the long tradition of social control over women's lives. While this history is one of relentless failure for both women and men, I found that women's criminalization is a particularly harrowing story of legalized discrimination for breaking sexual, social or legal codes of gendered conduct.

Beginning in the seventeenth century, the first women and men who came to North America were transported here in lieu of prison or execution in Europe for committing crimes that varied from petty theft to murder. Upon arrival, male settlers became free men, but many of the women were forced to become sexual slaves or indentured servants for the men who paid their transport. Some of the earliest records of women's criminalization were those of the Salem, Massachusetts, witch trials of 1692 and 1693. During those two years an estimated sixty-two persons, most of them women, were jailed in Salem, Ipswich, and Andover. Eventually, thirteen women and seven men were executed and one woman died in jail. The women's "crimes" were perceived as nonconformity in clothing and lifestyle, mysterious and mischievous wickedness, affliction by the devil, and the bewitching or afflicting of others. In reality, they were survivors "of the deeply embedded tendency in our society to hold women ultimately responsible for violence committed against them," as feminist historian Carol Karlsen has shown.[4] It was not until 2001 that the last of those executed during the Salem witch trials were finally pardoned in a ceremony held by Governor Jane Swift of Massachusetts.

Women continued to be condemned throughout the next century for such mutinous affronts to society as prostitution, adultery, petty theft, or neonaticide— all essentially survival responses to the oppressive socioeconomic and dangerous conditions of their lives. They were imprisoned in attics and other hidden corners of men's prisons under the most abominable conditions of disease, filth, and violence. Sex work and other acts of survival by women remain both stigmatized and criminalized. Neonaticide is also still criminalized despite the fact that today it is recognized as a gendered social issue that primarily affects young women who have mental illness or histories of trauma and abuse. In Michigan, an estimated nine young women are currently incarcerated for neonaticide. Their minimum sentences range between probation and twenty-seven years; one woman–the only person in twenty-eight years to be sentenced to life for that crime–is represented by the Clemency Project. None of these women deserve to be in prison.

In the nineteenth century, a new scientific discourse brought even more contorted rationales for the denial of women's personal, social, and economic realities. Sigmund Freud wrote interpretations of women as biologically and intellectually inferior in keeping with the male scientific establishment. Cesare Lombroso, often called "the father of criminology," added to the discourse of misogynist theories of women as morally deficient and with "evil tendencies" that meant "the criminal woman is consequently a monster."[5] The concept of woman-as-evil continues to play out to this day in class and racial dynamics wherein black women and poor white women are seen by the courts as embodying sexually deviant behavior that poses a threat to male claims of superiority and moral order. This research led me to a cache of archival mug shots of women from the nineteenth century that I later reproduced in a series of prints affixed with metal plaques that are engraved with quotes taken from contemporary women's cases (*For Dear Life*, 2017, a title I also gave to this book).

The atrocious conditions in American prisons (many of which remain today) brought campaigns for reform, especially by the Quakers in the early twentieth century. As the reform effort continued and as religion, solitary meditation and hard labor were imposed on the inmates, prisons were renamed "penitentiaries" and "reformatories." Some of the changes involved moving women closer to the male prisoners to calm the men down, doubly exploiting the women as sexual servants and caretakers. When separate prisons began to be built their focus was on training women to be obedient wives and mothers. Those who did not learn their lessons well were whipped or sexually abused by staff in keeping with prevailing notions of women's just punishment. Black and lesbian women were often subjected to racist, sexist and homophobic systems of humiliation, isolation and brutalization by prison staffs, abuses that continue to this day. When I discovered the sale of archival photographs and newspaper coverage of women arrested for murder in the 1920s and 1930s,

I bought them and researched this corner of women's history for a series of grid pieces (*For Love or Money*, 2009; *Files on the History of Justifiable Homicide*, 2010; and *Nightclub Girl in a Curfew Town*, 2012).

The prison boom that erupted in the late twentieth century is unparalleled. The number of people incarcerated in prisons and jails in the United States and its territories by 2017 was 2.2 million, at least five times greater than in 1970. [6] The U.S. Census indicates that African Americans constitute nearly 40 percent of the prison population, but only 13 percent of the general population. As a tragic consequence of global corporatization as well as of opportunistic exploitation by politicians and the corporate media who pushed for more punitive sentencing policies, the war on drugs and crime became a war against women and people of color that spawned the mega-industry of prisons in the United States. Despite the decreasing violent crime levels and the human cost, the civil rights, black power, and Black Panther movements were all but destroyed by politically motivated government and media campaigns, and women—especially black women—were the easiest targets of all for police and prosecutors to take down. Research has shown that although women break the law primarily through acts of survival and minor roles as accessories to male co-defendants' crimes, and despite the fact that women's share of violent crimes has not dramatically increased, women have been the fastest growing prison population in the United States at a rate of 757 percent from 1977 to 2004, more than double that of men. [7] When I first entered Huron Valley Women's Prison in 1989, approximately 350 women were incarcerated there (about 1,300 women were incarcerated in two other prisons in the state at the time). Today, Huron Valley is the only state prison for women in Michigan and the count has swelled to more than 2,300 women, far beyond its actual capacity. [8]

The Demographics of Women's Incarceration

Totaling about 206,000, women in U.S. prisons now represent approximately one-third of all the women incarcerated in the world. [9] An underlying reason for this outrageous fact is that gender-based crimes represent relatively undemanding arrests and convictions. For example, prostitution is one of the few offenses for which nearly 100 percent of reported incidents result in arrest, and sweeps, stings, and entrapments regularly capture women en masse, as I witnessed in Detroit; meanwhile, violent crimes yield an arrest in only about 42 percent of reported cases. [10] By trading on the stigma of sex work and charging women, police are able to boost their arrest statistics and prosecutors their subsequent convictions. The high numbers that can result from this assembly line create a false impression of civil protection since such tactics only exploit mostly poor, mostly black women who commit minor drug or sex work offenses. Mandatory and preferred arrest policies meant to stem the tide of domestic violence have also been turned against women through dual arrest and other police practices even though domestic violence is not a gender-neutral violation.

The demographics of incarcerated women are telling. While women of color represent about one-third of the female population in the United States, they constitute approximately two-thirds of the women's prison population. African American women alone represent almost 50 percent of the female prison population yet are only 13 percent of the female population in the United States. [11] Of all incarcerated women, 70 to 80 percent are single heads of households serving time for nonviolent, poverty-induced, and gender-based crimes: prostitution, shoplifting, insufficient funds checks, and drugs. One in every twenty-eight children in the United States has a parent in prison; for black children it is more than one in nine. [12] These are women from economically distressed communities who are struggling to support themselves and their children the best way they can in an unequal and unjust society where they are denied access to adequate childcare and child support, education, jobs, mental health care and legal representation.

In intimate partner homicides and many other crimes, male violence is most often the precipitating factor regardless of who is the victim. These gender, racial, and economic disadvantages are rarely, if ever, considered when women are arrested, prosecuted, and sentenced. [13] In prison, institutionalized gender violence continues through sexual abuse by guards, retaliation, arbitrary and punitive ticketing and solitary confinement, a scarcity of programs and libraries, and medical and psychological neglect and abuse–because guards can get away with practices against women prisoners that do not work with men prisoners. At least 70 percent of incarcerated women suffer from mental illness, often arising from

a history of trauma or violence, but prison often only confines them to solitary cells, where they are locked down from twenty-two to twenty-four hours a day, fed through slots in the doors and offered little, if any, care or counseling. [14] One of the tragic results of the mistreatment of women in custody combined with the terrible conditions of their confinement is the number of suicides and suicide attempts that are precipitated in women's prisons. I felt the agony of this fact when Connie Hanes committed suicide in her cell in 2001, and I produced *Sentenced* (2003) in her memory. I have learned to track suicides in the prison in order to file complaints about the incidents and the lack of therapy and support.

Interdisciplinary Methods of an Artistic Practice

When attorneys Lynn D'Orio and Lore Rogers and I relaunched the Clemency Project in 1992–93 (Lore later accepted a position with the Michigan Domestic and Sexual Violence Prevention and Treatment Board), we set out to organize volunteer attorneys, review cases, interview women and educate ourselves about women's criminalization and the clemency process. By 1995, we had prepared petitions for clemency for several women on our original caseload of fifty-five inmates. The first of these was for Violet Allen, a woman who shot her violent husband after he threw their baby across the room.

In 1995, I installed *Violet and Judith*, a video installation, at the Detroit Institute of Arts, where viewers were invited to sign postcards to the governor for Violet's freedom. Although our petition for clemency for Violet was denied, we finally freed her in 1999, through an appeal in court prepared by Lynn D'Orio. Juanita Thomas, too, was freed by a volunteer attorney, Andrea Lyon, with research by the Clemency Project and University of Michigan law students. Both Violet and Juanita narrated my film *From One Prison…* (1995), which was sponsored and screened worldwide by both Amnesty International and Human Rights Watch during those years.

As we learned more about women's trials and the conditions of their incarceration, we submitted more petitions for clemency and expanded our mission to include broader human rights issues and more creative feminist, legal, and visual strategies and methods of representation, protest and collaboration together with the women inside. As artist-director

of the Clemency Project, I organized rallies and events; produced, exhibited, and distributed my films narrated by the women prisoners; wrote op-ed pieces, articles, and essays; recruited lawyers, judges, and legislators; and collaborated with the ACLU, the U.S. Justice Department, the governor's office, the National Clearinghouse for the Defense of Battered Women, Amnesty International, and other nonprofits and activists. Throughout this book, newspaper clippings and headlines, together with other visual materials, serve as backgrounds for the essays and written pieces, while film stills and photographs that overlay or are jump-cut together give a sense of the matrix of the visual, public, and political strategies, campaigns, and events created to produce each project within a time frame loosely represented by the book's sections. Especially potent and central are the women prisoners' voices, which are excerpted from my films or reproduced in their letters and documents. These are printed with permission from the women with deepest thanks for all their contributions. Often I wish I had studied law formally so that I might be able to do more on that front, yet I would not have given up art for law since law is based on limits and edicts and art is fundamentally about freedom. As an open, interdisciplinary, activist practice, art has offered me a range of research methods and public strategies to push boundaries, investigate broadly, and challenge the dirty details of the criminal-legal-penal system that I discover. Ultimately, it is the howling rage at the injustices I see that never quiets within me and will not let me walk away.

In 1998, Amnesty International representatives came to the New York opening of *3 on a Life Sentence*, a video installation that I produced that was written and narrated by Delores Kapuscinski, Mary Suchy, and Stacy Barker, three women serving life sentences together. Since then, Amnesty has cosponsored, along with my gallery, Denise Bibro Fine Art, all my exhibitions and screenings in New York and some abroad. At the time, Amnesty, Human Rights Watch and the United Nations were all investigating the rampant human rights violations in U.S. women's prisons. Their reports named Michigan's among the worst state prison systems for women in the nation with regard to rapes, four-point chaining, medical abuse, retaliation, and other atrocities. [15] It was these reports and investigations that convinced then governor John Engler to shut down all prisons in the

state to reporters, scholars, investigators, and virtually all other visitors except nuclear family members and limited friends. All cameras and other recording devices were banned. The closed system of prisons, which denies accessibility to citizens, advocates, and others, only fuels the horrors that are rampant inside today. By the time of the statewide ban, I could no longer film inside, but I was going in as a legal assistant anyway, taking student legal assistants with me on behalf of the Clemency Project's efforts. Some of my film and video work on women's incarceration relied on footage shot before the ban (*From One Prison…*, 1995; *Violet and Judith*, 1995; *Clemency*, 1999; *3 on a Life Sentence*, 1998; *Barred and Gagged*, 1999; *Sentenced*, 2003); other works were made with former prisoners (*Beyond the Fence*, 2004; *Time Like Zeros*, 2011; *Life on Trial*, 2018); and some were created with footage obtained through prisoners and their attorneys (*Segregation Unit*, 2000; *Prison Diary*, 2006), or else shot in court (*Courtroom*, 2019).

In 1999, I met Jamie Whitcomb, one of many courageous prisoners I have worked with who became an activist inside and who deeply affected my life and work. After she won her lawsuit for torture against the state, she narrated *Segregation Unit*, and the Clemency Project became more engaged in monitoring and reporting abuses that occurred to women in solitary confinement units in the state prison. My connection with so many individual women, their lives and their incarceration can only begin to be felt in the letters they wrote that are scattered throughout the book.

From 2002 to 2010, our governor in Michigan was Jennifer Granholm, a Democrat. We had high hopes that she would commute some women's sentences, and we kept the pressure on and the momentum high in our annual campaigns throughout her tenure with rallies at the state capitol, op-ed pieces, and media coverage, as well as meetings with the governor and her legal counsel and pressure from judges and a former governor, William Milliken, who worked closely with us.

Before leaving office, Governor Granholm granted a number of clemencies to prisoners. Although most were "safe" decisions, going to dying inmates and minor drug or probation cases, she freed ten women who had serious crimes—all first-degree murder cases except for one conspiracy to murder—and we represented four of the ten. Governor Granholm

also pressed the parole board to grant paroles to five women serving life sentences for second-degree murder, and we represented two of the five. While we celebrated every release, we were also reminded how political and arbitrary the clemency/commutation process is since so many more women deserve freedom who are still unjustly locked in prison.

The women prisoners we work with in the Clemency Project acted reasonably in unreasonable situations but they never received due process of law and do not deserve the inhumane, abusive treatment they receive from the state. Many brave women prisoners, such as Stacy Barker (*3 on a Life Sentence*, 1998; *Life on Trial*, 2018), have filed lawsuits against the State of Michigan and suffered horrific retaliation from the state for their efforts. In 2009, working with a team of intrepid lawyers, Stacy, together with more than five hundred other women, won a class action lawsuit for the rapes and retaliation they had endured from guards and prison staff for decades.[16] Many of the abuses in Michigan's prison for women have not improved, however, and as a result suicides and other needless deaths and suffering continue. In 2016, the Department of Corrections failed to notify police of both a suicide and the criminal behavior of its guards that led to the suicide. It was only the reports by brave women prisoners that brought media attention and police inside to investigate. Those who report such incidents frequently lose their jobs and suffer other retaliation as a result. Since the ACLU had been investigating and challenging abuses in solitary confinement in the women's prison at my request, based on reports from women prisoners, they filed a whistleblower lawsuit on behalf of a woman prisoner to challenge the prison's retaliation against her and others.

In 2017, Machelle Pearson, another fearless activist for women's human rights in prison and one of many women we have worked with who entered prison as a juvenile, was resentenced based on the 2012 U.S. Supreme Court decision in *Miller v. Alabama*, declaring that a nonparolable life sentence for a juvenile is cruel and unusual punishment and therefore unconstitutional. We fought to get a reduced sentence that would free her. I argued with the prosecutor, who insisted on keeping her in prison beyond the thirty-three years she had already served. The judge, in usual manner, sided with the prosecutor and sentenced her to five more painful years despite the fact that she is

seriously ill with a debilitating disease; had been raped by a guard who impregnated her, giving birth in prison; had lost her job for reporting a crime committed by the Department of Corrections to the police; and had been a model prisoner throughout her incarceration. It was a low moment, but we had to be grateful for the work of the many activists and attorneys who convinced the U.S. Supreme Court to change the law that condemned juveniles to die in prison. It is the network of activists working in grassroots groups like ours as well as in large organizations that gives us hope for a truly just system one day. Ultimately, thanks to the good behavior credits Machelle Pearson earned before the State of Michigan banned them for prisoners, she was freed in 2018.

In 2017, Nancy Seaman drafted a lawsuit against the State of Michigan opposing restrictive laws that deny a woman's right to give full evidence of self-defense in court, specifically, expert testimony relating to women whose history of battering relates to their crime. More than one hundred women have joined with her on that effort. We worked with her on that, and we also filed, together with the Michigan Coalition to End Domestic and Sexual Violence, an amicus brief in her case to the U.S. Supreme Court. In her case, and in the case of another woman serving life for killing her violent husband, Karen Kantzler, we have worked together with the trial judges for years. Both women's judges, to their credit, recognize their own and the systemic failures that wrongly sentenced these women to life in prison and want to see them freed. We have worked closely with the legal counsel, of Govenor Rick Snyder, who leaves office at the end of 2018; they selected these two women and six more from the Michigan Women's Justice & Clemency Project for consideration of clemency. In December 2017, Karen Kantzler was freed after we won a second public hearing for her. Two judges and many of her friends testified in her support.

A number of the women I have known and worked with in and after release from prison have died over the years. I feel certain that prison shortened their lives. Years of living under sexual, physical, and psychological abuse in overcrowded and stressful conditions; eating food without nutrition (some of it actually labeled "not for human consumption"); sleeping on hard bunks in cells that are cold in winter and hot in summer; hungering for education and programs and jobs and contact with outsiders that are too rarely available; and worrying about children and other loved ones on the outside are agonies that injure the mind and body and take their lives too soon. I believe citizens in the future will be appalled and sickened when they look back at the way we treat human beings in our prisons today.

Together, Lynn and I, with our roster of volunteers and students, have helped to free twelve women from life sentences and have supported probably hundreds more to reach for clemency, parole, and appeals, and to challenge the endless torture and misery of prison. It is still the spirit of Greenham that I carry as I struggle to raise hell and havoc against the state's injustice to women.

This book is organized roughly chronologically into nine sections. Each one spans several years and revolves around a body of visual, documentary, and public dissent on behalf of incarcerated women's freedom and human rights. The major themes represented in the book are explored in detail throughout by cultural and legal scholars and evidenced by letters, photographs, and narratives with generous permission of the women prisoners. News headlines serve as background to trace the momentum of annual campaigns and events while legal and official documents signify the interminable bureaucratic morass of the criminal-legal system. I am deeply indebted to all the feminists on both sides of the fence with whom I have worked over the decades. I hope this book provides a greater understanding of how and why women are forced to break the law yet are consistently denied equal protection, due process, and humane treatment by the state, and that it contributes to the seismic shift needed to end this country's destructive addiction to punishment. It is our great wish to join with others to challenge our broken criminal-legal-penal system and rid it of police and prosecutorial misconduct, ineffective defense counsel, racist and sexist legal and court processes, punitive parole boards, harsh sentencing practices, and the monstrous prison industry. We yearn for— and can imagine—massive change that renounces prisons and punishment as a solution to individual or collective harm and invests in educational and economic equality, mental and physical health care, and compassionate and restorative forms of justice.

Notes

1. Virginia Woolf, *Three Guineas* (1938; repr., Harmondsworth, U.K.: Penguin Books, 1977), 24.

2. Rogers, Lore, "Challenging Solicitation Statutes as Unconstitutional: Appellate Brief in Support of Defendant Appellant in Ypsilanti v. Patterson, " *Michigan Journal of Gender & Law* (1993): 135–161.

3. Patricia Gagne, *Battered Women's Justice: The Movement for Clemency and the Politics of Self-Defense* (New York: Twain Publishers, an imprint of Simon & Schuster, Macmillan, 1998).

4. Carol Karlsen, *The Devil in the Shape of a Woman: Witchcraft in Colonial New England* (New York: W. W. Norton, 1987), 263.

5. Cesare Lombroso and William Ferrero, *The Female Offender,* (New York: D. Appleton, 1895), 150–152.

6. "Incarceration, " The Sentencing Project, http://www.sentencingproject.org/issues/incarceration/.

7. Natasha Frost, Judith Greene, and Kevin Pranis, *The Punitiveness Report: Hard Hit: The Growith in the Imprisonment of Women, 1977-2004* (New York Institute of Women and Criminal Justice, Women in Prison Association, May 2006), 7–30; Barbara Bloom, Barbara Owen, and Stephanie Covington, *Gender-Responsive Strategies: Research, Practice, and Guiding Principles for Women Offenders,* v-viii, 4, 8, 18 (Washington, D.C.: National Institute of Corrections, June 2003); see also Beth Richie, *Arrested Justice: Black Women, Violence, and America's Prison Nation* (New York: New York University Press, 2012); Michelle Alexander, *The New Jim Crow: Mass Incarceration in the Age of Colorblindness* (New York: The New Press, 2010), 112–16; Jane Evelyn Atwood, *Too Much Time: Women in Prison* (London: Phaidon Press, 2000).

8. Michigan Department of Corrections, "1989 Statistical Report."

9. Policy Initiative, https://www.prisonpolicy.org/global/women/.

10. *Revolving Door: An Analysis of Street-Based Prostitution in New York City,* Urban Justice Center, Sex Workers Project, http://sexworkersproject.org/downloads/RevolvingDoor.pdf; Julie Pearl, "The Highest Paying Customers: America's Cities and the Costs of Prostitution Control." *Hastings Law Journal* 38.4 (April 1987): 769–800.

11. Bloom, Owen, and Covington, *Gender-Responsive Strategies,* 2–8; Frost, Greene, and Pranis, *The Punitiveness Resport,* 25; "The Changing Racial Dynamics of Women's Incarceration," The Sentencing Project, http://sentencingproject.org/wp-content/uploads/2015/12/The-Changing-Racial-Dynamics-of-Womens-Incarceration.pdf.

12. Bloom, Owen, and Covington, *Gender-Responsive Strategies,* 2–8; David Murphey and P. Mae Cooper, "Parents Behind Bars: What Happens to Their Children?" ChildTrends, 4, https://childtrends-ciw49tixgw5lbab.stackpathdns.com/wp-content/uploads/2015/10/2015-42ParentsBehindBars.pdf; Bloom, Owen, and Covington, *Gender-Responsive Strategies,* 5, 8, 18.

13. Frost, Greene, and Pranis, *The Punitiveness Report,* 7–30; Jacquelyn C. Campbell et al., "Assessing Risk Factors for Intimate Partner Homicide," *National Institute of Justice Journal,* 250 (November 2003):14–19; Nancy Gertner, "Women, Justice and Authority: How Justice Affects Women," *Yale Journal of Law and Feminism,* 14 (2002); 291–305.

14. Jennifer Bronson and Marcus Berzofsky, "Indicators of Mental Health Problems Reported by Prisoners and Jail Inmates, 2011-2012," U.S. Department of Justice, Bureau of Justice Statistics, June 2017; Jamie Fellner, "Solitary Confinement and Mental Illness in U.S. Prisons: A Challenge for Medical Ethics," *The Journal of the American Academy of Psychiatry and the Law,* 38.1 (2010): 104–108.

15. Amnesty International U.S.A., *"Not Part of My Sentence": Violations of the Human Rights of Women in Custody* (1999); Human Rights Watch, *All Too Familiar: Sexual Abuse of Women in U.S. State Prisons* (1996); Human Rights Watch, *Nowhere to Hide: Retaliation Against Women in Michigan State Prisons* (1998); Radhika Coomaraswamy, *Report of the Special Rapporteur on Violence Against Women, Its Causes and Consequences, Addendum Report of the Mission to the U.S.A. on the Issue of Violence Against Women in State and Federal Prisons,* United Nations Commission on Human Rights, 55th Session, E/CN.4/1999/68/Add.2, January 4, 1999.

16. Neal v. Mich. Dep't of Corr., 592 N.W.2d 370 (Mich. Ct. App. 1998) was the largest lawsuit filed by women prisoners against the state for sexual assaults.

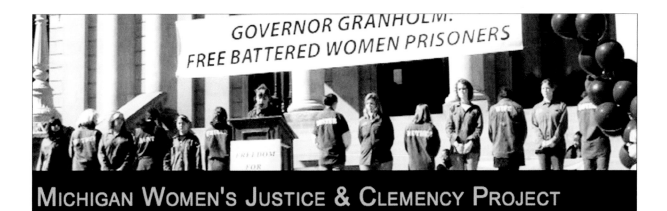

MICHIGAN WOMEN'S JUSTICE & CLEMENCY PROJECT

OUR MISSION

Michigan Women's Justice & Clemency Project works to free women prisoners who were convicted of murder but who acted in self-defense against abusers and did not receive due process or fair trials; and to conduct public education and advocacy for justice, human rights and humane alternatives to incarceration for women.

DEMAND FREEDOM NOW!

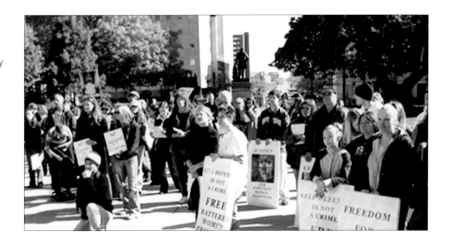

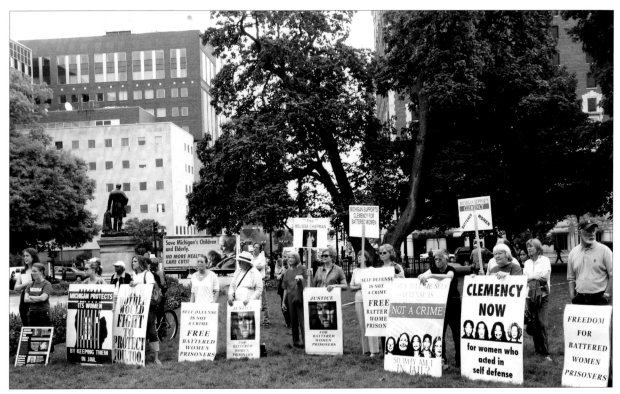

Above images are from annual rallies organized by the Michigan Women's Justice & Clemency Project
Michigan State Capitol, Lansing, Michigan 2001–2008. Website: www.umich.edu/~clemency

MCL 780.972

SELF-DEFENSE ACT (Excerpt)

Act 309 of 2006
780.972 Use of deadly force by individual not engaged in commission of crime; conditions.

Sec. 2.

(1) An individual who has not or is not engaged in the commission of a crime at the time he or she uses deadly force may use deadly force against another individual anywhere he or she has the legal right to be with no duty to retreat if either of the following applies:

> (a) The individual honestly and reasonably believes that the use of deadly force is necessary to prevent the imminent death of or imminent great bodily harm to himself or herself or to another individual.

> (b) The individual honestly and reasonably believes that the use of deadly force is necessary to prevent the imminent sexual assault of himself or herself or of another individual.

(2) An individual who has not or is not engaged in the commission of a crime at the time he or she uses force other than deadly force may use force other than deadly force against another individual anywhere he or she has the legal right to be with no duty to retreat if he or she honestly and reasonably believes that the use of that force is necessary to defend himself or herself or another individual from the imminent unlawful use of force by another individual.

UNIVERSAL DECLARATION OF HUMAN RIGHTS (Excerpt)

Preamble

Whereas recognition of the inherent dignity and of the equal and inalienable rights of all members of the human family is the foundation of freedom, justice and peace in the world,

Whereas disregard and contempt for human rights have resulted in barbarous acts which have outraged the conscience of [hu]mankind, and the advent of a world in which human beings shall enjoy freedom of speech and belief and freedom from fear and want has been proclaimed as the highest aspiration of the common people,

Whereas it is essential, if [a hu]man is not to be compelled to have recourse, as a last resort, to rebellion against tyranny and oppression, that human rights should be protected by the rule of law,

Whereas it is essential to promote the development of friendly relations between nations,

Whereas the peoples of the United Nations have in the Charter reaffirmed their faith in fundamental human rights, in the dignity and worth of the human person and in the equal rights of men and women and have determined to promote social progress and better standards of life in larger freedom,

Whereas Member States have pledged themselves to achieve, in cooperation with the United Nations, the promotion of universal respect for and observance of human rights and fundamental freedoms,

Whereas a common understanding of these rights and freedoms is of the greatest importance for the full realization of this pledge,

Now, therefore, The General Assembly, Proclaims this Universal Declaration of Human Rights as a common standard of achievement for all peoples and all nations, to the end that every individual and every organ of society, keeping this Declaration constantly in mind, shall strive by teaching and education to promote respect for these rights and freedoms and by progressive measures, national and international, to secure their universal and effective recognition and observance, both among the peoples of Member States themselves and among the peoples of territories under their jurisdiction.

CLEMENCY
FOR
BATTERED WOMEN
PRISONERS

CLEMEN

FOR
RED WOMEN
SONERS

RIGHT TO
A FAIR TRIAL
A RIGHT 4
ALL

he's not dealing with women who came out of criminal backgrounds. The attorneys need to be educated to know what kind of defense these women need, to know what the lifestyle was that they lived, what that does to you emotionally, mentally, physically."

Statistics show that she is correct; 80 percent of women who kill, kill out of self-defense. She continues, "I am angry at the court system. I believe they fail women...not only in their lack of knowledge of domestic violence, but in their judgmental attitudes towards women who make a mistake."

Francine was luckily assigned Aryon Greydanus to represent her. He welcomed feminist and other support, and he fought hard for a fair trial. His most crucial move was to get Judge Harrison to disqualify himself for making this biased statement: "What kind of woman would do that kind of a thing anyway?"

On the same day that Judge Harrison withdrew from the Hughes case, he returned to his courtroom, and presided over Violet Allen's trial. In only a matter of hours, she was convicted of first degree murder. Unlike Francine Hughes, she

Francine Hughes was acquit of the same crime 17 years a

Her call as an artist, to "make visible that which is not, and needs to be" will no be thwarted. She continued her work in the Michigan prisons.

Remarkably, producer Ca Jacobsen reports, "There many women serving life se tences for murder who ne picked up a weapon, or co

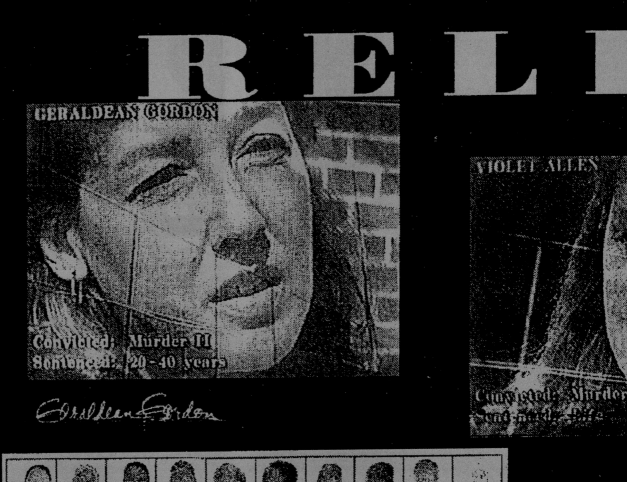

GERALDEAN GORDON
Convicted: Murder II
Sentenced: 20 - 40 years

VIOLET ALLEN
Convicted: Murder

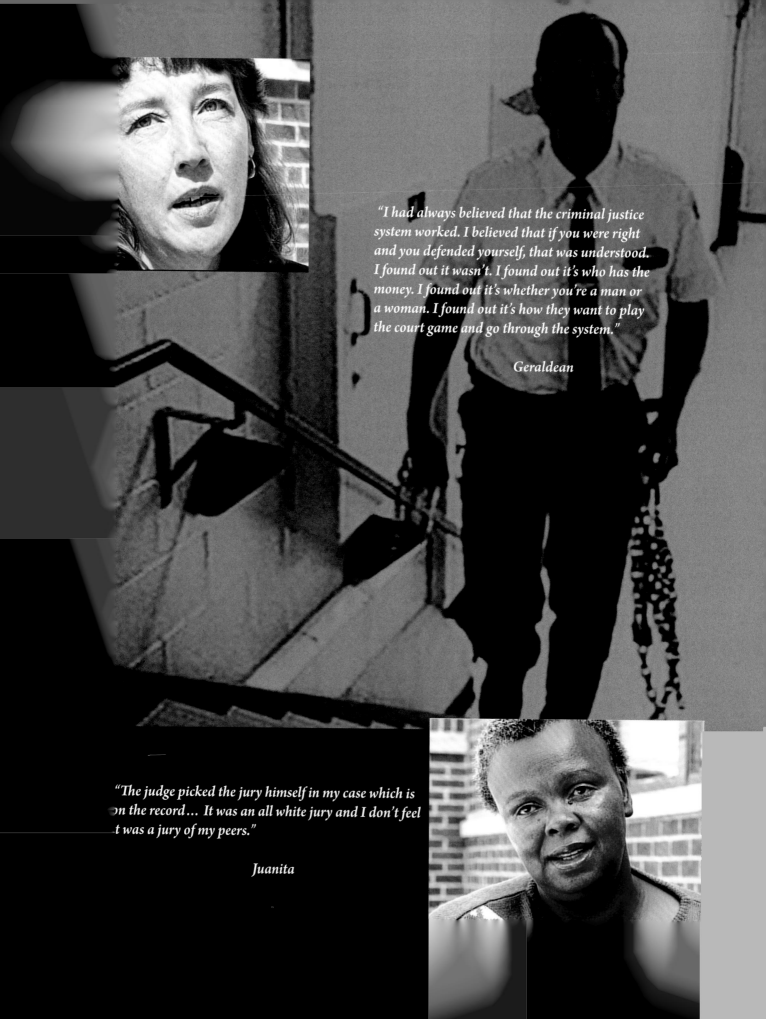

"I had always believed that the criminal justice system worked. I believed that if you were right and you defended yourself, that was understood. I found out it wasn't. I found out it's who has the money. I found out it's whether you're a man or a woman. I found out it's how they want to play the court game and go through the system."

Geraldean

"The judge picked the jury himself in my case which is ɔn the record … It was an all white jury and I don't feel t was a jury of my peers."

Juanita

FROM ONE PRISON (1992–95)

When I first went into a women's prison in 1989 it was at the invitation of an activist to make a short film with the women about their children's visitation program, *Our Children Do Time With Us* (1990). Once inside, I was shocked to discover that most women are serving time for gender-based crimes induced by poverty and/or violence. Most are also poor single heads of households; and about half are women of color. Their stories of abuse were familiar to me. I, too, had broken the law —with an illegal abortion—to free myself from a violent man. As we spoke, a shock of recognition set in that I could not shake off.

The crisis of women abuse, from intimate relationships to interactions with the state, is a human rights issue of epic proportions. Amnesty International estimates that one-third of all female murder victims are killed by male partners in the United States. In Michigan, one woman is killed by a husband or boyfriend every six days. This figure has not changed in decades. While governments officially condemn the violence, they fail in substantive ways to provide resources to end the crisis or to meet women's needs for survival. Worse, those who survive by breaking the law that does not protect them face severe penalties from the state. The criminal-penal system overcharges, harshly sentences, and then abuses them in prison.

From the beginning, filming in the women's prison was tense and difficult. I was concerned about the degrading attitudes of the officers and staff toward the women that I saw and the crushing domination of the prison system that I felt. But I soon realized this had only suppressed these women's resistance, not killed it. When I finished the film about the children's visiting program, I knew I had to do another film. In my research for *From One Prison...*, I discovered footage of the women's prison belonging to the state, but my request for a copy was denied. The reason given was that I was "a controversial person." I argued that it was public property and finally obtained the copy, but that was only one of many efforts by the state to bar my access to information. In the prison, guards interrupted the filming, jumped in front of the camera, made me erase footage, and threatened to kick me out for asking questions about corruption or abuse. Once, the warden seized my footage and sent it to the state for review. Another time I was threatened with expulsion for hugging. These were, of course, minor hassles given the human and civil rights violations the women were enduring every day. Taking the women's faces and voices outside the prison to public audiences was my initial goal. I wanted others to come face to face with them and to recognize the injustice of criminalizing women for their acts of survival. But the deeper I delved into the work, the more I realized I wanted to expand my practice as an artist into legal and political realms as well. In 1993, together with attorneys Lynn D'Orio and Lore Rogers, I relaunched a grassroots effort that had become dormant. Founded by former prisoner, Susan Fair, the Michigan Battered Women's Clemency Project (later renamed the Michigan Women's Justice & Clemency Project) sought to free women who acted in self-defense against or because of abusers but did not receive fair trials based on the facts of their cases and were now serving life sentences for murder. The original case load was fifty-five women. We had support from the ACLU at first, but later became a nonprofit on our own.

In 1994, I received permission from the warden to show the rough cut of *From One Prison...* to the four women who narrated the film. When I arrived at the prison, I was ushered into a small room where the warden, deputy warden, several guards, and Violet Allen, Juanita Thomas, Geraldean Gordon, and Linda Hamilton sat together facing a TV set. I sat between the women and the officials. As the narrations shifted from painful accounts of the women's "crimes" and trials to their critiques of the prison system, the tension in the room increased. Guards shuffled their feet and grumbled to each other. But the women ignored them. They felt validated, they said, by the ways their words echoed and reinforced each other. The moment the film ended, I stood up and the five of us hugged each other—a rare luxury in prison where any touch by another prisoner is a sexual misconduct. Soon afterward, I received a letter from the state demanding a copy of the film. I called my friend Marjorie Heins, an ACLU attorney in New York, and was advised not to send it. I wrote back stating the film was not finished and I never heard from the state again. I was more determined than ever to make the issue of women's criminalization visible from a critical, legal, and feminist—these women's—point of view. It was also a necessary antidote to the deep anguish I felt about the injustice I was now witnessing.

From One Prison...
70 min. 1995
Excerpts

Linda: Because my husband was in the military, I thought the military would handle the problem. But I was in for a big surprise.... I thought they were going to take him away and that would be the end of it. But... that's when he took the alternator off of my car, he took the phone off the wall, he took the money that I had. I became like a prisoner.

Geraldean: I felt the police identified with him.... They would take him out, and like I say, have a good talk with him outside, more or less like one of the boys, and send him back in the house.

Juanita: They [police] would talk to me and say, "Is he his sweet self tonight?" and a lot of times they wouldn't even say nothing to him, just tell me to go someplace and spend the night. I told them his name wasn't on the house, but they said go someplace and spend the night till he cools down.

Violet: I learned from my childhood abuse that calling the police didn't do any good.

Geraldean: If a judge is going to sit on the bench over a case like this I believe that he should be educated and know what he's dealing with... that he's not dealing with women who come out of criminal backgrounds. I believe that the attorneys need to be educated to know what kind of defense these women need... I believe they fail women not only in their lack of knowledge to domestic violence but in their judgmental attitudes toward women.

Linda: In prison touching anyone is a misconduct... There's plenty of times when people are hurt and they need comfort. That's a real need. I read somewhere that animals that weren't touched and loved, you know, tend to die. And yet we're supposed to go years and years and not supposed to be able to touch or feel.

Violet: When we get upset and cry they automatically think the worst so they go to the most extreme measures. They handcuff you to the bed. Call the clinic to give you a shot, you know? Bum rush - three officers run in and grab you by the arms and legs and throw you on the ground....

Geraldean: Medical care is nonexistent in here. I've seen women really suffer. I have personally suffered.... They're not going to supply your medication. You have to buy it. You have to buy all your personal needs....

Violet: One girl died. She had an asthma attack. And the officer walked over her and kept on walking. One woman had a heart attack. She was pounding on the door. She was telling them she had chest pains, and they told her just to lay down.... She died.

Geraldean: For everybody it's building a network of support in here. Which is hard to find the people that you can depend on, especially in a system where they don't want you to have that.... But you search it out and you find it for your own survival.... You become mother, father, sister, brother... because there is nobody else.

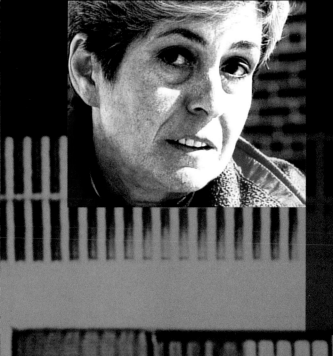

"I walked in and it was like my whole world - John was sitting there with his shirt off and Robin was lying on the bed crying and she didn't have any clothes on... and I seen that Robin was bleeding. I took her to the bathroom and she kept telling me that John had hurt her butt. I bathed her and I got her dressed and I took her to the military hospital.... I don't know how to say this - have you ever cried without feeling yourself cry?"

Linda

"He came in from wherever he was and he just went on a rampage. And it was like, he picked my daughter up and he threw her. And it was like I just had a flashback of my own childhood and I can remember thinking, 'I can't let her go through this like I did.'... All I could see was I had to stop him from hurting her.... He used to try to have sex with her. And it was like I was reliving my whole childhood all over through her. I just couldn't let him do it to her. I had to stop him, so I did."

Violet

Life Sentences:
The Plight of Women Inmates

Sidonie Smith and Kay Schaffer

Women prisoners are the most invisible of those serving time in America's prisons. They remain far more isolated than incarcerated men and receive far fewer visitors. Often their own families do not support them. Far fewer lawyers represent them. Once incarcerated, their sustained invisibility is an effect of their relative nonresistant and non-litigious behavior. Women prisoners rarely riot. They do not file the number of lawsuits male prisoners do. Moreover, women prisoners are rarely the focus of extensive studies. Nor have women prisoners gained public recognition as prison writers or prison journalists. Given this situation, it has been incumbent on activist artists and scholars to bring the stories of incarcerated women to a broader public through documentaries and published narratives.

*In 1994-95 , Carol Jacobsen, who has advocated for women serving life sentences in Michigan prisons for killing their abusive partners and for the human rights of incarcerated women, produced **From One Prison…**. The video interweaves fragments of interviews with four of these women–Violet Allen, Juanita Thomas, Geraldean Gordon, and Linda Hamilton–who tell about their family relationships, describe the circumstances of their abusive relationships, recall the killings, and offer their own analysis of their treatment within the criminal justice system. **From One Prison…** presents women who have not so much reformed, in terms of confessing and acknowledging their criminality, as women who have begun to understand and articulate the ways in which the criminal subject is produced by social structures (of marriage, justice, and punishment).*

In the intercutting of multiple stories, the women become at once four individuals, with different stories to tell, and a chorus whose collective narrative accumulates

From One Prison…, still, 1995

Detroit F

On Guard

Wives w

BY JACQUELYNN BOYLE
Free Press Staff Writer

When she was 10, Violet Allen taken from her home because she'd physically and sexually abused by rela

To escape foster care at age 1 married a man nearly twice her age, c find he was abusive.

After two years of marriage, sh and killed James Allen, who she sai her and kept her a virtual prisoner i home. A few months later, she was c ed of first-degree murder and senten life in prison without parole.

That was in 1977. Today, Violet

the force of truth through repetition (but always with differences). Neither the artist nor the women make claims of innocence; they do, however, make claims about the systems that put them on a life sentence. Critical to Jacobsen's project is enabling the women to position themselves not as passive victims of domestic violence and state indifference but as critics of the justice and penal systems and of the institution of the family itself. Thus, she listens for, and edits to capture, the public voice of the social critic rather than the personal voice of the victim.

In 1995, Human Rights Watch, a sponsor of the project for a worldwide tour, took **From One Prison...** to the International Women's Conference in Beijing. The video has been used as an organizing tool within rights organizations; it circulates in galleries, museums,

and arts festivals, where it is mobilized in efforts to spur activism on behalf of women's rights. In this way, the four women who tell their personal stories speak to a broad international audience far beyond the confines of the prison facility in Michigan.

They enter their stories into circulation within the field of non government organizations active on behalf of women prisoners, among them the Clemency Project (the activist arm of Jacobsen's work), Critical Resistance in California (Angela Davis is a founding member), American Friends, the California Coalition for Battered Women's Defense, and the New York-based Women in Prison Association. In circulation, their stories participate in the "social and global contextualization of violence against women" so central to 'locating' it within the human rights framework.

ree Press

Monday

March 6, 1995

35 cents (50 cents outside 6-county metropolitan area)
For home delivery call 1-313-222-6500

63 Years

no killed seek clemency

Husbands' violence caused the slayings, imprisoned spouses say

is hoping for a second chance.

On Tuesday, Allen's lawyer will file a petition asking Gov. John Engler to commute her sentence or grant a pardon. Her claim: she was a battered woman who never got a fair shake from a justice system that only recently has recognized its failure to help victims of domestic violence.

"I'm asking him to understand . . . I'm pleading for my life," the soft-spoken Allen, now 36, said last week in an interview at Scott Correctional Facility in Plymouth Township.

"In '77, this was a taboo subject. I never knew so many other women were in this situation. No one talked about it. No one helped me. What's my mother's favorite saying? 'You made your bed, now you lie in it.'"

The state parole board will review the case and make a recommendation to Engler. The process could take months.

See **CLEMENCY**, Page **7A**

Inside

Convicted murderers Juanita Thomas and Geraldean Gordon also say they were battered.
Page **7A**.

FROM ONE PRISON... 19

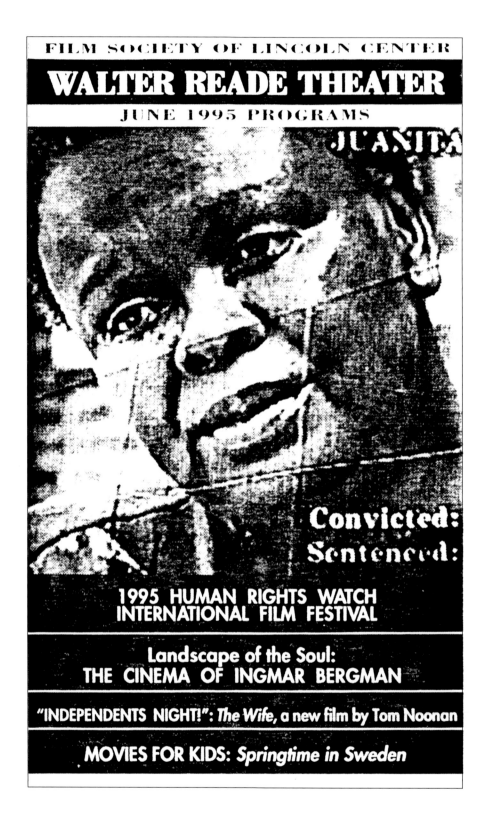

Human Rights Watch, International Film Festival program cover: *From One Prison...*, still, 1995

MICHIGAN DEPARTMENT OF CORRECTIONS
PRISONER STATIONERY

CSJ-110 4/90
4835-3110

TO:

NAME: Carol

NO. AND STREET OR R.R.

CITY | STATE | ZIP

FROM:

NAME: J. Thomas

NO. 161091 LOCK C-22

INSTITUTION DATE 3-6-95

IN CORRESPONDENCE, USE NAME AND NUMBER ON YOUR **LETTER** AND ENVELOPE

the Article was to come out today, the
officers say it come out today, I don't have
a copy, could you Get the paper and cut out
put in Brown envelope and Send me
Will write again Soon,
Tonite I Feel pretty Depressed, seem
when it Rain, it Really does Pour, I Do
Want you all to Find Some one else to work
on my case, write me Soon,

From J. Thomas #161091
C-22

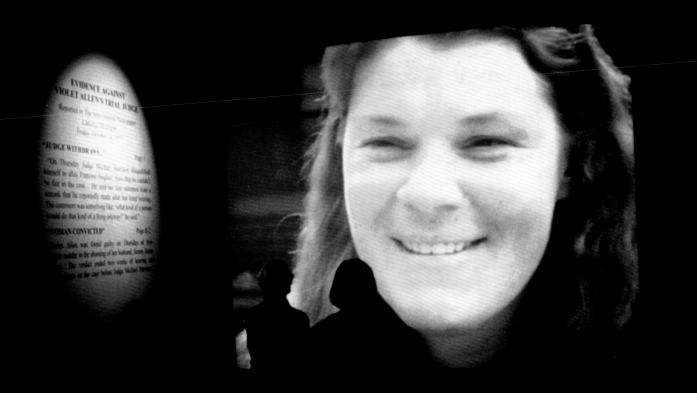

EVIDENCE AGAINST
VIOLET ALLEN'S TRIAL JUDGE
Lansing State Journal
October 14, 1977

JUDGE WITHDRAWS
*On Thursday Circuit Court Judge Michael
Harrison disqualified himself to allay Mrs. Hughes'
fears that he couldn't be fair in the case. Before trial
he said, "What kind of a person would do that kind
of thing anyway?"*

WOMAN CONVICTED
*Violet Allen was found guilty on Thursday of
first degree murder in the shooting of her husband,
Jimmy James Allen. The verdict ended two weeks of
hearing and deliberations on the case before Judge
Michael Harrison.*

Testimony of
Artemisia Gentileschi at Rape Trial
Naples, Italy, 1612

Manuscript 19

"And after he had done his business he got off me.
When I saw myself free, I went to the table drawer and took
a knife and moved toward Agostino saying, 'I'd like to kill
you with this knife because you have dishonored me.' He
opened his coat and said: 'Here I am,' and I threw the knife
at him and he shielded himself; otherwise I would have hurt
him and might easily have killed him."

Artemisia Gentileschi, age 17

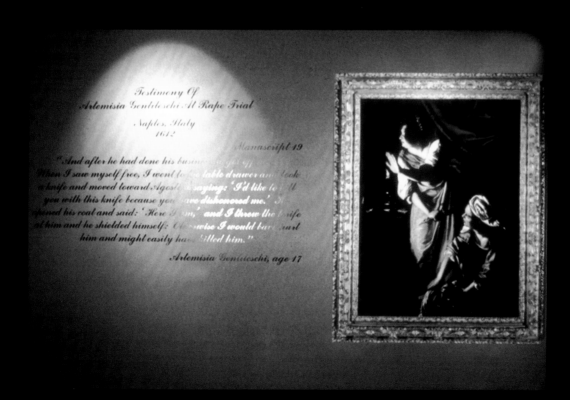

Left and above: *Violet and Judith*, video installation, Detroit Institute of Arts, 1995

Battered Women's Clemency Project Issues Call for Justice
Lynn D'Orio

Excerpt from Opinion in Ann Arbor News, April 4, 1996

The fact that much of our population knows about domestic violence came about through the efforts of many. Programs for school children, law enforcement officers, judges and the community, as well as reports in the news, all helped to enlighten the general public about the scourge of domestic violence. There are new shelters in several parts of the state, albeit not enough.

Domestic violence is now a crime instead of a family problem once ignored by law enforcement agencies that did not want to get involved. Something is being done to help the victims of domestic violence.

Before the news media turned its attention to domestic violence, before domestic violence was criminalized, before the education program, and before the grassroots organizing that birthed the first shelters for battered women, women were beaten by their partners and too many could never escape their captors. Some escaped with the help of friends and family, some were killed, and some finally—desperately—fought back.

The women who fought back went to prison for their actions because they faced an ignorant public and an ignorant criminal justice system. No one was there to explain how these women acted in self-defense or in defense of their children. So, they were convicted and sent to prison with sentences often longer than the sentences for batterers who killed their partners. Until recently, these women were forgotten.

The Michigan Battered Women's Clemency Project (now Michigan Women's Justice & Clemency Project) was founded in 1990–91 by Susan Fair. Volunteer attorneys and advocates joined with her and distributed questionnaires to women in Michigan prisons. Their purpose was to identify women inmates for whom battering was an explanatory or mitigating factor that should have been considered in their criminal defense, but for whom that evidence either was not raised, was raised inadequately or was rejected by the judge.

Approximately 70 women were interviewed. In March 1995, the first petition for clemency was filed on behalf of Violet Allen. In six short weeks, the petition was denied by Gov. John Engler without explanation. In December 1995, the Clemency Project filed its second petition, this time on behalf of Delores Kapuscinski.

Our criminal justice system recognizes that there are situations when the killing of another person is justified. Yet, the state will not acknowledge the injustice of the continued incarceration of women who protected themselves and their families from abusers.

Governors embrace the cause of domestic violence because it promotes a "tough on crime" platform, not because of compassion for women and the violence they faced before domestic violence was even a crime.

Incarceration will not make the inequity go away. It is time to correct these gross wrongs. The government must be educated. We must raise our voices and send the governor letters demanding the freedom of these forgotten women prisoners. The solution is not to lock them up and throw away the key.

Lynn D'Orio, Legal Director, Women's Justice & Clemency Project, speaking at Rally, Michigan State Capitol, Lansing, Michigan, 2002

Please read instructions on reverse side before filling out this application.

APPLICATION FOR PARDON OR COMMUTATION OF SENTENCE

TO THE MICHIGAN PAROLE BOARD: Date March 7, 1995

I, Violet Mae Allen , No. 150376 , Scott Correctional Facility
(name now serving under) (prison)

hereby make petition as provided by law for a commutation of sentence or pardon
(pardon or commutation of sentence)

and present the following facts supplementing material information already on record:

I (was convicted, pleaded guilty) on the 14th day of October 19 77 , in the

Circuit Court of Ingham County of the crime of first degree murder

and was sentenced to a term of natural life

I (am, am not) a citizen. My age is 36

My present marital state is widow , and I now have
(married, divorced, single, widow/er, separated)

no minor children dependent on me for support. Name and ages n/a

I (am, am not) subject to the payment of alimony as follows: n/a

I communicate regularly with the following: (give name, address and relation of each) Randy Dickinson, Mojabe, C
(friend); Bonnie Dibell, Hastings, MI (sister); Professor Roy Younce, Bentville, AR (frienc
Elizabeth Cramer, South Carolina (former domestic violence counselor and friend)

There are the following other members of my family dependent on me for support:

None

I believe that the following achievements during the term of my imprisonment will aid me in my efforts toward making a good social adjustment: I have had 18 years of group and individual psychological counseling; as well as college classes, including certificates in Century 21 Typing and Graphic Art My prison work has prepared me for many jobs like, commissary, graphic arts and data entry.

The following plans have been made for me in the event of my release: Upon release, Ms. Allen will live with JoAnn Jahner of Detroit. she will immediately seek work so that she can support hersel Ms. Allen plans to apply for admission to Wayne State University in order to earn a bachelor

VIOLET AND JUDITH, 1995
Carol Jacobsen
Detroit Institute of Art

Dear Governor Engler:

As a citizen of Michigan, I respectfully urge you to right a terrible wrong generated by ignorance about domestic violence and to hold a public hearing to reconsider the sentence of Violet Allen, who was denied adequate protection for safety and survival against a batterer and was deprived of due process under the law.

Sincerely,

Signature

Print Name and Address

THE MICHIGAN BATTERED WOMEN'S CLEMENCY PROJECT
AMERICAN CIVIL LIBERTIES UNION (ACLU)
339 E. LIBERTY, ANN ARBOR, MI (313) 995-1600

Governor John Engler
State Capitol Bldg.
Lansing, MI 48909

This installation is supported in part by a Regional Artists' Project Grant, administered by Randolph Street Gallery and the National Afro-American Museum and Cultural Center, and by funds from the Presenting and Commissioning Program of the National Endowment for the Arts, The Rockefeller Foundation, The Andy Warhol Foundation for the Visual Arts, with additional support from the Illinois Arts Council, the Ohio Arts Council and Randolph Street Gallery.

GOVERNOR ENGLER:
CLEMENCY NOW
FOR BATTERED WOMEN PRISONERS

2. PROTESTS AND PROSTITUTES' RIGHTS

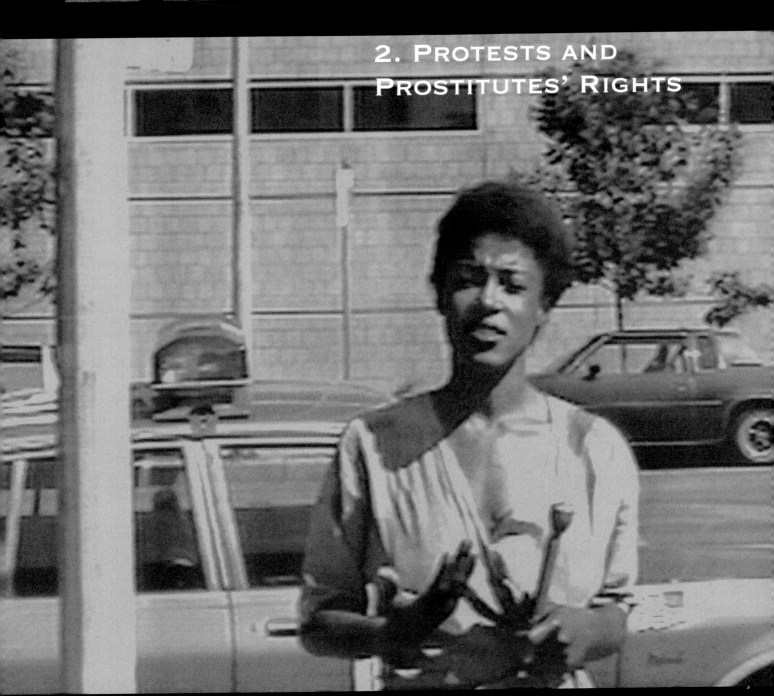

The University of Michigan exhibit "Porn'im'age'ry: Picturing Prostitutes"

Artist ignites U-M controversy about pornography and art

hat's the difference between a bad man and a bad woman?

"A bad man is someone who hurts some-one else and takes from someone else," says Michigan artist Carol Jacobsen. "A bad wom-

"*They got me for A & S and Disorderly Conduct. It cost me $1,500 to get out of there. I paid it. You make money when you work on the streets. Some girls spend it, some girls save it. I save it.*"

Sugar

Street Sex, video installation, Detroit Artist's Market, 1989

PROSTITUTES' RIGHTS (1985–2019)

I began work on the Prostitutes' Rights project in 1985, after living in Europe for a year. The experience of visiting Greenham Common Women's Peace Camp and following the protesters to court in London made me think more deeply about the ways women were stigmatized and punished for their acts of resistance and survival. When I returned to court the next time, it was in 36th District Court in Detroit, where I found that it was prostitutes who were being arrested for the same crimes of "disturbing the peace" and "disorderly conduct" that the London protesters had faced for defying the law over nuclear weapons.

As I sat through arraignments in Detroit over the next four summers, I watched hundreds of women being cranked through the legal assembly line. In the halls of the courthouse, police officers high-fived each other as they chalked up another conviction against the street prostitutes who were working to feed their kids, their habits, and their dreams—and taking their lives in their hands to do it. I followed many of the women outside and asked to talk with them about their views on the police, the laws and the courts. I explained that I was an artist doing research, that I was critical of the criminal system and the illegal status of sex work, and that I would pay them for their time. As I listened to them, I felt I was tapping into something deeply rooted in the relationships all women have to sexuality, gender, race, and class that have shamed, silenced, and punished us.

I searched for contemporary research on sex work that could help me analyze the issue, but I found very little. One exception was Julie Pearl's groundbreaking study, "The Highest Paying Customers: America's Cities and the Costs of Prostitution Control" (1987) exposing how police use sex work to boost their arrest records. I was excited when two new books appeared: *Sex Work* (1987), edited by Priscilla Alexander and Frederique Delacoste, and *A Vindication of the Rights of Whores*, by Gail Pheterson (1989). After the first summer of talking to women alone, I hired a camerawoman and set up my equipment in the parking lot across the street from the courthouse to interview women on film.

One day a judge noticed my returning presence in her courtroom and asked me to stand up and identify myself. I was surprised that she had noticed me in this large roomful of people, although most were black and I was not. I answered that I was an artist doing research, and she instructed me to follow her to her office. She was friendly but harsh. What did this subject have to do with art? Making art about prostitution was not a good idea, she warned. I was wasting my time; no one was interested in these women except their pimps. As an artist herself (her office was filled with her sculptures), she advised me to find a better subject. The summer after that, she went out to the parking lot while I was in another courtroom and she warned my camerawoman that she would have me arrested if I kept talking to these women. But I did and she didn't.

As soon as I began to exhibit *Street Sex* and other video and installation works from that project—from Detroit to San Antonio and in Canada—they were taken down, covered over, dismantled. The rationales for banning them were that children might see the work, adults may be offended or the gallery might lose its funding. In 1992, when the University of Michigan Law School banned *Street Sex*, along with art by six other artists in the exhibit, *Porn'im'age'ry: Picturing Prostitutes*, which I had organized at the law school's request, I began a year-long battle to have the show reinstalled.

Although we won the battle against the law school and the entire exhibition was reinstalled a year later, my clashes with the censors had only just begun. Prison was another lesson entirely. Censors may be everywhere, including in ourselves, but none can be more pernicious than the prison regime. "Security" is the lie that serves to lock out human rights investigators, scholars, artists, activists and journalists. But by working together with women across the fence, it is possible to find ways to expose the corruption and inhumanity that go on inside.

"It shouldn't be against the law here in Michigan for ladies of the evening. It's hard to be harassed by police officers."

Doreen

"I don't think it's fair. It might be our only income. Over the whole year we pay at least $5,000."

Loraine

The Detroit News

r 7, 1992 **Metro edition** ·†

x, laws and videotape

"Police try to set you up... they should be the ones to watch out for you... and keep all these crazy maniacs away from women."

Goldie

I'm tired of the street. I been working about 4 years - don't want to do it no more. I worked topless and as a bar maid 4 years. It was just about as good money as this. I'm ready to get a legal job.

You'd be surprised how many women work in the winter. I work the same area all the time, and I been hurt before. This time I wasn't working when they picked me up. I was just going to get my baby some birthday candles. I have 3 kids.

They treat prostitutes like dogs. There were about 40 women in that back room.

Jo

Arraignment: Disorderly Conduct/Flagging
 Pled Not Guilty
 Released on $2,000 Personal Bond
 Trial: 10/5

Left and above: *Street Sex,* detail and stills, 1989

Detroit Free Press

On Guard For 163 Years

Feminist artist ignites U-M controversy about pornography and art

"I've been picked up by the police plenty of times. Plenty of times. And they have asked me, propositioned me. There's a police officer right now that goes out with my girlfriend. I don't want to mention his name because I don't want to get him in trouble. He takes women up on 8 Mile Road. He's got a woman right now that works for him on 8 Mile Road."

Linda

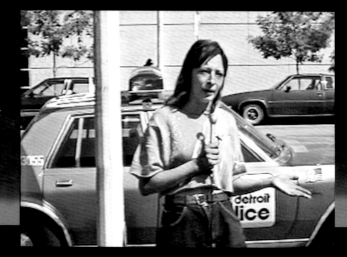

"There's people out here getting killed and I don't see the police trying to catch them. They're trying to get their bonus money. It's entrapment. Detroit, this is Dodge City. This is the wild, wild west. It's nothing like Chicago. Over here, they'll kill you. In Chicago, they just beat you up real bad."

Angela

They fed me once in jail. I been there 3 days and 3 nights. I got one bologna sandwich at 2 a.m. That turnkey guy says, 'I don't have to feed you at all.'

All I did was ask this guy for a ride. I got in his car and we drove over to this other car and he said, 'I want you to meet my partner. You're under arrest.' I didn't know if he was a cop or what. I thought it was somebody acting like a cop. They didn't show me no pictures, no I.D. This was the first time I've ever been picked up. First time I've ever been fingerprinted. They charged me with sex for $10.

Mary

Arraignment: Accosting and Soliciting
Pled Not Guilty
Released on $2000 personal bond
Trial: 11/6

Left and above: *Street Sex*, video installation, stills and detail, 1989

Feminist Fundamentalism: Women against Images

Carole S. Vance

The seeming resolution of an art censorship case at the University of Michigan Law School has done little to quiet artists' fears about the directions that attacks on sexual imagery are taking. In the midst of a four-year furor over National Endowment for the Arts funding of "offensive" images, antipornography feminists stepped into the fray, adopting tactics that strongly parallel those employed by conservatives and fundamentalists. By piggybacking their own views onto notions put into wide circulation by right-wing groups—for example, that virtually any visual imagery about sex is "pornographic"—antipornography feminists managed to shut down an art exhibition focusing on the work of women and feminists and to redefine notions of pornography and free expression.

The flap started when critics assailed a multimedia exhibition about prostitution, claiming that the installation was "pornographic" and a "threat." They physically removed the offending art and ultimately closed down the entire show. The censors were feminists opposed to pornography and law students who claimed they weren't engaging in censorship; their goal was to protect viewers from videos that made people "uncomfortable" and "created feelings of anxiety"[1] and from images "used to get men pumped."[2] Lee Bollinger, the dean of the law school and a specialist in First Amendment law, initially seemed to agree, suggesting that the students were merely

exercising their First Amendment rights by removing art from a gallery.

*What visual images set off such a ruckus? The works were part of an exhibition called "**Porn'im'age'ry: Picturing Prostitutes**," curated by feminist artist and videographer Carol Jacobsen, and featuring documentary photography and videos by seven artists, five of them women. The show included the work of Paula Allen, Susanna Aikin and Carlos Aparicio, Carol Leigh, Veronica Vera, Randy Barbato, and Carol Jacobsen. The exhibition, representing a prostitutes' rights perspective, was commissioned as part of a two-day conference called "Prostitution: From Academia to Activism," held at the University of Michigan Law School. The conference itself gave center stage to the views of leading antipornography theorists Andrea Dworkin and Catharine MacKinnon, the latter a professor at the law school; they regard both prostitution and pornography as central—and interrelated—causes of women's inequality. Because feminist opinion on these questions is quite divided,[3] student organizers initially wanted the conference to explore diverse perspectives, and the exhibition was part of this approach. They soon found, however, that antipornography advocates— following a now familiar maneuver—refused to appear if feminists holding different views were invited.[4] The complete installation was on view for no more than a few*

Furor on Exhibit at Law Scho

Are pornography and prostitution more dangerous than censorship?

By TAMAR LEWIN

The closing of an art exhibit on prostitution two weeks ago has plunged the University of Michigan law school into an angry debate about free speech, feminism, pornography and censorship.

Legally, the issue is whether students at the school violated the First Amendment guarantee of free speech by removing from the exhibit a two-

Feuding Femi

It is no accide occurred at the U gan, whose law fac arine MacKinnon, fight against porn the moving forces newly organized s The Michigan Jou Law, which sponso

hours before it was dismantled. Evidently panicked by the charge that some of the artworks were pornographic or dangerous, student organizers immediately removed all of the videos from the installation—sight unseen.

The next day, Carol Jacobsen discovered that the videos were missing: when she learned the reasons for their removal, she objected strongly. Controversy raged across the campus and then across the country. The ACLU, representing the artists, threatened to sue the university on grounds of First Amendment rights and for copyright violations because of unauthorized reproduction and circulation of the artists' videos by school officials and students. MacKinnon vowed to sue the ACLU for alleged defamation over their press release about the incident.[5] And Jacobsen waged an uphill battle at considerable personal cost to compel the university to redress the censorship. She demanded reinstallation of the show, as well as a campus forum to address issues of feminism, representation, sexuality, and censorship.[6]

This case, together with others, shatters the illusion that restricting sexual imagery for feminist purposes is distinguishable from fundamentalist censorship - either in method or in consequence. Such skirmishes show that the answer lies in expansion, not closure, and in increasing women's power and autonomy in art as well as sex.

Notes

1. Erin Einhorn, "Law Journal Censors Video, Citing Pornographic Content," *Michigan Daily*, November 2, 1992, 1.

2. Statement of law student and conference organizer Laura Berger in Reed Johnson, "Sex, Laws and Videotapes," *Detroit News*, December 7, 1992, 2E. Berger went on to say that "women such as this speaker [who complained about the videos] have been harassed by people who have watched pornography in the past."

3. For the antipornography feminist analysis, see Laura Lederer, ed., *Take Back the Night* (New York: William Morrow, 1980); Andrea Dworkin, *Pornography: Men Possessing Women* (New York: G. P. Putnam, 1979); Catharine MacKinnon, "Pornography, Civil Rights, and Speech," *Harvard Civil Rights–Civil Liberties Law Review* 20 (1985): 1–70; Dorchen Leidholdt and Janice G. Raymond, *The Sexual Liberals and the Attack on Feminism* (New York: Pergamon, 1990).

For feminist critiques of the antipornography position, see Kate Ellis et al., eds., *Caught Looking: Feminism, Pornography, and Censorship*, 3rd ed. (East Haven, CT: Long River Books, 1992); Carole S. Vance, ed., *Pleasure and Danger: Exploring Female Sexuality*, 2d ed. (London: Pandora, 1992); Lynne Segal and Mary McIntosh, eds., *Sex Exposed: Sexuality and the Pornography Debate*, (New Brunswick, NJ: Rutgers University Press, 1993); Nan Hunter and Sylvia Law, "Brief Amici Curiae of FACT (Feminist Anti-Censorship Taskforce) et al. in American Booksellers Association v. Hudnut," *Michigan Journal of Law Reform* 21 (Fall 1987–Winter 1988): 99–135.

4. For feminist views favoring decriminalization and efforts to improve the situation of prostitutes, see Gail Pheterson, ed., *A Vindication of the Rights of Whores* (Seattle,WA: Seal Press, 1989); Frederique Delacoste and Priscilla Alexander, eds., *Sex Work: Writings by Women in the Sex Industry* (San Francisco, CA: Cleis Press, 1987).

5. See *Arts Censorship Project Newsletter*, 2 (Winter 1993): 6.

6. Reflecting widespread impatience in the arts community with the university's foot-dragging actions in the case, almost two months after the original incident, art writer Elizabeth Hess encouraged readers to launch a "fax attack" to "remind Dean Bollinger that it's time to get on with the forum and on with the show," *Village Voice*, January 20, 1993; his rejoinder is in *Village Voice*, February 23, 1993.

ork Times

l Splits Feminists

awyers

t the furor
ty of Michi-
cludes Cath-
ader in the
y and one of
nd behind a
publication,
f Gender &
e art exhibit

'Trafficking Women'

The next morning, that videotape was removed by a group of law students from the journal staff who said they were acting in response to complaints by two of the speakers. Evelina Giobbe, the director of an anti prostitution group in St. Paul, and John Stoltenberg, a New York writer "We really didn't think of it as

He'll take you down just for being out there. All I was doing was waving and he picked me up for soliciting.

I do use protection. I use Chinese II. It comes in a tube, like baby cream. When you pull the skin back you look and if something comes out he's got something. Without protection you'd be killing yourself. I have friends and we keep an eye out for each other.

Theresa

Arraignment: Accosting and Soliciting
Pled Not Guilty
Released on $2,000 Personal Bond
Trial: 10/23

Above: *Street Sex*, video installation detail, 1989
Right: *International Detroit Pro Press*, detail, 1990, Collection of Museum of Modern Art, New York, NY

INTERNATIONAL
Detroit Pro Press

Police, Loring residents discuss prostitution and gay-bashing

INTERNATIONAL HERALD TRIBUNE 11/22/90

Quiet Inquiry Into Slaying Outrages Bostonians

BOSTON — Three weeks ago, when the woman was found slain in a park here, the police seemed to treat the case as just another killing in a city that has seen 128 of them this year.

But the death was far from ordinary. The victim had been raped, beaten and stabbed more than 130 times. This week, eight gang members were arrested and charged with killing Kimberly Kae Harbour, 26, as part of a Halloween "wilding" spree.

The case has drawn outrage throughout Boston, and not just at the crime. People want to know why the police at first played it down.

The victim was a poor black woman who the police said was a prostitute; some blacks say that

had she been a middle-class white woman, presumably there would not have been so reticent.

"I'm extremely outraged and perplexed at what their rationale might be in keeping this so quiet," said Louis A. Elisa, president of the Boston chapter of the National Association for the Advancement of Colored People. "If it had happened in any other community, they would have let people know that there was harm out there. We have seen major onsets of public policy that need to be resolved."

The Boston police, who did not reveal the extent of the brutality of the crime until Monday, when they announced the arrests, they were trying to conduct a thorough investigation outside the spotlight of public attention and that they had

done their job, however, eventually arresting suspects.

A spokesman for District Attorney Newman Flanagan said the authorities had been wary if prematurely disclosing information some of the 1989 murder of Carol DiStefano Stuart.

In that case, officials were severely criticized for publicly accepting Charles Stuart's story that his wife was shot and killed by a black man at a jogging spot, a story that generated tension between Boston blacks and whites. Investigators produced three suspects, all black, only in the end to have Mr. Stuart, who was white, turn out to be their main suspect. He then apparently jumped to his death from a bridge.

In the recent case, however, fear of racial tensions does not appear to have been a factor in the police decision not to publicize...

the slaying took place. "The alleged perpetrators have been walking the streets for three weeks, and there could have been other victims."

A police spokesman said. "that we report is what the officer reports. After that it goes to the district attorney's office. We don't assert the staff to resolve. The D.A.'s office has complained about us giving out information. That's why we didn't do it."

According to the police, Ms. Harbour, who they said worked as a prostitute to support a crack habit, was walking with a friend in a low-income housing development when they were accosted by several members of a street gang known as the Poisons.

The friend, Laura Peterson, escaped unharmed. Ms. Harbour, the mother of a daughter, 7, and a former Census Bureau employee, did not. According to the police, ...

— Carlos Garcia, 19, and Christopher William Pond, 19 — were arraigned and charged with rape and two others — Duron...

The Prostitutes Among Us

Sex workers sound off on heroin addiction, social rejection, legal troubles and judgmental lesbians

BY LORI MEDIGOVICH
Lesbian News Staff Writer

They live in the shadows of society's consciousness. They work at a job many consider immoral and others believe is degrading to women. As lesbian prostitutes, they are hidden within the lesbian community because they are afraid to tell their sisters that they make their living having sex with men.

"Most lesbians think that having sexual relations with men is gross..."

Prostitution was a job it sure hurt when people would accuse me of not being a real lesbian.

and madame of a house. She eventually was arrested for selling drugs and ended up in prison, where she began to get sober. By the time she got out of jail, she had kicked the drug habit, so she found a job, got a degree and is now a mental health and chemical dependency counselor.

Michelle, not her real name, also got into prostitution because of her heroin addiction. Now a clerical worker in her 30s who lives in Eagle Rock, Michelle was also a prostitute...

Study finds arrests for prostitution cost $2,000 each

By LAURA BECKLUND
LOS ANGELES TIMES

Law enforcement agencies in America's biggest cities spend an average of about $2,000 for each arrest of a prostitute, for a total of about $120 million a year in enforcement costs nationwide, according to a new study that describes itself as the country's first "cost-benefit analysis" of prostitution laws.

The study, published by the University of California's Hastings Law Journal in April, concludes that "arrests for prostitution, a misdemeanor, exact a disproportionately high toll on law enforcement resources" to the point that agencies can no longer "afford" to keep the crime "illegal."

Research for the study was conducted in 1985 by Julie Pearl, a 1987 graduate student of Hastings College of the Law. The premise of the study was that law enforcement resources would be better spent investigating and preventing violent crimes instead of prostitution.

"We can't afford to keep prostitution illegal anymore," Pearl said in a telephone interview from her San Francisco home. "That's the point."

Jim Rasmussen, chief of the California Bureau of Criminal Statistics, confirmed in an interview that the study was the first known to look at the costs of prostitution enforcement nationwide.

According to the study, Los Angeles arrested 15,000 prostitutes —

The premise of the study was that law enforcement resources would be better spent investigating and preventing violent crimes instead of prostitution.

spent by big cities nationwide.

Several "hidden costs" taken into account by the study were time spent driving to arrest sites, overtime pay for officers working...

Anti-hooker law pleases doughnut maker, alarms local rights activists

By LAURA BRANAM
YPSILANTI — Though civil libertarians decry it and the owner of a doughnut store calls the law...

10 deaths of women may be connected

State, local police compare Inkster slaying with others

By JOEL THURTELL
Free Press Staff Writer

Ten women whose bodies were found in the Detroit area and Ypsilanti are investigating whether a serial murderer may be responsible for 10 unsolved slayings of women dating back to 1985, an Inkster police spokesman said Wednesday.

There are strong similarities in the slayings, said Inkster police Detective Sgt. James Twiner...

DETROIT FREE PRESS/THURSDAY, SEPTEMBER 22, 1988

NATION/WORLD

Oakland police say they ignored rape reports

203 cases, called unfounded, to be reopened

SAN FRANCISCO — The Oakland Police Department has reopened 203 rape cases, many involving prostitutes or women who abused drugs, after admitting that the cases were dropped without even minimal investigation.

The admission Wednesday by the department that it had mishandled so many cases, excluding 187 in which the victim was never interviewed, followed publication of several articles this week in the San Francisco Examiner.

"Candidly, we blew it," said Police Chief George Hart.

The action by the department, beleaguered by a sharp rise in drug-related crime, was hailed by rape counselors, who said the criminal justice system often ignored prostitutes and saw rape victims who used drugs or engaged in prostitution.

The counselors say the police tend to give those cases little attention because they are often unsuccessful in court, with victims who are themselves criminals, often uncooperative, untruthful and unsympathetic.

"It's always been easier to think that prostitutes disappear or cases without official consequences," ...

people who don't fit in with what we think is an appropriate life-style. But the department here deserves a lot of credit for saying they messed up," said Marcia Blackstock, the executive director of an Oakland group, Bay Area Women Against Rape.

The numbers collected by the Examiner show that the Oakland Police Department last year listed 24.4 percent of its rape reports, or 143 of 585, as "unfounded."

According to federal crime reporting requirements, a report is considered unfounded if an investigation finds that a rape never happened.

The Federal Bureau of Investigation said Oakland's rate of declaring rape cases without merit is unusually high, more than five times the national rate of 9 percent.

Oakland police officials said the national statistics were misleading because many departments abandon rape cases without officially listing them as unfounded.

Ypsilanti clamps down on waving prostitutes

EYE-OPENER

Dallying truck driver gets brothel surprise – his wife

Associated Press

TERAMO, Italy — A truck driver who went to a brothel expecting a discreet dalliance instead came upon a shocking surprise — his wife.

The story was recounted Thursday in La Stampa newspaper of Turin.

The newspaper said a friend gave the unidentified 35-year-old truck driver the address of an exclusive bordello in Teramo in central Italy and recommended he ask for a particular woman working there.

"After a half-hour wait, when he finally obtained the prohibited meeting, the woman he dreamed of and whom he knew only by her working name turned out to be his wife, housewife by day, high-class call girl by night," the newspaper said.

Police said the driver recovered from his surprise to insult, kick and punch his wife. She was rescued by other customers and colleagues and filed an assault complaint against her husband.

Sniper strikes vehicle

BEAUMONT, Calif. — A man...

Paper Says 6 Officers May Be Tied to Slaying

SAN DIEGO, Sept. 29 (AP) — Detectives looking into the slayings of 43 women here are investigating up to six current and former police officers who may be linked to one of the slayings and the disappearance of a prostitute, according to a newspaper report.

Investigators last week searched the home, car and police locker of San Diego police officers who might be linked to Ms. Maene's disappearance or to the murder of Donna Gentile, one of the victims in the series of the killings.

The timing of a prostitute's death puts suspicion on the police.

Higher bonds chase hookers out of 2 cities

U.S. DATELINE

Woman in Swaggart case sentenced

Reds in the Beds

RUBBER RUMPUS WITH MADAME SIN
724 3220

Prostitution Charges Are Dropped by D.A.'s Office

■ **Vice:** Sheriff's deputy allegedly allowed woman to perform sex act before arrest. The department is proceeding with an internal investigation.

BY SEBASTIAN ROTELLA
TIMES STAFF WRITER

The Los Angeles County district attorney's office abruptly dropped prostitution charges Tuesday against a dancer because an undercover sheriff's deputy allowed her to perform a sex act on him before she was arrested, authorities said.

Serial killers have always been partial to prostitutes, expert says

Traveling hookers

Police say Michigan is part of a Midwestern circuit traveled by prostitutes during the summer. Starting in California, one group of prostitutes will move through the South to Florida, then North, eventually heading westerly into the Midwest. Another group, originating in the Northeast travels west through Pennsylvania and Ohio, before entering Michigan.

Police begin to seize cars in prostitution crackdown

Vice-related arrests

In Michigan, traveling prostitutes hit larger outstate cities such as Grand Rapids and Flint, where penalties are generally light and customers readily available. Smaller cities, such as Kalamazoo, report no influx of outsiders.

June arrests – Prostitutes and "Johns"			
Flint (Pop. 160,000)		**Grand Rapids** (Pop. 182,000)	
1986	1987	1986	1986
96	187	96	84

Source: News research

WATER SPORTS
Madame Niagra !
221 2405
O PEN LATE

IF YOU DARE
RING 402 1485

DOMINATION & BONDAGE, 19yr OLD BLONDE Miss P.
723 8565

Into Banking? Try Spanking!
243 1111

THE NERVE
262 2411

A Move to Ban Bordellos
Nevada legislators may outlaw licensed brothels

Governess Seeks Pupils
Only Old Colonial Boys Need Apply
224 9220
Top Marks Assured

Uncle Madam

There has been a stir in Newark about prostitutes.

Reds in the Beds

Dropped by D.A.'s Office

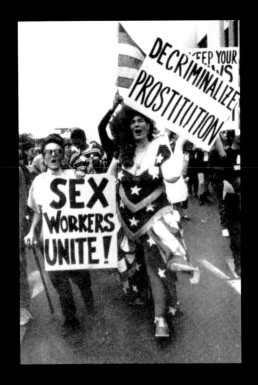

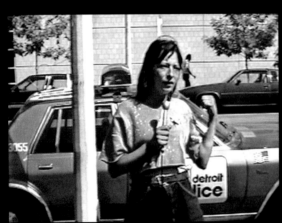
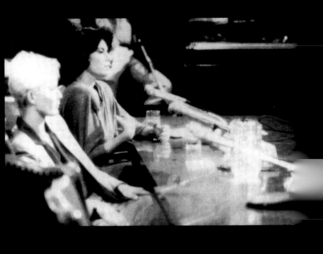

Above: Images and stills of censored artworks in *Porn'im'age'ry: Picturing Prostitutes*
Clockwise from top left: *Outlaw Poverty Not Prostitutes*, by Carol Leigh, a.k.a Scarlet Harlot; *The Salt Mines* by Susanna Aiken and Carlos Aparicio; *Portrait of a Sexual Revolutionary* by Veronica Vera and Annie Sprinkle; *My Own Private Seattle* by Randy Barbato; *Foxy/Angeline* by Paula Allen;

I'm not ashamed of what I do. I've probably been arrested 50 times - sometimes for doing nothing, sometimes for doing something. Lots of times they give you a ticket for loitering, just for walking down the street. Right now we're standing here on the street - we could be picked up for loitering. I'm a known prostitute. But maybe not because you're writing.

I had to jump out of a moving car one time because this guy was taking me someplace I didn't want to go. When I'm out in the street I'm working. I have to watch out for three things: police, guys sticking up prostitutes to take their money, and cops acting as prostitutes.

I use condoms all the time. My health is good. The guys that won't use condoms I say forget it. Most of my days I make $150 a day. On weekends I can make up to $500 on Friday and $700 on Saturday. It all depends on how I look and what I've got on. A lot of guys just want to talk.

<div align="right">Sherrie</div>

Arraignment: Accosting & Soliticing
 Pled Not Guilty
 Released on $1000 Personal Bond
 Trial: 10/2

Night Voices, video installation detail, 1990

" I work all the time. It's a scary life. But the money is so easy to get. You're hungry or you need some shoes—so you work. I never steal."

Barbara

NIGHT VOICES

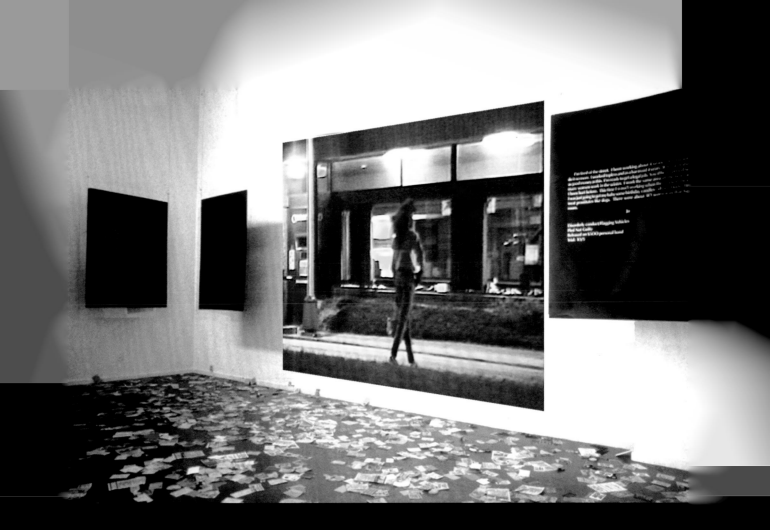

"Cops proposition girls left and right.
Sometimes they pick them up and ask the
girl, 'We'll let you go if you do this for me, if
you have some sex with me, give me a blow
job.' And, of course, she's going to do it 'cause
she doesn't want to go to jail. And then after
she does it they take her to jail anyway. Yeah,
it's happened to me."

Linda

Left and above: *Night Voices*, video installation and stills, Artists Space, New York, 1992.

CENSORIOUS

A Film by
CAROL JACOBSEN
SHAUN BANGERT
MARILYN ZIMMERMAN

Censorious (2005)

Freedom of expression may be formally enshrined in the law, but social and political pressures continue to produce covert censorship—of individuals, of groups, of art, of whole cultures. First of all, there is an essential incompatibility between art and the law since creative work is built on expressions of freedom, openness, and constructive acts, while the law sets boundaries, enacts codes and enforces edicts. Second, a paradox exists in the fact that women and other marginalized groups must claim and struggle for their human and civil rights from the same set of white, patriarchal institutions that sustain and benefit from the ideologies of sexual, racial, and class subordination and abuse.

Perhaps it was inevitable that clashes would occur between the liberation movements that emerged in the 1960s and the backlash from the religious right and Reagan-era corporatization that rose up against them in the 1980s. As new, unfamiliar expressions and activities gained access to public venues and visibility, they were attacked by powerful right-wing legislators and religious leaders who brought charges of blasphemy and pornography through court cases and media attacks with the intent to end for good all government support for the arts and open expression.

The good news of the culture wars was that the attacks were evidence of a new heterodox culture and discourse that had real power in the world. The bad news was that the attacks on women artists were themselves largely censored out of the public and cultural discourse of the 1980s and 1990s, leaving us vulnerable to some of the costliest as well as the loneliest battles of the culture wars. Some artists, like Holly Hughes, endured homophobic death threats; others, like Carolee Schneeman and Linda Montano, lost jobs because of their sexually provocative works; and still others, like Marilyn Zimmerman, had their homes and studios raided by police, were arrested, and/or lost custody of their children because of trumped-up charges of child pornography.

Our own battles during that period were the motivation for *Censorious,* a film produced by Shaun Bangert, Marilyn Zimmerman, and myself in 2005. A scathingly funny, feminist overview of the culture wars, the film is narrated by Martha Wilson, Holly Hughes, Renee Cox, and other artists who fought for their sexually and politically explicit works on issues of sexism, racism, homophobia, prostitutes' rights, abortion rights, and rape.

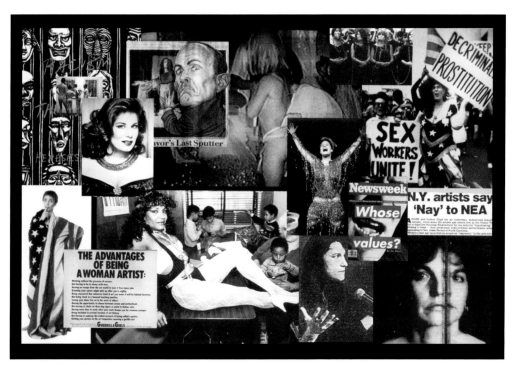

Above: *Censorious,* announcement card, 2005
Left: *Censorious*, stills: Clockwise from top left: Barbara DeGenevieve, Martha Wilson, Marilyn Zimmerman, Howardena Pindell, Renee Cox, Carolee Schneemann, Holly Hughes

"*A few days ago I finished the Fresh Start Program and I'm going for a master's degree...That morning when I was going to go to treatment, I said to Melissa, 'What's gonna happen if you go back out and use?...' And a couple weeks ago they found her in an alley, butt naked, dead.*"

Tonyia

74-167. Soliciting.

a) No person shall solicit another to engage
h such other person in sexual activity, whether
solicitor is the one buying or selling his or her
ors.

COURTROOM (2019)

Despite the massive exodus of Detroit's population, the number of sex workers arrested in Detroit annually—more than 800 (even more in years when police sweeps occur)—has changed very little over the decades since I first interviewed women coming out of jail and court in the mid-1980s. The extreme poverty that fell upon the city as the auto industry absconded with its profits to find labor it could exploit elsewhere has not been alleviated yet. As ever, arresting women for prostitution remains one of the easiest ways for police to increase their arrest records albeit at taxpayers' expense.

In the first decade of the twenty-first century there was a glimmer of hope in the form of pilot programs implemented in cities across the United States to decriminalize drug addiction and sex work. In Detroit, Judge Leonia Lloyd, unlike the judge who threatened to have me arrested for filming and interviewing women on the street in 1986, invited me into her courtroom to interview women and film with my coproducer, Shaun Bangert, and camerawoman, Susan Gardner. Women who agreed to speak with us on camera were participants in a program that was offering abuse counseling, drug treatment, job preparation, and, finally, expungement of their arrest records upon completion of the program, which lasted from ninety-three days to eighteen months. Although

Courtroom, still, 2019

the program was a criminal court approach to the issue, its compassionate premise and Judge Lloyd's expertise in handling the women's cases were positive steps toward decriminalizing sex work and drug addiction in the city.

As long as prostitution remains illegal in this country, women cannot report rape, assault or other crimes to police for fear of arrest, harassment or worse. Murders of women working in prostitution are often unsolved and their bodies unnamed and unclaimed in morgues, especially if they are black or transgender, and especially in large cities like Detroit.

In 1992, while I was battling the censors to reinstall *Porn'im'age'ry: Picturing Prostitutes* at the law school, a group of artists in San Diego was installing a billboard and exhibition also on the subject of prostitutes' rights. It was titled *NHI–No Humans Involved.* The project gave faces and stories to a series of murdered women in that city and exposed the shocking police practice of dismissing an entire category of homicides because, as one officer admitted, police labeled them "NHI's–no humans involved" since, he said, they were just bikers and hookers.

Many pilot projects assisting sex workers, including the one Judge Lloyd oversaw in Detroit, have since ended due to lack of funding. So it's back to profiteering in arrests by police and prosecutors who show little concern for either the women who work to support themselves or those who are trafficked.

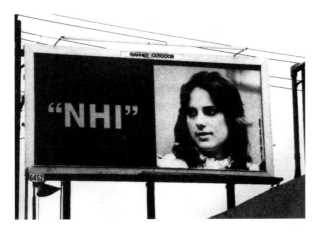

NHI–No Humans Involved, Elizabeth Sisco, Deborah Small, Carla Kirkwood, Scott Kessler, & Louis Hock, San Diego, 1992

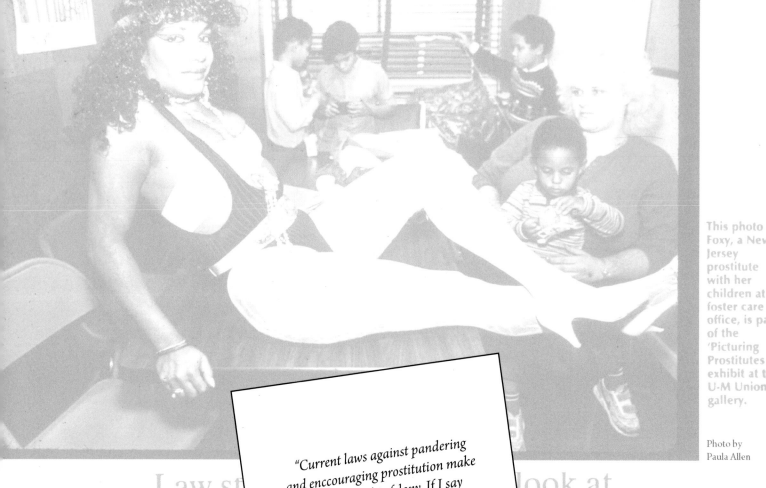

> "Current laws against pandering and enccouraging prostitution make my life into one big felony. If I say anything besides 'I hate prostitution,' I can be charged with a felony. Talk about censorship!"
>
> Carol Leigh a.k.a. Scarlot Harlot

Law st... look at

The wo... ...stitutes

AMI WALSH
'S SPECIAL WRITER

Most girls that's in the street, they've
n child molested by somebody in their
lly. I was. My father had me from
en I was 8 'til I was 12 years old. He
supposed to give me child support
ney because my mother and father
re separated, and when you go visit
r parents he's suppose to give you
e money. But my father had it like,
l, I had to lay down with him before I
uld get some money. So that's what
rted me like this.

feel now, any man, even if I like a
n, I can't lay down with him for free.
en if I like him, I can't do it. He has to
e me something. He has to take me
opping. He has to do something. I just
't do it for free. I just can't. As a mat-
of fact, I don't even like females who
up with men for nothing ...

□ □ □

That's how one 26-year-old Detroit
man explains how she became a prosti-
e. Andrea and a handful of other wom-
appear in "Street Sex," a videotape by
al artist Carol Jacobsen. Candid self-
fessions of their profession, the 55-
nute video is part of a multimedia ex-
it currently on display in the Union
lery at the Michigan Union.

e exhibit and a symposium that runs
Friday and Saturday — featuring
nsylvania State University sociologist
ssor Kathleen Barry, U-M law pro-

The

Here are d...
FRIDAY:
1 p.m. - 1:1...
Catharine ...
1:15 p.m. - ...
Panelists:
■ "The Psychological Profile of a Pimp" — Evelina Giobbe, director of
WHISPER (Women Hurt in Systems of Prostitution Engaged in Revolt).
■ "Children & Prostitution" — Susan Hunter, director for Council for
Prostitution Alternatives.
■ "Experiences of African-American Women" — Vednita Nelson, WHIS-
PER advocacy director.
■ "Male Sexuality: Why Ownership is Sexy" — John Stoltenberg, New
York city-based writer.
3:30 p.m. - 5 p.m.
Speakers will discuss topics including a critique of the feminist view of
prostitution, international trafficking in women and male prostitution.
7:30 p.m. KEYNOTE ADDRESS
"The Prostitution of Sexuality: A Violation of Human Rights," by Kath-
leen Barry, Pennsylvania State University sociology professor. (Honig-
man)

SATURDAY
9:30-10:30 a.m.
"Prostitution and Civil Rights" — Catharine A. MacKinnon (Honigman).
10:30-12:30 p.m. — PANELS: POLITICAL SOLUTIONS
(100 Hutchins Hall)
Topics will include legalization arguments, state, national and internation-
al solutions.
1:15 p.m. - 2:45 p.m.
■ "Local Experiences: How Public Officials Address Prostitution" —
Judge Vesta Swenson, 36th District Court; Sheila Blakney, Washtenaw
County public defender; Jerry Farmer, assistant county prosecutor, Lore
Rogers, Ann Arbor attorney (120 Hutchins Hall).

didn't have no job so I say, 'Wow, may
can meet someone on the street.' I
high. I was intoxicated when I went
there. And I just started walking
next thing I know cars start stopp
Then when they stop and talk to me,
scared. I don't want to talk, but I k
that I had to make the money some
of way ...

□ □ □

Born in Ann Arbor and raised in J
son ("home of the Republican party
the largest walled prison in the wo
she says wryly), Jacobsen began figh
for the rights of women shortly after
own rights were abused: At 17, she
ried a man who beat her. When she
vorced her husband several months
their wedding night, she was pregnar
"I got an illegal abortion," she says
ly. "I almost died."

A trained artist, Jacobsen has spen
past couple years gathering intervi
from prostitutes in Detroit. She foun
subjects while observing their trials i
36th District courthouse and approac
them after they'd been let out, usual
ter posting personal bonds.

In all, she interviewed some 50 won
capturing their stories on video tape
in print. ("I paid them 20 bucks for a
terview and 50 bucks to go on video,'
explains. "Most of them laughed and
it was a lot easier money ...")

Jacobsen has put together several
stallations," or multimedia exhibits
work, displayed in galleries from

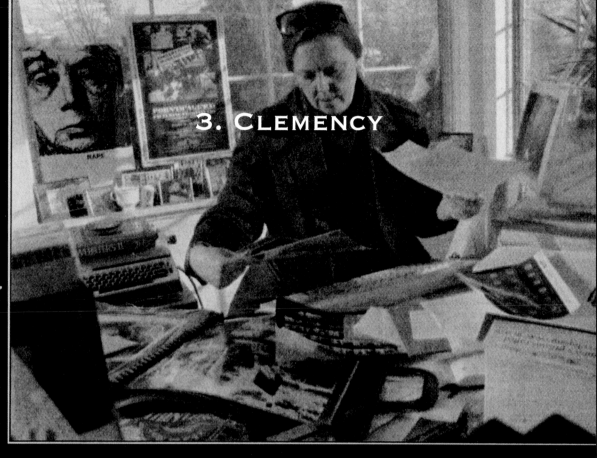

SHOWING THEIR SIDE

Video artist follows convictions in championing women who killed their mates

Ann Arbor artist Carol Jacobsen says she belives the women inmates in her videos killed in self out of abusive relationships.

By Carol Azizian
JOURNAL STAFF WRITER

Feminist artist Carol Jacobsen identifies with the women prisoners whose stories she tells in videos showing at two local galleries.

"A number of the stories affected me very deeply," she said in a telephone interview from her Ann Arbor home. "I realized that it could have been me because I, too, had been forced to break the law to survive an abusive marriage."

Like some of the women she interviewed, Jacobsen had been abused by her first husband.

"I had been married at 17 to a man who beat on me, choked me, threw me downstairs, and abused me sexually and emotionally, " she said.

"I left him, then got an illegal abortion to free myself from any connection with him."

Now in her 40s, Jacobsen has a burning desire to present the perspective of women who, she believes, acted in self-defense to get out of an abusive relationship. Most of the women she interviewed are serving long sentences for killing spouses or boyfriends.

One video, titled "They'll Find You Guilty," is being shown through Jan. 28 at Buckham Fine Arts Project, as part of the gallery's 10th anniversary show. It features four inmates, including M. Diann Suchy, a former Atlas Township woman convicted of hiring hit men to kill her husband in 1982.

Another, titled "Political Prisoner #150376," will be shown Jan. 31-Feb. 15 at Mott Community College Fine Arts Gallery in the DeWaters Art Center. Jacobsen will give a lecture at 11 a.m. Feb. 2 in the auditorium of the Flint Institute of Arts.

That video focuses on Violet Allen, who is serving a life sentence for murdering her husband. She was the cellmate of Francine Hughes, the woman whose life story was depicted in the book and TV movie, "The Burning Bed."

"She (Allen) told me that she had shot her husband after he threw their infant child across the room," Jacobsen said.

Both videos express the viewpoint of the women prisoners, who, according to Jacobsen, "are not given any

Scenes (above and below) fro videos of women in prison.

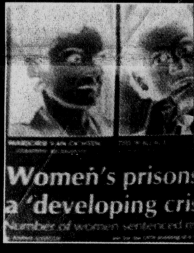

Women's prison a 'developing cri
Number of women sentenced

Please see **ARTIST, B3**

Life sentences

Paying for the sins of the fathers.

CONNIE HANES

MURDER I, ROBBERY: LIFE
*Went to meet abusive husband in a bar with
her cousin who shot 2 people*

*"I went to prosecutors in three
different counties. And at that time I
had two broken thumbs and a black eye.
He had rammed my mother's car and
she went to Genesee County prosecutors
on that and they wouldn't help either
one of us."*

Connie

VIOLET ALLEN

MURDER I: LIFE
*Shot her abusive husband in
defense of their baby*

*" I feel like they should take into
consideration all the pain and
agony that battered women go
through. Had I had somewhere
to go I wouldn't be here and he'd
still be alive."*

Violet

Clemency, stills 1999

Engler given the opportunity to release battered woman

CLEMENCY (1992–99)

In 1999, I finished *Clemency*, a short film narrated by eleven women who were serving life or long sentences for murder in Michigan. Together, their brief narratives construct a powerful message about the denial of equal protection for women by the criminal system. One woman recalls officers interrogating her while they blatantly ignored her requests for an attorney. Another was sent away by police when she tried to file a complaint against her batterer, and another could get no help when she was suffering incest as an adolescent. One woman describes her experience with a doctor who tended to her injuries but refused to report what she told him about being battered because, he said, "I will not get involved." In most instances, the women's attempts to convince their defense attorneys to present their evidence of abuse at trials failed. The prevailing, gendered, wisdom has been to deny women's truths, no matter the cost.

Ever since Governor Celeste granted clemency to twenty-six women in Ohio in 1990, governors in many states had followed suit and released more women. My aim was to put this film in the hands of judges, legislators, and parole board members, as well as the Michigan governor, to give them face-to-face encounters with the women in Michigan who deserve the justice they never received in court. Over the years, the film has become my primary educational, lecturing, and recruiting tool for the Clemency Project. It has had a powerful impact on audiences to see and hear directly from women who articulate so eloquently the details of the unfair and unequal treatment they have received from police, prosecutors, judges, and even their defense attorneys because they are women, and worse if they are also black, lesbian, or poor. Though much of the responsibility for the prison/punishment disaster lies with judges who too easily collude with prosecutors and rush to judge and punish, they are also limited by mandatory sentences and punitive laws. Prosecutors, however, have virtually unlimited power. Accountable to no one (except voters who count the notches on prosecutors' belts), they are concerned primarily with winning and advancing their careers. They are free to overcharge; to employ threats, coercion, and bullying; and to induce pleas and withhold evidence with near impunity. They need not worry since charging, pleas, and other major decisions are all made behind closed doors. While sociopolitically embedded racism and sexism, corporate globalization and mainstream media are all major contributors to the prison crisis in the United States, a large part is owed to prosecutors whose abuse of power within the criminal-legal system is a national scandal that has gone unchecked.

In many ways, the eleven women who narrated the film became the heart of the Clemency Project for me. I have remained especially close to them and committed to each one's freedom. Every time I screen the film or show a clip in a classroom, to a community group, at a conference, or in the prison itself, I am moved and motivated all over again. It has helped to bring a steady stream of attorneys and volunteers to the project. I have shared many disappointments, but also unfailing hope, with these eleven women over the years. Some scholars have marked battered women's murder cases among the most difficult to overturn in court, and I would agree. Both systemic misogyny and willful ignorance about women abuse by the criminal-legal as well as the parole system operate to deny women their constitutional right to due process and equal justice and to keep them in prison long after they are eligible for parole.

Lansing State Journal

A fight for 13 woman to get released from prison on clemency

Engler given the opportunity to release battered woman

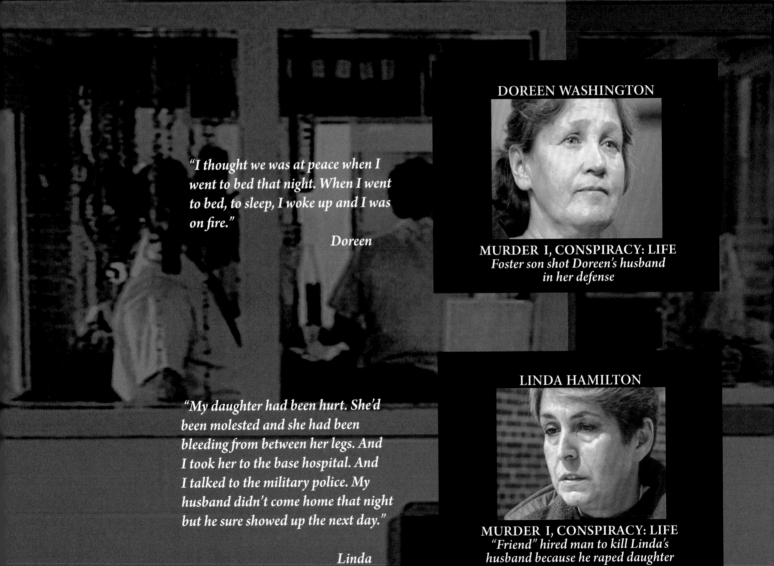

"I thought we was at peace when I went to bed that night. When I went to bed, to sleep, I woke up and I was on fire."

Doreen

DOREEN WASHINGTON

MURDER I, CONSPIRACY: LIFE
Foster son shot Doreen's husband in her defense

"My daughter had been hurt. She'd been molested and she had been bleeding from between her legs. And I took her to the base hospital. And I talked to the military police. My husband didn't come home that night but he sure showed up the next day."

Linda

LINDA HAMILTON

MURDER I, CONSPIRACY: LIFE
"Friend" hired man to kill Linda's husband because he raped daughter

Clemency, stills, 1999

Saturday.

Hi Carol.

Just wanted to get this paper work to you as soon as possible.

Decided to send it in two envelopes because I didn't want it to get returned for postage. I thought that the sooner it gets there the better

Talked to Mary about what you asked. Will talk to Deloros and Melissa later and any one I may run into. I know you have talked with Karen. She said she got a letter

Well I want to get this in the mail. So I'll go for now.

You have a nice trip. May God and the Angels keep you safe and healthy

Love Linda

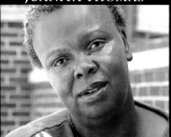

JUANITA THOMAS

MURDER I: LIFE
*Stabbed her violent boyfriend
in self defense*

"I didn't know nothing about the shelter or nothing like that because the police never told us about that. Only thing they would say was, 'Leave home.' They didn't say where to go. They didn't care."

Juanita

GERALDEAN GORDON

MURDER II: 20–40 YEARS
*Stabbed her abusive husband
during prolonged beating*

"I had an attorney who more or less saw it as one more performance, one more case to put on a show to the courtroom, a judge who had no comprehension of what domestic violence was about. He had no training in the background. It was just another murder case. So the systems failed me completely all the way through."

Geraldean

Clemency, stills, 1999

3/27/95

Dear Carol

Greetings and Blessings in the Name of God our Father and in the Name of Jesus our Lord!

I hope everything is going well for you out there...thank you for sending the magazine article from Michigan Women's Times...they did a good job with it I think.

I am not happy with the way the article Jackie Boyle from the Press went...in fact the last paragragh on my article is a complete misquote...I told her that the abuse was proven during my trial and that the judge even acknowledge that I was abused...__but__ that he said that was still not reason to commit the crime I did. She also did not mentio the fact that it was under coercion from my nephew that we hid the body and that I at first told the other story of my husbands death...or that I talked the the police on my own. I feel the article was more detrimental to my story than helpful and I'm disappointed at what she did with it.

I'm enclosing a letter for Susan that I'm asking that you send/give to her from me, as I do not have an address for her. There is a copy that is yours as well as I cc:'d it to you as I am asking her to release all my transcripts/paperwork to you if she is not ready to do something with my paperwork. I'm not trying to make her angry or be difficult, but I just cannot take the way things are going with this, not knowing anything, being kept in the dark as to what is or is not being done, etc. Five years is a long time to keep waiting for someone to do something.

Things are going ok here, except that I am still looking at the possibility of a couple of surgeries. I will be going out in the near future for an excision and biopsy of a lump on my left breast...then the hysterectomy is still on hold until I see what the specialist wants to do. In the meantime I'm still working and trying to stay busy and do the best I can.

If there is any new news, let me know...as well as what Susan has to say about my paper-work...Keep up the good work out there!

In Christ Love & Service

Terri

Caring for ourse...

MICHIGAN Women's T

Volume II, Number 18 • 50¢

A record and confirmation of

Engler denies clemency to battered woman; Advocates vow to continue the fight

by Marianne Martin

MACHELLE PEARSON

MURDER I: LIFE
At 16, terrorized by abusive boyfriend, she accidentally killed a woman

"You say justice is fair and it's equal? Where? I have yet to see it. You didn't show it to me when I was sixteen. You didn't show it to me when he was beating the shit out of me. You didn't show it to me when my people was raping me."

Machelle

MILLIE PERRY

MURDER I, CONSPIRACY: LIFE
Psychic friend enlisted man to kill Millie's abusive husband

"I went to the hospital. We went in the back door. It was just like that, it was behind closed doors. I told the doctor, 'I can't take this. You have to make a statement.' He said, 'I will not get involved.'"

Millie

Clemency, stills, 1999

Dear Carol,
 Happy New Year
I was good hearring your voice and
Knowing your holiday(s) was well.
 Thank-You, for Everything you've
been doing to help me on Every
level.
I'm Enclosing the following items
we spoke on.
 And "Melissa" is suppose to write
you she says she has something
she needs for you to Know.
IF you decide you want an up-
date on my medical file just
send me the necessary paper-
work.
 Well, I need to lay down my
hip is hurting.

 Love
 Madielle

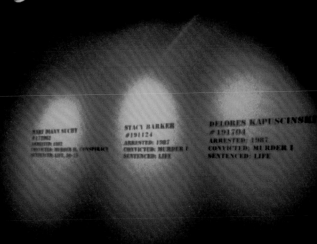

MARY DIANE SUCHY
#172982
ARRESTED: 1987
CONVICTED: MURDER II, CONSPIRACY
SENTENCED: LIFE, 20-25

STACY BARKER
#191124
ARRESTED: 1987
CONVICTED: MURDER I
SENTENCED: LIFE

DELORES KAPUSCINSKI
#191704
ARRESTED: 1987
CONVICTED: MURDER I
SENTENCED: LIFE

"At both of my trials my attorney asked the judge to tailor the jury instructions to say that a woman has a right to use deadly force to prevent a sexual assault. The judge refused to do this at both of the trials."

Stacy

"My attorney said, 'No, I don't want to know about any of those things—the domestic violence, the injunction against your husband—because that would be a motive.'"

Mary

"I said, 'I may need an attorney.' And they did not stop the questioning. I said that several times. Even though once you make a reference to an attorney they're supposed to stop all questioning and call. But they did not do that."

3 on a Life Sentence, video installation, Ceres Gallery, New York, 1998

Delores

Detroit Free Press

Metro Final
Cloudy, chance of drizzle.
High 48, Low 37.
Tuesday: Rain likely. ●

On Guard For 163 Years

Monday
March 6, 1995

Prison report hailed, jeered
State officials, women's advocates at odds

3 ON A LIFE SENTENCE (1998)

One day in the early 1990s, Stacy Barker, Mary Suchy and Delores Kapuscinski—three of the first women I met at Huron Valley Women's Prison—called and asked me to come and film them again, this time in conversation together. They wanted to write their own scripts, each detailing the issues that prevented her from receiving due process and a fair trial. The warden granted permission to film again and agreed to keep the guards at bay so they could not jump in front of the camera or stop the filming and the questions. Each woman described a disturbing story of interlocking systems of domestic and institutional violence that led to tragedy for their abusers as well as themselves.

Inaccessible and invisible as they are to most people, prisons can only be accessed by non-family members through an endless maze of obstacles. I take student assistants or other citizens with me, also as legal assistants, on every visit both to educate and to encourage their own activism. Even as legal assistants, our visits are difficult because prison rules are harsh, arbitrary and constantly changing, and because outsiders are treated as interlopers who are guilty by association with prisoners. Entering the lobby, we can expect long delays and hours of waiting to get inside. Sometimes the officer on duty cannot find our clearance information in the computer—even if we were there the day before—the prisoners we plan to see are not notified, or the computer is down, or we have waited so long the shift is changing, or the prisoner count is on so no movement is allowed. Women visitors must wear long enough skirts or baggy enough slacks, high enough collars, closed enough shoes, and a bra, though men visitors are not required to wear long pants, jock straps, or other equivalent clothing.

The women who narrated *3 on a Life Sentence* have shown incredible grit and grace and constant hope through the years. Writing on her own, Mary eventually won her pro se appeal, and her life sentence (for the death of her violent husband) was vacated after she served twenty-four years. Stacy won two new trials after her first trial ended in a mistrial and she changed Michigan law by establishing the right of a woman who defended herself against rape to have full and proper instructions on self-defense given to the jury: specifically, that a woman has the right to use deadly force to prevent a sexual assault. Delores remains in prison for the 1987 death of her abusive husband, and we continue to fight for her release.

METROTIMES

November 13, 1996

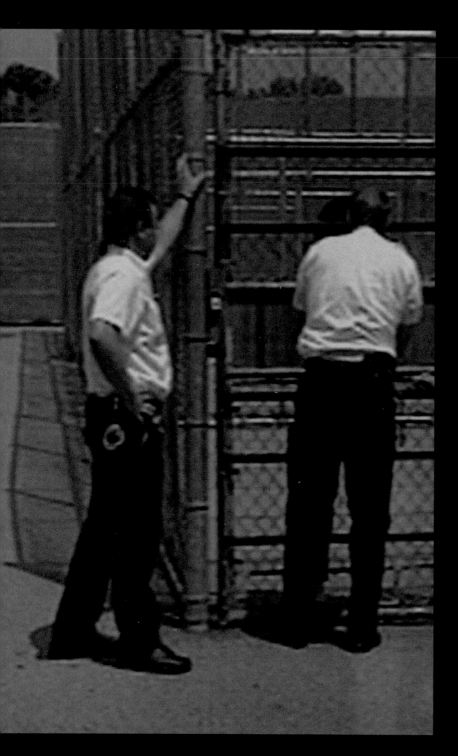

DELORES KAPUSCINSKI

MURDER I: LIFE
*Shot her sexually abusive husband
after night of terror*

STACY BARKER

MURDER I: LIFE
Stabbed her rapist in self defense

MARY SUCHY

MURDER I, CONSPIRACY: LIFE
*"Friend" hired man to shoot
Mary's abusive husband*

3 on a Life Sentence, stills from video installation, 1998

DOUBLE JEOPARDY

12-4-99

Dear Carol,

How are you? I seem to be holding on, I just get real tired.

I am writing to ask you to please send me the following papers: the 6.500 that I did Pro per in 1992, In fact please send a copy of anything after 1992. That way I will have all action papers from all courts.

I need this stuff to research and I can't do that if I have already argued an Issue.

So what are your plans for this Christmas? I sure hope you have a good one this year.

You know Brandy has been coming up alot lately. I am getting to know Brittney. She is 3 now and such a pretty little girl. Marcy is getting a divorce and really going through alot of changes, mostly Money problems.

Well I will hush for now, take special care. And Carol thank you for being my friend.

Sincerely

Mary

3 on a Life Sentence

Maryann Wilkinson

Carol Jacobsen's works on women in prison, including **3 on a Life Sentence** and **From One Prison…**, are video portraits filled with compassion, wisdom, wry humor and elegance. Jacobsen's works at first have the feel of documentary films and indeed are often discussed and viewed as reportage. A closer look, however, even without the wall texts that often accompany her video installations and serve to underscore their essential points, reveals that the videos are crafted in a subtle manner of carefully observed portraits. While video is a medium well suited to the performative moment acted out before the camera, in Jacobsen's hands it suggests a transparency allowing the viewer a largely unmediated view into another's "reality." Her strategy of close-up framing allows her to create a vision in which her own hand seems to disappear. Images consist almost exclusively of the face of the speaking woman, cropped so closely that often even the tops of her shoulders are not visible. The woman who fills the frame is thus truly "in-your-face," and the viewer becomes sensitive to every nuance of her expressions and inflections. The artist gently prompts the speaker on occasion without directly inserting herself into the scene. In **3 on a Life Sentence**, it becomes clear to the viewer that the three women are sitting together. But each is framed as a single visage, speaking as if in monologue. Each woman, without appearing to respond to an interviewer, seems encouraged to speak freely, perhaps for the first time. Each gradually reveals her personality, vulnerability, and inner strength in these clearly unscripted conversations. Like the most meticulous portrait painter, Jacobsen nurtures and refines her work, crafting the piece through long hours of talking with her subjects and filming: her careful editing presents a seamless, unhesitating outpouring of words. Their poignant expressions of pain, anger, and regret convey both profound trust in the artist and intense distress with the legal, judicial, and penal systems.

THE FLINT JOU

Group pushes fight to

By Sally York
JOURNAL STAFF WRITER

Prosecutors say Mary Diann Suchy hired someone to kill her husband in 1982 so she could use the insurance money to win the release of her boyfriend, a convicted murderer, from prison.

The Flint native's supporters say she was a battered spouse whose only mistake was to complain to friends, who conspired on their own to have Phillip Suchy shot in the head five times.

Now 54, Mary Suchy has served 20 years in prison and probably won't be released until 2008.

Suchy Ada

ing three from the a
John Engler for clen
a parting gift of free

In Jacobsen's work, survival and bearing witness become reciprocal acts such as those suggested by Terrence Des Pres in **The Survivor**. Jacobsen, herself a survivor of domestic violence, is clearly drawn to these women's stories and to bearing witness to their grit as well as their grief. The prisoners' survival—and their freedom—matters to Jacobsen. Women in and out of prison who confront desperate choices take desperate actions in order to survive. The women in Jacobsen's video offer testimony of the harrowing circumstances and actions that resulted in their incarceration, as well as the torturous conditions they live with now, in prison.

With this heartfelt and hard-hitting work, Jacobsen reaches several audiences. Foremost is the audience she has helped to create through her pioneering work as a feminist artist and educator. This audience is primed to access her films' underlying issues of gender, injustice, and institutional barriers to women's equality and freedom. Without the use of voiceover or narration, these issues are carefully embedded in the construction and editing. At the same time, the poignancy, depth of feeling, and expertise in crafting her work allows it to reach beyond her intended feminist audience to cross class, gender, age and race boundaries as it finds its broader public.

As accomplished as she is as an artist, Jacobsen is also an activist and critical writer who is not satisfied to simply point to an issue but instead compels her audience toward an active, educated response. Her pioneering work—disturbing, compelling, and personalized—moves out into the world through multiple venues and sponsors and her complex roles as artist, activist, educator, and writer redefine what an artist is.

RNAL

ain convicts' release

What's at issue

Gov. John Engler recently denied clemency for three local women who are serving lengthy prison terms for killing men they claim battered them.

Price

Deerfield Township— say they were victims of abuse who fatally struck back at their batterers.

Unlike a pardon, clemency doesn't imply society's forgiveness. Clemency acknowledges guilt but determines that justice would not be served by keeping the criminal behind bars. Typically, sentences are reduced to time served.

who petitioned Gov. this fall, hoping for before he left office.

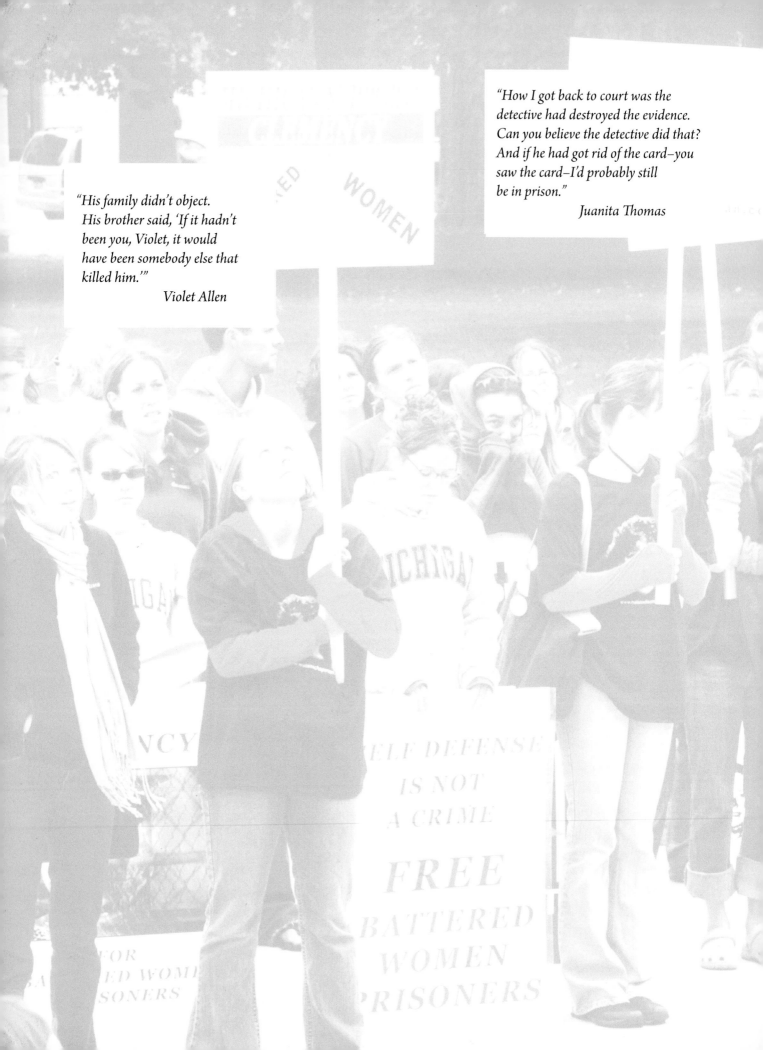

"His family didn't object. His brother said, 'If it hadn't been you, Violet, it would have been somebody else that killed him.'"

Violet Allen

"How I got back to court was the detective had destroyed the evidence. Can you believe the detective did that? And if he had got rid of the card—you saw the card—I'd probably still be in prison."

Juanita Thomas

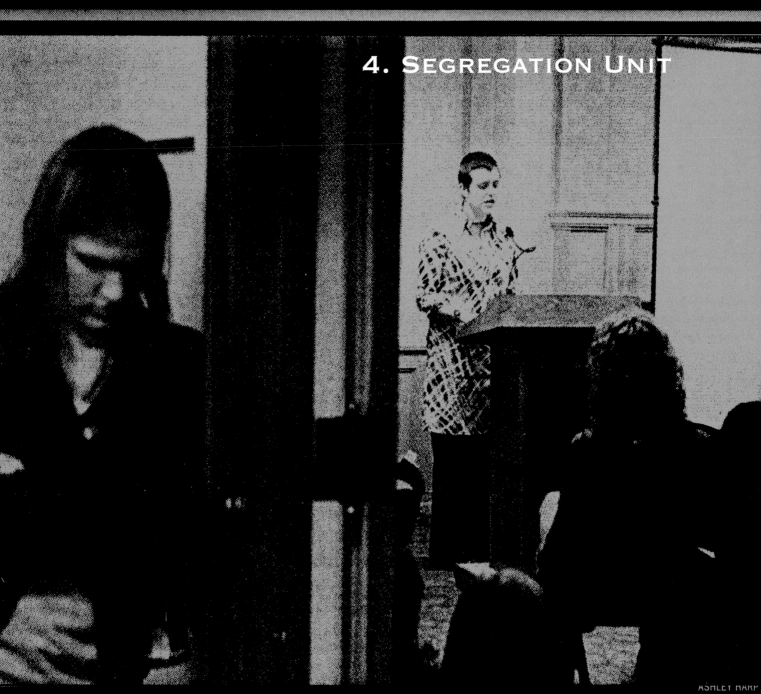

4. SEGREGATION UNIT

ASHLEY HARP

Education junior Becky Growhowski listens to "Speak up and Speak out" last night in the Michigan League. The event wa sponsored by the Michigan Battered Women's Clemency Project and University's V-Day Campaign.

Survivors of prisoner abus
recount stories, offer solution

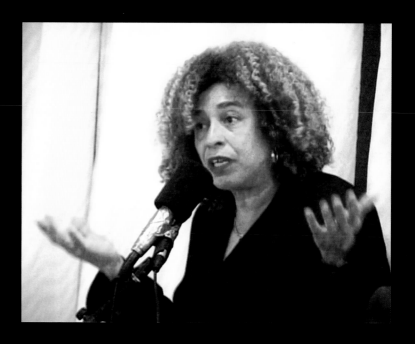

"It's really moving to watch Segregation Unit. It's
so hard to watch. As was pointed out by Carol, this
gives us an idea of what's going on in the prisons in this
country. It's true that women constitute the minority
of people who are in prison today here and in the world,
yet there are things we are able to learn about the system
as a whole by looking at women in prison. It tells us that
the system is a gendered system."

Angela Y. Davis

Above: Dr. Angela Y. Davis introducing *Segregation Unit* at a fundraiser
for Amnesty International, New York, 2000
Cosponsors: Puffin Foundation and Denise Bibro Fine Art

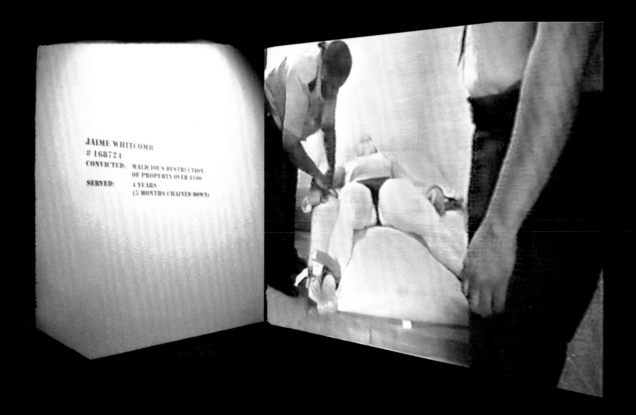

JAIME WHITCOMB
168724
CONVICTED: MALICIOUS DESTRUCTION
OF PROPERTY OVER $100
SERVED: 4 YEARS
(5 MONTHS CHAINED DOWN)

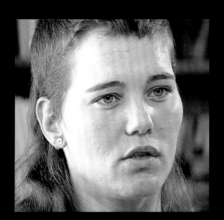

"The guards know that you're going
to be peeing on yourself. They know if
it gets hot you're going to puke. They
know sometimes you're not going to
eat. They know you're going to freeze
at night. They know all this and they
don't even—a lot of them don't care, but
others say, 'I don't want to get involved.'"

Jamie

Segregation Unit, video installation, Denise Bibro Fine Art, New York, 2000

Angela Davis Takes on Prisons

SEGREGATION UNIT (1999–2000)

In 1995, when Amnesty International launched its first ever campaign on torture in the United States, its focus was on the rapes, medical abuse, four-point chaining, retaliation, and other abuses of women occurring in jails and prisons across the country. At the time, Jamie Whitcomb was being tortured every day in the segregation unit (also called "seg" or "solitary confinement") in the women's prison in Michigan. It was cases like Jamie's that Amnesty had in mind when it later listed Michigan as one of the worst perpetrators of human rights violations against women in custody in its 1999 report, "Not Part of My Sentence."

Jamie's "crime" was "Malicious Destruction of Property Over $100." After her brother broke her hand during an argument, she grabbed a baseball bat and broke the windshield on his car. It was he who called police on her. She was arrested and sentenced to one to four years in prison. An out lesbian, Jamie was targeted by homophobic guards and spent much of her sentence chained, flat on her back, often naked, to a cement slab in solitary confinement. The pretense was that the chaining was for her own good, to prevent her from committing suicide; however, Jamie was suicidal only because of the torture. One day, a group of women prisoners, fed up with Jamie's mistreatment, held a "sit-out" on the yard and refused to come inside. They demanded the officers who were torturing Jamie be fired. At the end of the day, the warden appeared and promised to reprimand or get rid of officers who injured Jamie.

When she was released from prison after four years, Jamie filed a lawsuit against the state for the torture she endured, including being raped while she was chained down. She named individual officers as well as the state and she won the case in a jury trial. The most powerful evidence of her torture came from the videotape the guards were required to make of her chaining in segregation to prove proper procedure and to protect the state. The rape charge was dismissed due to lack of evidence. When the trial ended, Jamie gave me the footage (more than six hours of her torture), and she narrated the film. *Segregation Unit* premiered in New York in 2000, cosponsored by Amnesty International, Denise Bibro Fine Art, and the Puffin Foundation, and introduced by Dr. Angela Davis. At the screening, an Amnesty representative told me that the footage of Jamie's torture was shown to several Michigan legislators to no effect. That was chilling to hear. Sometime later, I received a call from Jamie saying she was considering withdrawing the film from public screenings. I was surprised, though I could understand how painful the exposure must have been for her. We talked for a long time. She promised to think about it, and for weeks I worried that I would have to shelve the film. It was a valuable educational tool because most people do not believe it unless they see it.

Because of Jamie, I began to visit other incarcerated women who were being similarly abused in segregation - many of whom have mental illness - as well as women prisoners who witnessed torture inside. I forwarded their letters and reports to the U.S. Justice Department, ACLU, Amnesty International, Human Rights Watch, and others. The mainstream media has covered the problem from time to time, especially if a prisoner dies in seg. But it is the women's courage—despite retaliation, lost jobs, and other punishments by the state—that has brought ongoing investigations, media coverage, and, hopefully, one day an end to torture in U.S. prisons. To this day, I receive calls about women being tortured in seg at Huron Valley Prison.

To my relief, Jamie Whitcomb did not withdraw the film from public viewing. The next time we met was at a protest against torture in Michigan prisons that was organized at the state capitol by the mother of Timothy Souders, a young man who died of dehydration and torture in the segregation unit at Jackson Prison. Jamie and I hugged each other, and she told me how glad she was that we'd made the film. I felt honored by her trust and humbled by her extraordinary courage.

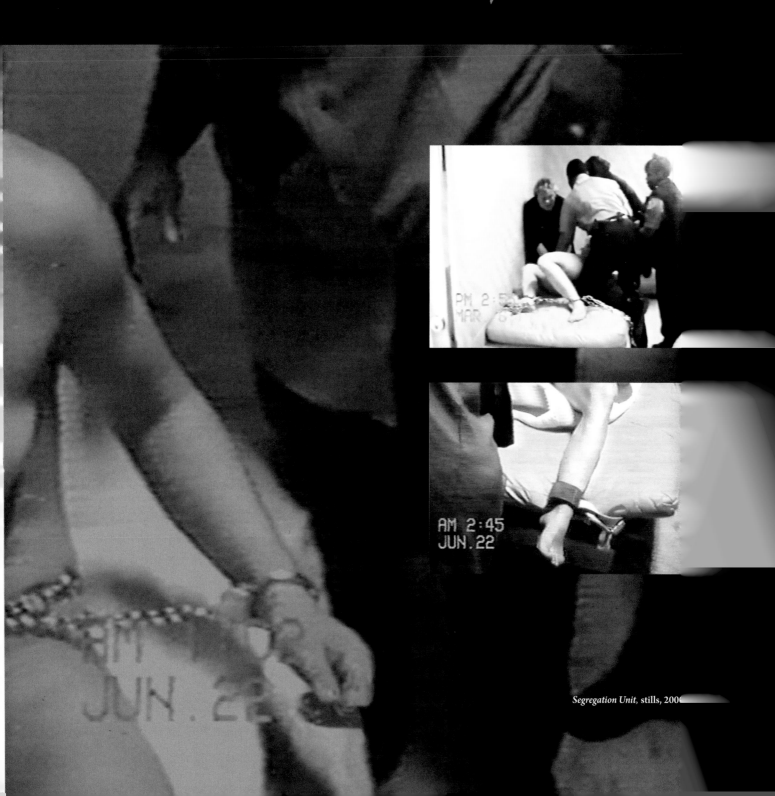

The Detroit News

FEMALE INMATES ABUSED, MISTREAT

PM 2:5
MAR 6

AM 2:45
JUN.22

Segregation Unit, stills, 200

"As a Human Being, Answer Me!": Jamie Whitcomb's Solitary Demand

Ruby Tapia

While the ethics of documenting and screening human suffering have long made up the contours of high-stakes debates about visual records of violence and death, the photographs documenting the torture of individuals incarcerated by the U.S.-led coalition in Abu Ghraib in 2003 infused immediate and significant energy into the theoretical, aesthetic, and political debates that continue to rage around how we visually consume, and whether or not we can ethically deploy, pictures of what Susan Sontag called "the torture of others." Well before these questions reached the mass public realm in the wake of the visual realizations of human rights violations at Abu Ghraib, however, Jacobsen's collaboration with Jamie Whitcomb screened some brutal, complex, and courageous answers on behalf of women tortured by the U.S. domestic carceral state. Their work makes a compelling case for torture to be seen, even as it clearly establishes visual exposure as a tactic of torture itself.

As did Whitcomb's successful lawsuit against the State of Michigan in 1996, **Segregation Unit** *appropriates footage that unwittingly documented state torture while it meant to merely record state procedure. Whitcomb's legal case and Jacobsen's film (re)produce this footage as visual testimony, constructing a space for creative witnessing of state torture and the possibility for resistance and redress. All of that sounds quite straight-forward, but the work of the film and the experience of viewing it are utterly incommensurate with simplicity or the possibility of an "end." If you watch* **Segregation Unit** *only once, you will never be done seeing it. Perhaps it finishes when solitary confinement in prison finishes. If so, in the United States, we are currently between 80,000 and 100,000 tortured cases away from that end.*

Segregation Unit *is devastatingly sparse in composition. Jacobsen layers Whitcomb's spoken reflections on her experiences over the state's footage of prison guards transferring, restraining, chaining and gassing her*

during the months she spent in solitary confinement at Michigan's Scott Correctional Facility for Women. While she narrates the details and significance of many events that we see in the footage, Jamie's words also point to specific tortures that are not captured by any image: her struggle to simply breathe while guards smothered and raped her; her terrified uncertainty about which guards stood by and did nothing, the depression brought on by being stripped and restrained and taunted by guards who were ironically, obscenely charged with ensuring her safety. Jamie's voiceover makes plain the stark senselessness of the scenes that the footage repeats and the moments never recorded, pointing out the specific elements and cycles of her torture that worked through repetition and absence, and the repetition of absence, of solitude, of so many hands on her with no human touch. They chained her down in a segregation unit because she kept trying to kill herself. And she kept trying to kill herself because she was chained down in a segregation unit. Jacobsen's masterful edit of the footage sounds Jamie's indicting clarity about the murderous logic of solitary confinement as "protection" at the mid-point of the film: to a prison guard's claim that Jamie's suicide attempts are the reasons for the torturous conditions against which she physically struggles and verbally protests, Jamie yells, "Now what kind of sense does that make?!?" And she asks, "What kind of treatment is this? Answer me. As a human being, answer me!"

Jamie Whitcomb repeatedly addresses the agents of her torture directly, asking them to answer her, as human beings. Jacobsen's **Segregation Unit** asks the same of the film's audience. What will we do about the ongoing torture of people in prisons? The film not only reveals what happened to Jamie but, through its emphasis on Jamie's pointed questions—both in the spliced footage and in her narration of the footage—it uncovers the obliteration and "protective" isolation made material in chains, cages, and solitude. And still, Whitcomb screams her questions as a human being to other human beings.

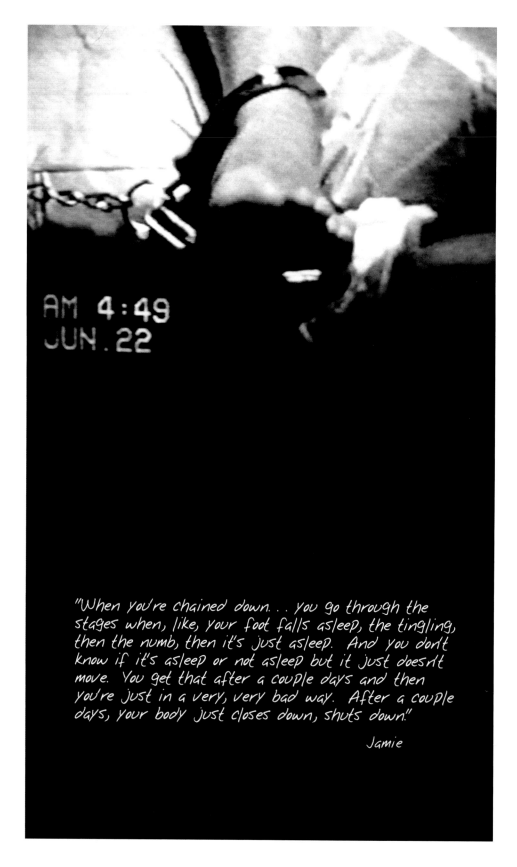

"When you're chained down. . . you go through the stages when, like, your foot falls asleep, the tingling, then the numb, then it's just asleep. And you don't know if it's asleep or not asleep but it just doesn't move. You get that after a couple days and then you're just in a very, very bad way. After a couple days, your body just closes down, shuts down."

Jamie

Chains 4, Kodalith, 2000

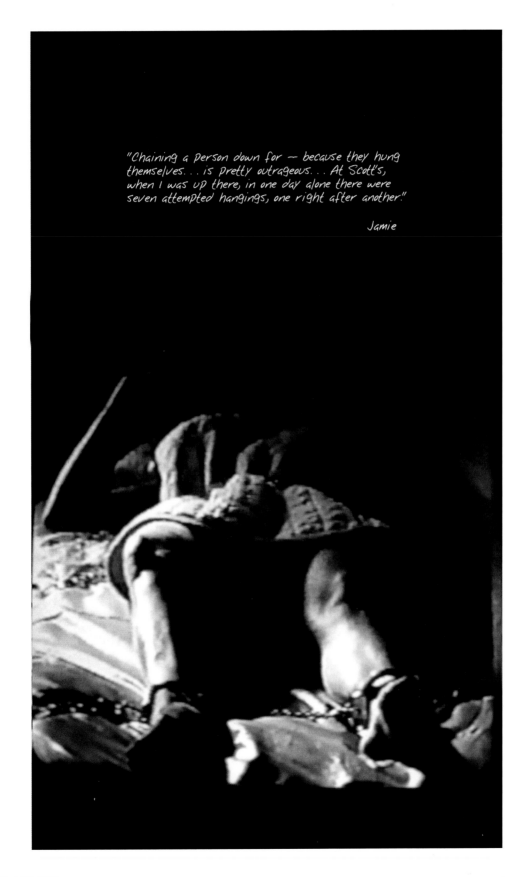

"Chaining a person down for — because they hung themselves. . . is pretty outrageous. . . At Scott's, when I was up there, in one day alone there were seven attempted hangings, one right after another."

Jamie

Chains 9, Kodalith, 2000

Detroit Free Press

March 31, 1995

Prison officials, employees deny abuse charges

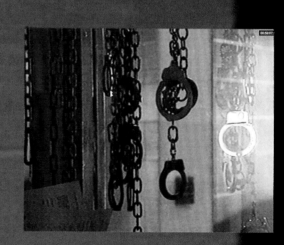

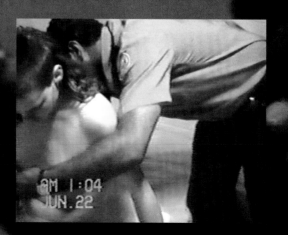

Segregation Unit, stills, 2000

To Whom it may concern:

I have witnessed an ongoing problem in the segregation unit that needs to be addressed.

These women need proper mental care — not punishment!

Some have even been placed in restraints (chained to their bunk), and left to urinate on themselves, (I know, I cleaned up the mess)

Segregation is for women inmates who purposely break the rules, not the mentally impaired.

I hope these poor women can get some proper help, care, & relief from this cruel treatment. We are, after all, still human beings!

Sincerely!

Leon

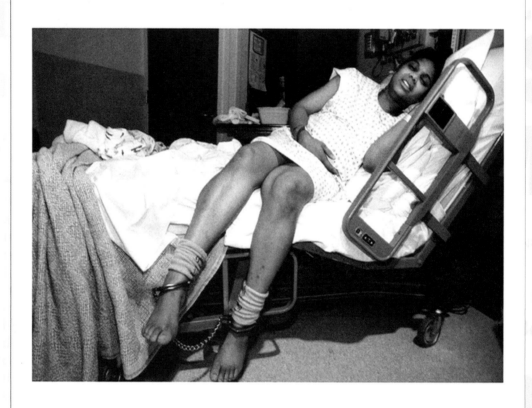

Above: Amnesty International Report, March 1999
Photograph by Jane Evelyn Atwood

SHOULD THEY GO FREE?

5. SENTENCED

he Michigan attered Women's emency Project inks chances e better than er to get ese women t of prison.

Theresa D. McClellan
Grand Rapids Press

S he is a grandmother now. That is one of the reasons Delores ham Kapuscinski wants nove closer to her year-old daughter in Bay .

ut the only person able hange Kapuscinski's ress is Gov. Jennifer aholm.

was 15 years ago this nth that Kapuscinski sentenced to life in on for shooting her band twice in the head 987 as he slept at their kford-area home.

fter enduring 17 years buse, she said, "I was pped and I just pped."

apuscinski is one of 13 nen in state prisons who erve freedom, according ne Michigan Battered nen's Clemency Project, ch has taken up their ses. While past requests been rejected

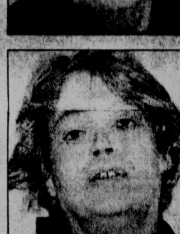

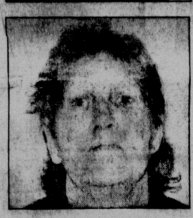
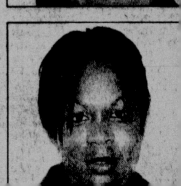

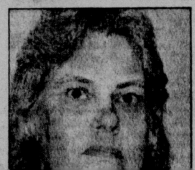

IN OUR OPINION
State must do more to prevent prison suicides

SENTENCED (2001–3)

When I received a letter from Connie Hanes in 2001, I didn't recognize it as a goodbye message. She hanged herself in her cell not long after that. Connie had suffered the cold brutality of the prison for too long, and she could not get medical care for her acute arthritis and chronic illness. She was in severe pain, physically and emotionally. She had served almost thirty years for a murder committed by her cousin when he drove her to a bar so that she could talk with her violent husband about their divorce in a safe, public place. She had no knowledge of the crime but was unjustly convicted as an accomplice and sentenced to life in prison. When her friend and cellmate called to tell me about Connie, I felt compelled to return to the footage I had shot of my interview with her. Another friend, Serena, who had just been released from prison, narrates the opening and Connie's voice narrates the rest.

Harsh, punitive sentencing of women has produced severe overcrowding in prisons, while cutbacks in food, medical care and programs have brought gnawing hunger and physical and mental health crises. From 2010 to 2015, at least eight women killed themselves and many more attempted suicide at Huron Valley Women's Prison. News reports said the suicide that occurred in 2016 was precipitated by two guards who refused to respond to a prisoner begging for help and instead made a bet on how long it would take the woman to kill herself. Police informed me that the prison failed to report the death, which is against the law. Consultants who advocate for improved treatment and conditions in the prisons are ignored by officials even when they suggest only minor, Band-Aid solutions to a national prison system that Angela Davis, the ACLU, and others have identified as obsolete and broken beyond repair. My complaints to the Michigan Department of Corrections are usually ignored, although the last two wardens have been moved from Huron Valley in as many years, apparently due to lawsuits, media coverage, and complaints against them.

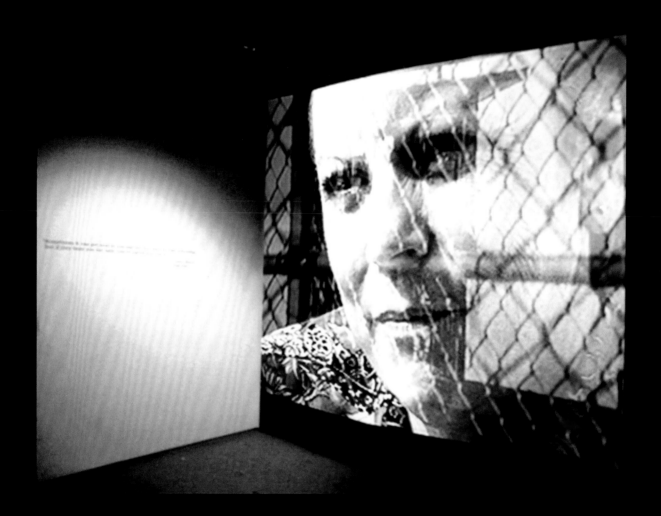

"I first had a court-appointed attorney,
and it was like, 'Who are you kidding, we
know you're guilty. I am going to do my
best, but I don't really have time for this.'"

Connie

Sentenced, video installation, Denise Bibro Fine Art, New York, 2003

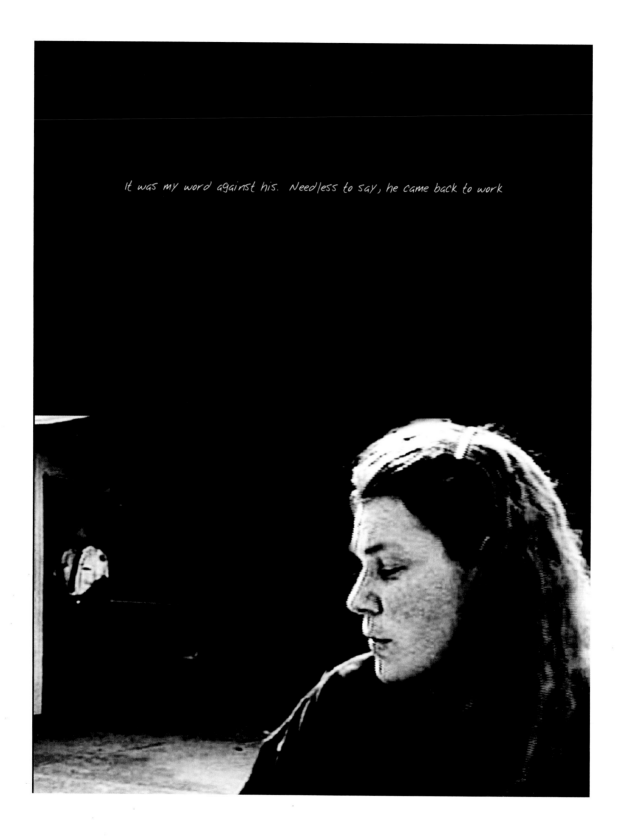

It was my word against his. Needless to say, he came back to work

Sentenced: Violet, archival digital print on film, 2003

Then we had a lady who
said she was having problems
breathing. The officer called
the clinic to get her help but
was told to have her send a
kite. The officer tried a second
time and they refused to help
her. Not long later she just
fell to the floor. The nurse
came then with a oxygen
tank but when they went to use
it, the tank was empty. So they
sent for a second one and when
it came it was also empty.
Needless to say she died right
there on the floor. They left
her there for three hours while
they waited for the coroner
to come. It was all one big
nightmare. It was not
the first time I've seen some
thing like this happen but
its something that you never
get use to

Love,
Linda

Sentenced

Nina Felshin

It is no secret that the fusing of art and politics that characterized so much of early modernism (e.g., German Expressionism, Dadaism, Futurism) has, in the course of time, been eclipsed. For Carol Jacobsen, however, preserving that fusion is a central part of her practice. And for Jacobsen, unlike much of the modernist project, the solder for this cultural/political alloy is a feminist critique. In keeping with the spirit of Helene Cixous and Catherine Clement in their groundbreaking **The Newly Born Woman**, Jacobsen's decades-long project seeks the rebirth of silenced women—prostitutes, prisoners, the hysterics of yore—by the relatively modest tactic of allowing them a voice. Yet this modesty should not be confused for a Victorian deference. For what is being said with this determined, refusing-to-go-away voice is to quote no less than Amnesty International: "a heart-piercing voice… on behalf of women in U.S. prisons against their torture and abuse in custody."

The work has been seen in cutting-edge museums, galleries, and film festivals, as well as embraced for its use as a pedagogical tool by grassroots organizations and human rights groups, which only underscores the fusion of art and politics that Jacobsen pursues. Often it is the canniness of her formal decisions and strategies that allows the attention of so many and varied auditors to be seized. By employing the means and materials of journalism, reportage and the researcher—video, photography, and text—Jacobsen allows the work to have a familiar tone, a friendly patina, as if it were all indeed a known commodity. That what is taped, shot, printed should detonate so loudly with the unfamiliar

cadence of suppressed knowledge is how Jacobsen grabs our attention. Yet the subtlety in this work resonates as well. In the quotes and interviews, in the crevices between the formal paraphernalia, the detailed rhythms of actual voices of actual people become an audible presence. And, of course—this is pretty much the point–they are voices we are not accustomed to hearing. By staying in close, literally so,—the extreme close-up tends to be Jacobsen's shooting style—the humor and intelligence of the subjects' words come through.

Importantly, Jacobsen knows from firsthand experience about being silenced—by the censors, that is. In 1992, Jacobsen's video work **Street Sex** was censored in an exhibition. In the piece, through a series of first-person interviews, Jacobsen invites sex workers to speak about themselves and their lives. With this invitation, a remarkable one to be issued to prostitutes in the first place, Jacobsen also incurred the wrath of the power that be. The show was closed. The work was removed—banished, one might speculate, because Jacobsen invited the sex workers to speak beyond the shadows of their street corners. From the close vantage point Jacobsen held in **Street Sex**, she examined the laws, ideologies and judgments that criminalized her female subjects. By using the words of her subjects, Jacobsen encouraged the biographies of the otherwise anonymous sex workers to come through. How the prostitute feels about her job, her life—all details that are, by and large, irrelevant to the monolithic categories of the criminalizing lexicon—becomes the material of Jacobsen's installations and tapes. And once these details, these biographical fragments, have been uttered, the

THE ANNA

'Sentenced:' Por

U-M art professor
exposes conditions
in women's prisons

BY ROGER GREEN
Ann Arbor News Bureau

Photographer and video artist
Carol Jacobsen is a committed

York gallery. The first will hou
eight, large-scale photographs
digital images combining inte
or shots of prisons, portraits
female inmates and passag
from inmates' letters to Jaco
sen. The second room will a
commodate the video, a gris
tour of Scott Prison
Northville Township, narrat

criminalizing lexicon begins to crack and disintegrate – or at least it feels threatened enough to vigorously suppress. The furor that followed this censorship is emblematic of Jacobsen's entire project. Through protest and negotiation, the show was ultimately reinstalled, and the voices of both Jacobsen and her subjects were again released from confinement. This notion of confinement, whether it be to the shadows, to silence, or to jail resonates, in Jacobsen's project **Sentenced**. As the title richly suggests, beyond the horizon of the metaphorical prison lies real prisons. Jacobsen has been going into women's prisons since 1989. She has met the inmates, spent time with them, interviewed them, videotaped them, photographed them, and above all listened to them. She has been among the first to pay attention to these voices. But unlike the others, she has then brought these voices to the public.

In a previous body of work, **Segregation Unit**, which addressed the imprisonment and torture of women in U.S. prisons, Jacobsen produced a harrowing exhibition that detailed the disciplinary procedures employed. Through documentary video, photographs, and written testimony, Jacobsen allowed stories to be told of women prisoners being "restrained," that is, tied down with metal chains in isolation cells, sometimes for days at a time, allegedly as a means to protect and guard the prisoners against self-mutilation but inevitably employed as a controlling and disciplining regime. Given this background collision of restraints, torture, and self-mutilation, **Sentenced** is itself laced with a particular, tragic irony. The project is dedicated to Connie Hanes, a prisoner Jacobsen worked with on a number of occasions. Hanes, who co-narrates the video piece and whose final letter to Jacobsen is presented within the installation, took her own life in her cell by hanging–apparently unprotected and unguarded.

Something of Hanes's experience is recreated for the viewer of **Sentenced**. Inasmuch as the video offers a traveling shot of a journey around, into and through the corridors of a jail, we are able to grasp some small semblance of the labyrinthine trap that snared Connie Hanes and her comrades. The glaring apparatuses of confinement– fences, razor wire, guards, check points, chains, and gates–swallow the viewer of **Sentenced**. Meanwhile, the photographic works in the project are based on correspondence of more than a decade's standing between Jacobsen and the inmates with whom she works. This epistolary exchange quietly attests to the importance, and indeed the liberating potential, of persistently demanding to be heard.

Inevitably, Jacobsen's work brings to mind the ideas of Michel Foucault. Not only because he ardently advocated for prison reform. Not only because he wrote so chillingly about the effects of the carceral regime upon its subjects but also because he directed those who cared to listen toward the power they have to challenge that regime. Angela Davis's recent introduction of the screening of **Segregation Unit** affirmed the artist's agency, noting that Jacobsen examines the system as a whole by letting us know what goes on in women's prisons nationally, and thus provides a revolutionary challenge to our tendency not to see the prisons—or regimes—in our midst.

The Detroit News AND Free Press

Metro edition ·†

Sunday, May 22, 2005

The Detroit News **EXCLUSIVE REPORT** | **Sexual Abuse Behind Bars**

GUARDS ASSAULT FEMALE INMATES

INACTION: ACCUSED OFFICERS GO UNCHECKED

REFORM: PROMISED CHANGES SLOW IN COMING

PRICE: LAWSUITS COST MICH. TAXPAYERS MILLIONS

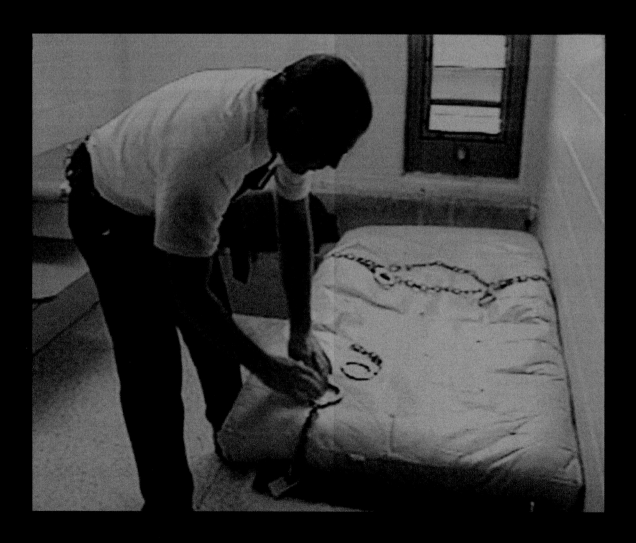

Sentenced, stills, 2003

Dear Carol,
Enclosed you will find a letter that informs you of our priviacy
rights are going to be taken away. Stress beyond control of health
problems developing with no morals standards are promcting to mush
for us to handle alone. we need help in anyway that you can help.
In any letters that you might undertake, please do not call
names... be are having harrassment from anything that we persue.
This is a hate administration.
I am haveing the papers in the south to print this also,,, as they
will look cn this as ungcdly. this will all so hold some weight on
election day...

Caol please help if you can, we are really in pain here.

In struggle

Types of harrassment range from
repeated shakedowns at all hours, following
me into women's bathroom, cursing me
and calling me queer bitch. etc etc.
I'd appreciate your assistence
in this matter. I've repeatedly grieve
the officer and there has been no
resolve nor change in his attitude
I feel my contacts with administration
and chains of command has been
futile.

Carol, 12-4-2004

 Hello, How are you doin?
ME, just being harassed out of this
world for writing you. Two prisoners
would like for you to come see them.
I told them I would write and let you
know. I really appreciate all that you have
done for me. Thank you for the books I really
enjoyed them both and I got my T.V. your very
sweet. I have been trying to call you but I
always get your answering machine. Have you
got in contact with my daughter? Have you
wrote the parole board again in my behave? Have
you wrote the Governor again in my behave? I
holding on the best I can right now. I have good
days and I have days where I want to hide so
I isolate myself. I really need out of this place
but I'm trying to stay strong through the struggle.
I'm out of segregation, but like I told you I
would recieve some majors misconduct for
talking to you and I got 2 so they might send
me back to segregation. I really admire
you for your realness and I totally trust
you to the fullest.
 Love,
 Sherry

STATE OF MICHIGAN
OFFICE OF THE GOVERNOR
LANSING

JENNIFER M. GRANHOLM
GOVERNOR

JOHN D. CHERRY, JR.
LT. GOVERNOR

August 26, 2004

Carol Jacobsen
1019 Maiden Lane
Ann Arbor, MI 48105

Dear Ms. Jacobsen:

Thank you for writing me to share your concerns about Michigan Department of Corrections grievances. The success of our democracy is built on the idea that citizens take an active role and engage their elected officials.

I have taken the liberty of forwarding your information and concerns about Sherry Savage in prison to our liaison at Michigan Department of Correction (MDOC) for further consideration and review. Please be assured that your views and suggestions will be considered both in my office as well as in the office of MDOC.

Again, thank you for contacting my office. The diverse opinions and ideas of people like you make our state strong and give us a solid foundation upon which to build. By actively participating in state government, not only are you proof that our democracy is thriving, you are helping to move Michigan forward.

Sincerely yours,

Jennifer M. Granholm
Governor

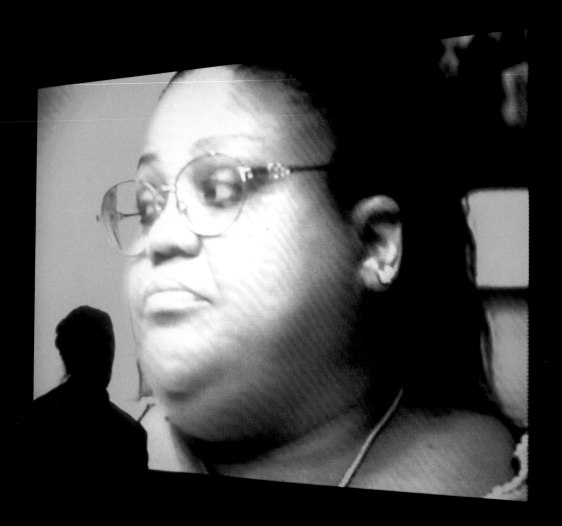

"There was this one officer and he says, 'You know, I can't believe I get paid to do this.' And we said, 'to do what?' And he says, 'Just watch girls all day.' And we noticed that the girls he chose were always overweight, young—the type of girl I was when I first came to prison—easy to manipulate. And my heart would just break for them. So I helped as much as I could—to bust him."

Serena

Beyond the Fence, video installation, Denise Bibro Fine Art, New York, 2004

7/01/04

Dear Carol;

May all be well with you and
everything going on in your life. As
for me I have been writing and asking
people I know to write you a letter for you
in my behalf.

I also wrote Judge Drain a letter which
I am enclosing a copy for you to read and
Keep in my file. Hopefully he will take
the time out to write you.

I realize this is a waiting game and
hopefully Governor Granholm will find it
in her heart to grant some of some freedom.
I know it is a political thing but she
must also realize other Governors' from
here as well as other state have seen fit
to do so.

Governor Granholm also must realize the
majority of votes in Michigan are women
and she needs to think about this.

I'll close and hope you will always
keep me posted on all that is going on
with the project.

As always,
Doreen Washington

Carol Jacobsen: Women's Voices from Behind the Fence

Sally Berger

Inspired by the feminist art activism she witnessed in the United States and in Europe in the early 1980s, Carol Jacobsen has never waivered from working in a similarly passionate and all-encompassing way. Spending her time between Michigan and New York City after completing her MFA in 1980, she served as an editor on the feminist art journal **Heresies** *and wrote about Greenham Common Women's Peace Camp set up outside a military base in England and the creative strategies of the women artists and activists who were protesting the use of nuclear weapons and promoting disarmament.[1] She joined the PAD/D (Political Art Documentation and Distribution) collective of artists that was inspired by Lucy Lippard's exhibition* **Some British Art From the Left** *at Artists Space (1979).[2] The members of the collective made socially and politically engaged art; largely eschewed the gallery scene; and alternatively presented their work in non-profit centers, public spaces, and publications.*

Jacobsen's early multimedia art projects incorporated photographs, texts, and videos to highlight the corruption and inequity surrounding the arrest and treatment of prostitutes. In the midst of doing this work, she was introduced to similar injustices affecting women in prison through the making of a documentary with women

prisoners. As Jacobsen points out, "The prison issue has been in my back yard my whole life," first growing up in Jackson, where the notorious Michigan State Prison for men was located and then teaching at the University of Michigan in Ann Arbor where Michigan State Prison for women (Women's Huron Valley Correctional Facility) is situated just over the city limits.[3]

Impassioned and angry at the unfairness of many women's convictions and the inhuman conditions in Michigan's prisons for women, Jacobsen found her mission and since then has utilized multiple strategies to encourage incarcerated women to represent themselves and to raise their voices in critical and self-empowering ways. Jacobsen's films present a woman's testimony, or interlace two or more women's critiques or stories, and are accompanied by gritty black-and-white footage shot by Jacobsen and her camerawoman, Susan Gardner, or utilize surveillance footage shot by guards. Fitting to her subject, Jacobsen keeps the production values spare in order to incorporate them into legal and political work that helps to re-represent as well as to free the women she documents.

In **Beyond the Fence** *(2004), a short but intensely personal film, three women sit in a semi-circle engaged*

in conversation; Jacobsen is there, too, but mostly as an attentive listener. The women go back in time to recall what they experienced and witnessed within the prison infrastructure and how they resisted unfair treatment and strove against all odds to help other women prisoners retain their rights and dignity. Susan Fair, one of the three subjects in the film, sums up the denigration with her simple statement, "The whole picture is that you lose your humanity."[4]

Jacobsen's artwork has mapped, recorded, and made public the hidden and systemic abuse of women in the criminal and prison systems in the United States through close-up attention to the mind-numbing isolation of segregation units, the lack of due process for women who act in self-defense, and the pervasive unhealthy living conditions in prison.

With each new law, censure, or obstacle that arises to hinder prison reform over the years, Jacobsen responds with revised strategies. Because she is an artist, Jacobsen is able to approach the subject of her work from multiple perspectives and disciplines rarely possible in other professions. Her artistic production is a synthesis of feminist theory, art, political action, human rights and law.

She produces films and installations, and writes Op-Ed pieces for newspapers and articles for legal journals. She screens her films in international human rights festivals, testifies at parole hearings, and meets women prisoners with fresh clothes when they are released. She tells me that she is "not a reformist." She does not want to teach inside or improve prisons; she wants to change the system.[5] Based on sustained encounters with women in prison whose stories she has presented over the past thirty years, Jacobsen's pioneering, life-long commitment to bring attention to the abuses against women by the state is trailblazing and singular: she is one gutsy and outside-of-the-box artist.

Notes

1. Carol Jacobsen, "Peace by Piece: The Creative Politics of Greenham Common Women's Peace Camp," *Heresies: A Feminist Publication on Art & Politics* 4.20 (1985): 60-65.

2. Tiernan, Morgan, "Art in the 1980s: The Forgotten History of PAD/D," *Hyperallergic*, April 17, 2014.

3. Conversation with Carol Jacobsen, September 2016.

4. *Beyond the Fence*, 2004.

5. Conversation with Carol Jacobsen, September 2016.

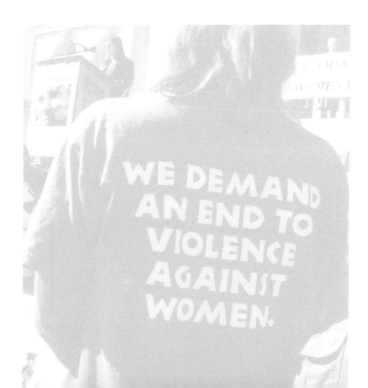

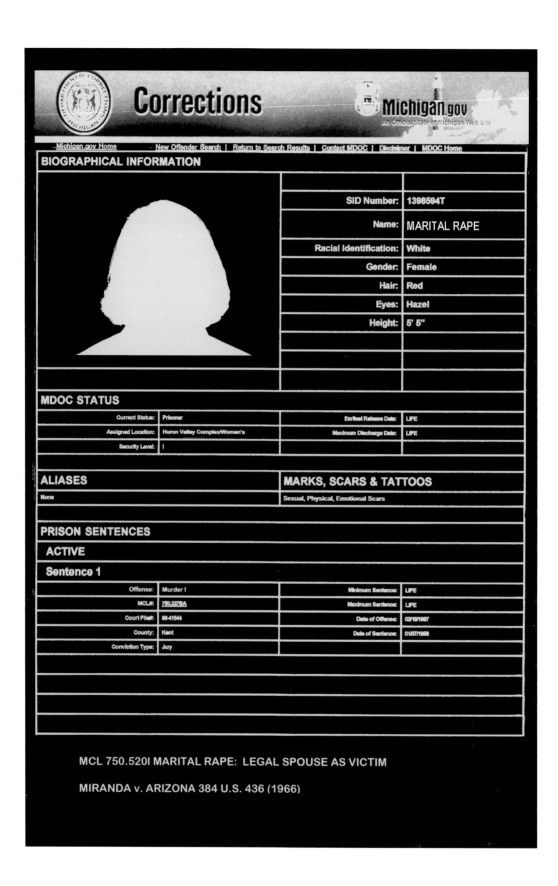

Corrections: Marital Rape, archival digital print on film, 2005

COORDINATORS **BATTERED WOMEN'S CLEMENCY PROJECT** **FOUNDER**

Lore Rogers, Attorney 1019 Maiden Lane Susan Fair
Lynn D'Orio, Attorney Ann Arbor, MI 48105
Kammy Mizga, Attorney 734 662-0776
Carol Jacobsen, Professor UofM www.umich.edu/~clemency jacobsen@umich.edu

Endorsements:

Michigan Coalition Against Domestic and Sexual Violence, Michigan Council on Crime and Delinquency, Michigan NOW, Amnesty International USA, American Friends Service Committee, Michigan CURE, Ann Arbor AAUW, Team for Justice, Michigan Women Lawyers Association, Michigan Women's Commission, Safe House, Jean Ledwith King, Esq., Sen. Elizabeth Brater, Alma Wheeler Smith, Dawn Van Hoek, Esq., Sen. John Conyers, Jr., Lynn Rivers, Mary Schroer, Lynn Martinez, James Neuhard, Esq., Governor William Milliken, Helen Milliken, Sen. Debbie Stabenow, Eve Ensler, William Edwards Foundation, Dr. Rosemary Saari, Jeanice Dagher-Margosian, Esq., Evanne Dietz, Esq., Human Rights Watch, National Clearinghouse for the Defense of Battered Women, American Civil Liberties Union, University of Michigan, Michigan Women's Foundation, First Step, Dr. Angela Davis, New Visions: Alliance to End Violence in Asian/Asian American Communities, Senator Michael Switalski, Rep. Frank Accavitti, Jr.,

Don Allen, Deputy Legal Counsel
Office of the Governor
111 S. Capitol Ave.
Lansing, MI 48909 May 31, 2006

Dear Mr. Allen:

 Congratulations on your appointment as Director of the Office of Drug Control Policy. Since you have been appointed to that office, I am directing this letter both to you and to your successor as Deputy Legal Counsel.

 We are in receipt of copies of the letters of denial written to the 20 battered women prisoners whom we represented for clemency petitions to Governor Granholm. We were, of course, deeply disappointed that none of these women received relief. Several are nearing 30 years of incarceration and a number of the women are seriously ill. None of them poses any threat to society. As battered women who acted because they were in a state of extreme fear for their lives and were not given due protection by the law, police or courts, they did not receive either due process or fair trials.

 Since we support Governor Granholm's re-election and we know this is a busy time, we would like to meet with you and the Governor's other legal counsel once the election is over to discuss the situation of these women and to receive your guidance for a more positive outcome in the next term.

 Thank you for your assistance,

Sincerely,

Carol Jacobsen
MICHIGAN BATTERED WOMEN'S CLEMENCY PROJECT

Cc: Governor Jennifer Granholm
 Kelly Keenan, Legal Counsel to the Governor

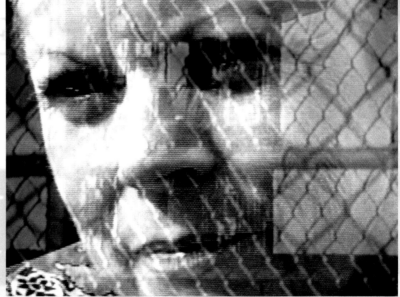

Dear Governor Granholm

 Today you have an opportunity to leave
a lasting legacy for human rights when you
leave office by commuting the sentences
of battered women prisoners who acted
to save their own lives. Your courage will
send a powerfaul message that women
abuse will not be tolerated in Michigan.

Sincerely,

Governor Jennifer Granholm

P.O Box 30013

Lansing, MI 48909

MICHIGAN WOMEN'S JUSTICE & CLEMENCY PROJECT
1019 Maiden Lane
Ann Arbor, MI 48105
www.umich.edu/~clemency

In memory of Connie Hanes, 1940-2001

inmates no strangers to abuse

HAMILTON

s to help others

Lunsford's murder, together with a known mob figure, Augustino Conte. Both are serving life terms.

"The witness was murdered by a member of the Mafia, and they threw the book at Linda because she was involved," said Kammy Mizga, Hamilton's attorney. Hamilton's defense lawyer also advised against mentioning domestic abuse during the trial.

Hamilton, who suffers from degenerative eye diseases that have left her nearly blind, has devoted her life to providing emotional support for other inmates. Once, she untied a woman who had hung herself in a suicide attempt.

If she ever gets out, she wants to be a domestic abuse counselor.

"The important thing is to make sure you don't stay damaged," she said. "You grow, you learn, you talk to others and you realize you're not alone. There's no comfort in being a hateful person."

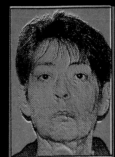

BARBARA ANDERSON

She called police to her home often

Barbara Anderson, 47, was too embarrassed to tell police about the severe sexual abuse her husband inflicted on her. Still, she tried to get help, calling police to her home time and again.

During 10 years with Rodernick Anderson, Barbara was raped with brooms, pop bottles and Lysol cans. He hit her with a gun, a walking stick and a telephone. He kicked her in the stomach while she was pregnant. He also beat her sons, smothered them with pillows, and forced them to watch the abuse of their mother.

When Anderson, who lived in Detroit, called police, she was told they couldn't do anything until he hurt her. Or they took Rodernick for a drive in the police car to cool him off.

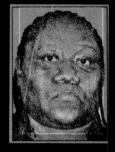

lent and aggressive.

"He was strung out on drugs, and I tried to get him treatment," she said. "But he would walk away."

Anderson admits that when a friend of her sister's offered to punish Rodernick, she wanted her husband hurt. But she didn't plan for him to die. Steven Lake shot Rodernick dead on Aug. 17, 1988. Lake is now serving life in prison.

"I wanted him to feel the pain, the way he made me feel the pain," said Anderson, who said she was promised eight years in prison if she pleaded guilty to second-

KAREN KANTZLER

Woman carries scars of beatings

n Kantzler, 51, is wracked h tremors that might be a f the time she was thrown n a concrete floor, or per- en she was smashed up a pine tree. The bones of e and the cheekbones on e of her face look like they oken and healed badly. She glass eye.

en the police came in," she he night Paul Kantzler

she was a burden on him financially. She signed her car and retirement over to him. She didn't work hard enough around the house.

Twice, Paul became angry with the way Karen handed him fire-

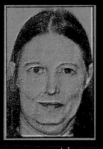

MILDRED PERRY

She seeks God on rough journey

Mildred V. Perry, 5-foot-1 and 100 pounds, sat very straight with her knees pressed tightly together and her hands closed in her lap. Traces of her strict southern Baptist upbringing were still evident, even after 24 years in prison.

"I don't think God turns his back on anyone," the 66-year-old grandmother said. "But it's been such a rough journey."

Millie Perry was a submissive

She put Perry in touch with her brother, who was also very spiritual. The brother offered to rough up Perry's husband. In the meantime, Sylvia would go to Florida to focus completely on prayer. All

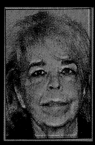

Officer: "This is a criminal matter. I have to read you your rights, OK? It's something I have to do."

Woman: "Can you tell me what happened?"

Officer: "That's what I'm here to do, to find out what happened."

Woman: "I'm sorry."

Officer: "That's OK. That's all right."

(Officer reads Miranda rights)

Woman: "I trust you. I trust you. I trust you."

Prison Diary, video installation, Denise Bibro Fine Art, New York, 2006

Fix prisons and mental care

PRISON DIARY (2004–6)

Prison Diary is a disturbing account of one woman's life in prison based on her letters to me. She was convicted of murder in the death of her abusive husband, and the Clemency Project worked on her appeal. Like most attempts by women who are serving life sentences, the appeal did not succeed. Her letters describe the deadly disease of cruelty that infects everyone and rules everyday life on the inside. She gave me footage from her arrest and bravely agreed to make it public. We all need to know what we are doing to human beings in our prisons.

"The prison corrupts everyone who works there," a prison therapist told me when we met for dinner one evening. He called me on the advice of several women prisoners. His eyes spilled over with tears as we talked about both the traumas and the injustice women prisoners must cope with. His support and the knowledge women gained from his presence in the prison made a difference in their lives. After he left, I worked with the local shelter to offer domestic violence groups. Many women have benefited from these volunteer programs, but the wait lists are long.

In 2006, the same year that *Prison Diary* was completed, I submitted fifteen clemency petitions to the governor and organized our biggest rally to date at the state capitol. We had strong support from former governor William Milliken and Helen Milliken, as well as from a number of judges and other policy makers. The mainstream media was becoming more supportive, too. But our petitions and my letters of complaint to the state about torture in Michigan prisons were met by denials from the Department of Corrections. Within weeks of the denials, a young man named Timothy Souders died tragically and needlessly of torture in the segregation unit at Jackson Prison.

Torture today

The death of Timothy Joe Souders in a segregation cell, chained down in four-point restraints is horrible. Tragically, it's not an isolated case.

Amnesty International U.S.A. Women's Human Rights, the Michigan Battered Women's Clemency Project and others have documented numerous cases of women in Michigan prisons who have been tortured in this same way in recent years.

This medieval torture could end tomorrow if the governor and the director of the Michigan Department of Corrections had the political will and compassion to end it.

Carol Jacobsen
Director, Michigan Battered Women's Clemency Project
Professor and 2005-06 Human Rights Fellow, University of Michigan

Prison Diary

Rebecca Jordan-Young

Carrie Roache is seated in a bare room, her head in her hands, the soft, coaxing voice of a police officer reading her rights and encouraging her to tell him what happened. In the same kind voice, he adds that once they get into the interview, if she then decides she wants a lawyer… but she cuts in, her voice cracking with pain and despair, and repeats, "I trust you, I trust you, I trust you." Carrie's image fades and recedes as an aerial view of the Robert Scott Correctional Facility for Women surrounds and then seems to swallow her, a fitting visual metaphor for the dehumanizing experience she will face inside Scott, the prison in southeast Michigan where she is serving a life sentence for murder. Like most of the other women with whom filmmaker, artist, and prisoners' rights advocate Carol Jacobsen has worked over the years, Ms. Roache is in jail for killing her abuser.

The footage of her interrogation, like all other interior shots used in Jacobsen's short film **Prison Diary**, *was obtained through subpoena. A social documentary artist, Jacobsen is the director of the Michigan Women's Justice & Clemency Project and professor at the Stamps School of Art and Design at the University of Michigan. The Clemency Project, which was founded in 1991, works for*

the release of women who have been wrongly convicted because of systematic bias in the criminal justice system against victims of domestic abuse. It also advocates for the health and human rights of all women prisoners. Jacobsen and her colleagues from the Clemency Project published a study of homicide conviction rates and sentencing patterns in Oakland County, Michigan, and, consistent with other research, found overwhelming evidence of bias against abused women who seek to defend themselves.

Prison Diary *conveys the daily deprivations, irrationality, and brutality of life inside Michigan's prison for women, a prison that Amnesty International has identified as one of the worst in the nation. In her larger body of work, Jacobsen uses photography, video, and first-person stories of women inmates to assemble a compelling account of the structural violence that lands abused women in jail and punishes them further once they are incarcerated.* **Prison Diary** *focuses mostly on the latter. Jacobsen conveys the disorientation and isolation of imprisonment with simple, often slow-motion shots of the prison's exterior, such as the wobbly, rotating aerial shot in the first scene and the repetitive pans of row after row of high fences and razor wire. The external shots are cut and overlaid with footage*

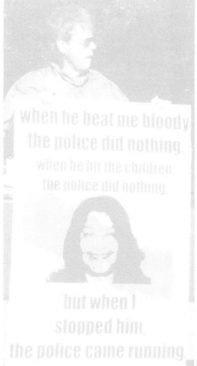

Patricia Betz at Michigan Women's
Justice & Clemency Project
rally, State Capitol, 2006

108

of mostly faceless, often brutal interactions between guards and the women prisoners, culled from the prison's own surveillance.

Jacobsen skillfully navigates the tension between illuminating structural violence (her visual focus on literal structures elegantly makes this point) and honoring the subjectivity and humanity of the women whose lives she documents. In **Prison Diary**, she effectively collaborates with Carrie by narrating the film with excerpts from Carrie's letters; Jacobsen's harsh, monotonous images echo the litany of abuses that Carrie has witnessed and endured inside Scott. The letters display Carrie's intelligence and acute sense of justice, as well as her intense empathy for her sister inmates: she narrates the violations they endure with righteous outrage and sadness. Jacobsen's selections from the letters also allow the viewer to observe Carrie's growing analysis of her own situation. Underfed, Carrie thinks she might be seriously ill, until one day she gets money to buy extra food and realizes her symptoms were from extreme hunger. She repeatedly awakes shivering in the cold Michigan night, unable to sleep because she has no blanket and no coat to cover her. "Being here is very much like being in an abusive relationship," she writes. "After a while you can't tell any more that you're being abused."

In the conventional narrative, a prison is a place apart, and the women inside are there by virtue of their own misdeeds or perhaps individually tragic circumstances. Feminist critic Wendy Kozol has noted how Jacobsen's work challenges this "exceptionalist" account of crime and punishment. I would add that this challenge extends even beyond the more familiar critique of criminal in/justice made by the important but limited focus on the exoneration of "innocent" people, mostly through the re-analysis of physical evidence with technologically improved DNA analysis. To be clear, the Innocence Project and other efforts to free wrongly convicted people are critical interventions in the systematic racism and classism of the in/justice system, as well as the procedural problems that exacerbate these biases. But rather than holding out the simpler possibility that the system has "gotten the wrong person," Jacobsen's art, and the activist project that it advances, requires a rethinking of such crucial concepts as "guilt," "self-defense," and the "reasonable" person whose actions are judged to be criminal or not. An analysis of gender is indispensable to this rethinking.

CITY TIMES

d News Source Since 1873 • Volume 130, Number 334

DEFINE
GUILTY'

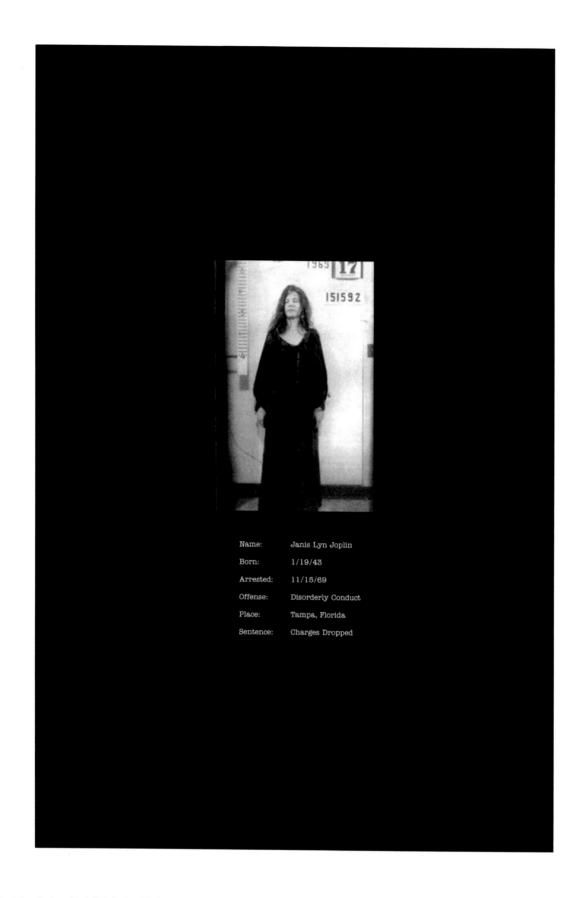

Name: Janis Lyn Joplin

Born: 1/19/43

Arrested: 11/15/69

Offense: Disorderly Conduct

Place: Tampa, Florida

Sentence: Charges Dropped

Conviction: Janis, archival digital print, 2006

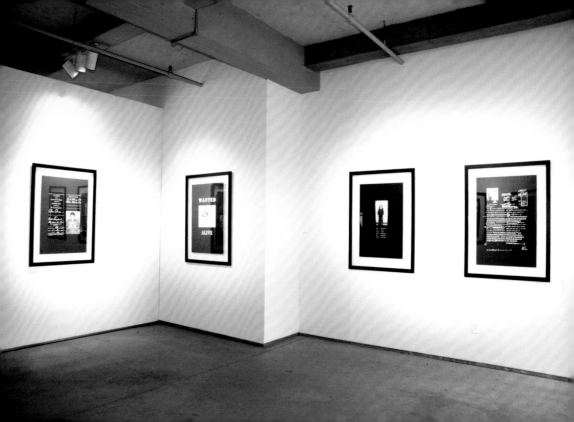

Conviction: Rosa, archival digital print, 2006

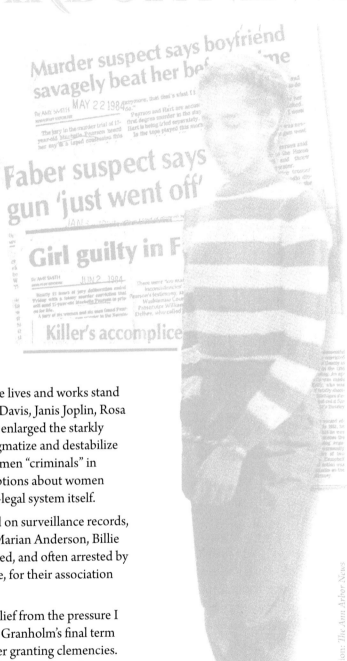

THE ANN ARBOR NEWS

October 8, 2005

Group says
murderer
deserves
clemency

Abuser forced woman
to commit '83 crime,
advocates say

Murder suspect says boyfriend
savagely beat her be...me

MAY 22 1984

Faber suspect says
gun 'just went off'

Girl guilty in F

Killer's accomplice

CONVICTION (2004–6)

My research into the history and imagery of
women's criminalization led me to discover
various photographic archives, including some
documenting the arrests and convictions of well-
known women artists, activists, and writers whose lives and works stand
as evidence of their political convictions: Angela Davis, Janis Joplin, Rosa
Parks, and others. I rephotographed and digitally enlarged the starkly
black-and-white series I titled *Conviction* to destigmatize and destabilize
conventional concepts and representations of women "criminals" in
ways that would serve to redirect viewers' assumptions about women
lawbreakers toward questions about the criminal-legal system itself.

A related series titled *FBI Wanted Women* is based on surveillance records,
also of well-known women artists—Alice Neel, Marian Anderson, Billie
Holiday, and others—who were hounded, harassed, and often arrested by
the federal government for being politically active, for their association
with others, or simply for being black.

Working on *Conviction* in 2006 provided some relief from the pressure I
was feeling for the women throughout Governor Granholm's final term
in office—a time when governors usually consider granting clemencies.
I was also working to free both Kim Lundgren, who was dying of cancer,
and Linda K., who was severely injured due to abuse she suffered in
segregation. Kim and Linda were two ferocious advocates for other
women prisoners. Both of those brave women died. Linda, at least, was
freed first.

A meeting with the governor's legal counsel in 2005 gave us high hopes
that our Democratic woman governor would grant clemencies to women
prisoners before she left office in 2010—which she ultimately did.

Photo and illustration: *The Ann Arbor News*

WANTED

GERRI SANTORO

DESCRIPTION

AGE: 27
OFFENSE: ILLEGAL ABORTION
SENTENCE: DEATH 6/8/64
PLACE: NORWICH, CONNECTICUT

ALIVE

Conviction: Gerri, archival digital print, 2006

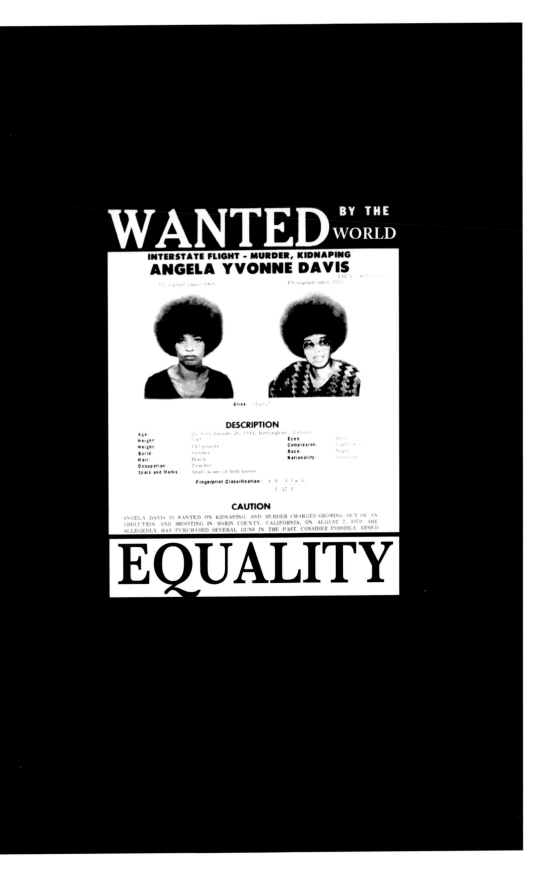

Conviction: Angela, archival digital print, 2006

11/3/04

Hi Carol,

I hope this letter finds you in good health and spirits. I too am very disappointed that Kerry didn't win the presidency. But I still have great faith that God will touch Gov. Grandholm's heart and release us.

This would be just as good a time as any to grant us clemency, since the nation is so focused on the outcome of the election. Plus, as you well know, I'm still dealing with the Oakland County Circuit court with regard to my parental rights.

I'm scheduled to go, once again, on Dec. 6 for the "Best Interest" hearing. That's when Judge O'Brien will render his decision, unless he has enough sense and mercy to await Grandholm's decision on my petition.

Is there any way you can contact her office and get a feel on when and what she's going to do? My attorney wrote her last month to make her aware of my predicament, but I don't really know if she got notice of it personally. Do you think writing Victoria Manning would help or hinder my chances. I surely don't want to rush her into a negative decision.

God Bless,
Anito Posey

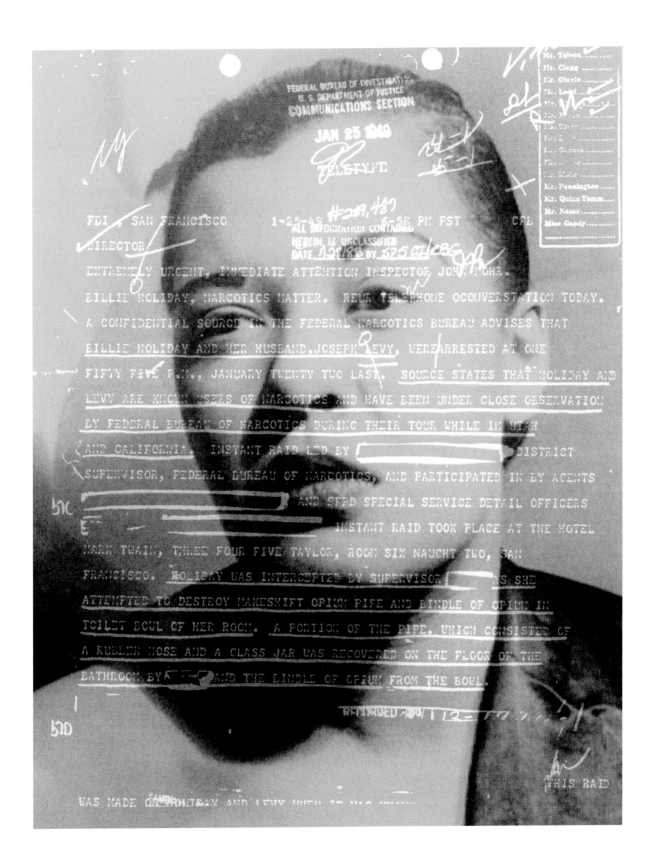

FBI Wanted Women: Billie, archival digital print, 2007

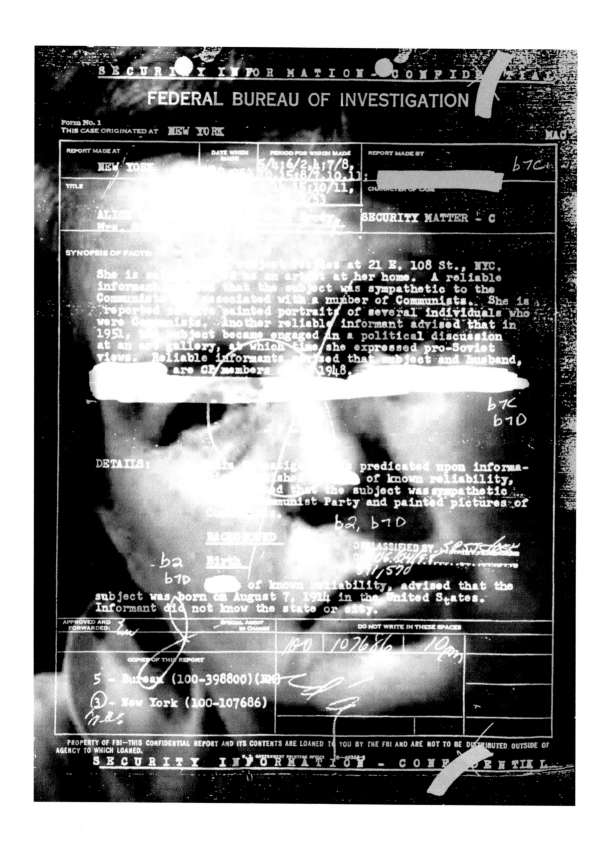

FBI Wanted Women: Alice, archival digital print, 2007

FBI Wanted Women: Marian, archival digital print, 2007

THE BAY CITY TIME

Sunday The Bay Area's Trusted News Source Since 1873 • Volume Number May 21, 2006

CLEMENCY BIDS DENIED

"We're not giving up."

"Laws need to be changed in Michigan to mitigate the charges or the sentences for women who act to save their lives. One woman a week is murdered in Michigan. This is unbearable."

Carol Jacobsen
Director, Michigan
Women's Justice &
Clemency Project

Prison Diary, stills, 2006

Dear Carol,

It's been a while since we've been in touch that I decided it's time to reconnect. I've really missed you and I'm sorry I been so neglectful.

I find it very hard to believe that another year has gone by. I'm not sure if time flies by because I stay busy or I'm just getting older. Guess it doesn't really matter why, just that it is.

Every year the holidays affect me differently This year it was mixed, some days were good, some days were not so good. All in all, it was okay. I've always said that no mater where you are, if your remember the true reason for the holiday, it can be a good wone. I think this year the season affected me in a not so good way because there were many fights and people going to segregation this year. One day, there were five from my unit alone. It's sad that people in this place care so little that they can't make the holidays special for the ladies. It seems the more crowded the prisons get, the less care there is.

Love and miss you.

Delores

The Detroit News

May 22, 2005

Metro edition ·†

"He figured he was going to get away with things forever. He used to brag about that all the time."

JULIE KENNEDY-CARPENTER, *a former Corrections officer in 1999 testimony against prison guard Albert Moon*

Suicides follow unheeded complaints

Prison Diary, stills, 2006

Criminal Defense Newsletter

CLEMENCY PROJECT:
A HOPE FOR JUSTICE

By Carol Jacobsen, Coordinator, MI Women's Justice & Clemency Project

The Michigan Women's Justice & Clemency Project is currently supporting over 30 women prisoners who acted in self-defense against their abusers for clemency and/or parole. Twelve clemency petitions have been submitted to Governor Jennifer Granholm, and four more will be submitted this winter. Several more petitions were submitted by the women themselves, and are supported by the Clemency Project. The remaining cases are eligible for parole and supported by the Project.

Many of the women have served over twenty years; several have served over thirty. The Clemency Project estimates that there may be more than 100 women in Michigan prisons who either acted in self defense against their abuser, or, because of their abuser's intervention, did not receive due process or fair trials. Several parolable women supported by the Project have been denied this year, despite the Governor's promises to release eligible inmates.

We hope that the Parole Board will reconsider these cases. We hope the Governor's Clemency Advisory Council will ultimately recommend commuting their sentences, finally bringing justice.

Today, the Clemency Project continues to see women who clearly acted in self-defense being convicted or convinced to plead guilty. One woman is murdered by her husband or boyfriend every five days in Michigan. Despite this lethal violence, those who are forced to act in self-defense are not seen as survivors, but too often unjustly convicted and sentenced. This is because Michigan's self-defense law does not reflect women's - especially abused women's - experiences. Prosecutors, judges, defense attorneys and jurors all continue to bring an astonishing level of ignorance to battered women's cases.

We conducted a study, examining Oakland County homicide convictions and sentences during the years 1986, 1987 and 1988. We discovered startling levels of discrimination against defendants who are victims of domestic vio-

lence. Results showed that domestic violence victims had higher conviction rates and longer sentences than all others charged with homicide, including those with previous violent criminal records. (See *Hastings Women's Law Journal*, Vol. 18, No. 1, Winter 2007.)

While clemency does not change the current systems that deny women equal protection and access to fair trials, it remains the only hope of justice for many women now serving time in prison.

For more information on the MI Women's Justice & Clemency Project, please visit http://www.umich.edu/~clemency/. A free, printable copy of our manual, *Clemency for Battered Women in Michigan: A Manual for Attorneys, Law Students and Social Workers* is available for download from the site.

Ms. Jacobsen is an Associate Professor at the University of Michigan in Ann Arbor. She co-coordinates the Project along with attorneys Lore Rogers, Kammy Mizga, and CDAM's own Lynn D'Orio.

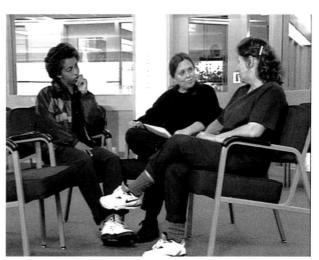

Left to right: Machelle Pearson, Carol Jacobsen, Doreen Washington

on Statement

Our mission is to free women prisoners ere convicted of murder but who acted in fense against abusers and did not receive rocess or fair trials; and to conduct public ion and advocacy for justice and human cy and parole are based on the failures of iminal-legal system to duly consider the quences to women of battering relationships e reasonableness of their actions in the t of repeated violence; and the inaccessibil- the Constitution's promise of justice and ights for women.

"I saw him grabbing toward the gun, and I saw the look in his face, and the rage in his eyes, and I knew if he got that gun, he was going to kill me."

Karen Kantzler was convicted of Murder II, and sentenced to life. Her judge admits he "made a serious and tragic error" in her case.

ecause of fear.
ent back to
...y.nh.ng...."

se Patterson's
nd was shot by
who went with
safety when she
get her clothes.

Recommendations

Violence against women is facilitated by gender and race-based inequalities in our social and political systems. The Michigan Women's Justice & Clemency Project makes the following specific recommendations:

1. We recommend the immediate release of all incarcerated women who acted in self-defense against an abuser or under force by an abuser.

2. We recommend that the Michigan legislature pass a Habeas law, such as is the case in California, establishing a special panel of domestic violence professionals to review for parole all cases submitted by women prisoners whose crimes are directly linked to violence by their intimate partners.

3. We recommend that the State of Michigan alter the sentencing guidelines to mitigate the sentences of battered women defendants and battered transgender defendants. Responsibility for a crime cannot merely be judged by the crime itself; consideration must be given to the history of any abuse the party experienced, self-protection strategies used by the survivor, and responses or lack thereof by police, legal systems, health care systems, etc.

4. We recommend that the marginalization and exploitation by persons and institutions with power, including the criminal-legal system and parole systems, be ended. We recognize that power is not distributed equally in society and that women, people of color, lesbian-gay-bi-transgender people, poor people, and people with mental or physical disabilities are continuously marginalized and exploited by the criminal-legal and parole systems.

5. We recommend that mandatory education and testing programs on domestic violence beyond those already in existence should be instituted for all government law enforcement and court officers, including all police, prosecutors, judges, members of the parole board and correctional personnel.

6. We recommend that the State of Michigan adopt preferred arrest policies (allow police officers to make judgment calls which are preferable to mandatory arrest policies because they result in too many wrongful arrests of women) and mandatory education programs be enforced by all law enforcement agencies and courts for first-time and repeat batterer-offenders.

7. We recommend that the Michigan Judges' Association recommend that prosecutors review cases for reduced pleas and release of battered women who have served sentences for the deaths of abusers.

8. We recommend that Michigan Judges' Association require proper instructions be given to juries in cases involving battered women defendants that explain self-defense law in ways that are inclusive rather than exclusive of women's experience, including, but not limited to, what a reasonable person would do in the context of ongoing assault and terror from an abuser; that imminent threat may or may not be immediate but is nonetheless imminent when a battered woman acts in her own defense.

9. We recommend that the Michigan Department of Corrections immediately end the practice of torture, including, but not limited to, 4 point chaining and use of 4 point restraints; sexual molestation, harassment, assault and rape committed by employees of MDOC against incarcerated people; isolated segregation of inmates; medical abuse and neglect; and all other forms of torture, harassment and mistreatment, especially of the mentally ill.

10. We envision a world without prisons where educational, health and social service institutional supports are available to all and a continuum of compassionate and humane alternatives to incarceration are offered, especially to the mentally ill.

MICHIGAN
WOMEN'S JUSTICE
& CLEMENCY PROJEC

In Memory of Kim Lundgren, 1960-2006

Coordinato

Lynn D'Orio, *Attorn*

Carol Jacobsen, *Professor Uo*

Found
Susan P

1019 Maiden Lane
Ann Arbor, MI 48105

734.662.0776

jacobsen@umich.edu

www.umich.edu/~clemency

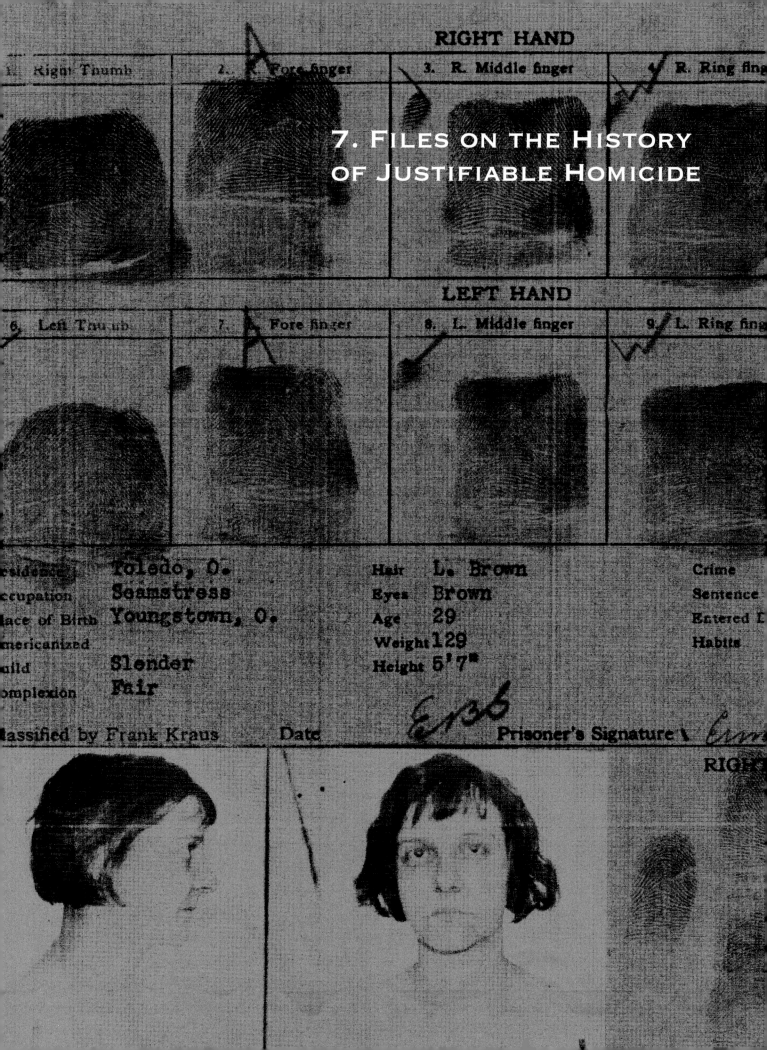

RIGHT HAND

1. Right Thumb	2. R. Fore finger	3. R. Middle finger	4. R. Ring fing

LEFT HAND

6. Left Thumb	7. L. Fore finger	8. L. Middle finger	9. L. Ring fing

Residence	Toledo, O.	Hair	L. Brown	Crime
Occupation	Seamstress	Eyes	Brown	Sentence
Place of Birth	Youngstown, O.	Age	29	Entered
Americanized		Weight	129	Habits
Build	Slender	Height	5'7"	
Complexion	Fair			

Classified by Frank Kraus Date Prisoner's Signature

RIGHT

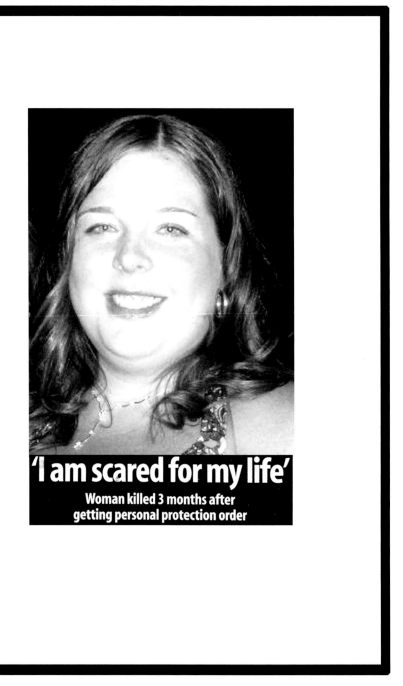

'I am scared for my life'
Woman killed 3 months after
getting personal protection order

Michigan Murders 2005, detail, archival digital print, 2008

130

THE MICHIGAN
independent
SEPTEMBER 4, 2008
'Justice' system fails to bring battered women justice
rally for women's clemency, Oct. 3

JUSTIFIABLE HOMICIDE (2005–11)

In the United States, gender-based violence against women, including homicide, has been legitimized by deeply entrenched social, legal and economic power structures. Thousands of women who appeal each year to police, courts and social service agencies for protection from batterers are turned away or receive little effective aid. If they are forced to defend themselves, the response is very different. They must face the same biased officials, institutions and laws that produce the ongoing violence. Biased interpretations of self-defense law, repudiation of women's reasonable actions in the face of lethal attacks, and police and courts that withhold equal protection are all means of denying women's due process. Beth Richie has noted that, for black women, justice itself is arrested. Despite the fact that male violence is the second leading cause of death for black women between the ages of fifteen and twenty-five, the criminal-legal system routinely criminalizes them instead of protecting them.

During Governor Jennifer Granholm's final term in office I felt more determined than ever to make public the point that the women in the Clemency Project would otherwise be among the death statistics had they not defended themselves and that their imprisonment was unjust. I searched newspapers and online sources to find out how many women were murdered by male partners each year in Michigan. I found fifty-nine cases in 2005, or approximately one woman murdered by her boyfriend or husband every six days. It is a conservative estimate since not all homicide cases reach the news media and others remain unsolved, particularly when the victims are poor, black, or transgender women. Also tragic was the discovery that almost one-third of the male killers committed suicide afterward.

When *Michigan Murders* was installed at the University of Michigan in 2008, several of the victims' families came to see it. I felt apprehensive about their

responses: How could I express my sorrow? Could the piece begin to say that for me? The parents and sisters who came were more than generous. It was meaningful to them, they said, that an artist who did not know their loved one paid homage to her in this way. They were shocked to discover how many other women were murdered by male partners in the same year. My students, volunteers, women prisoners and I have all used the list as an educational tool, distributing it in person and by mail to governors, the parole board, legislators, judges, educators, and others. In 2015, I conducted the same study again and found that the number had not changed: more than fifty-nine women were murdered by male partners that year as well.

Michigan Murders was the first of a series of photographic grid pieces from this period and the only one that focused on contemporary murdered women. The other works in the series were based on historical cases of survivors who were arrested or convicted of murder in the deaths of, or because of, their male partners.

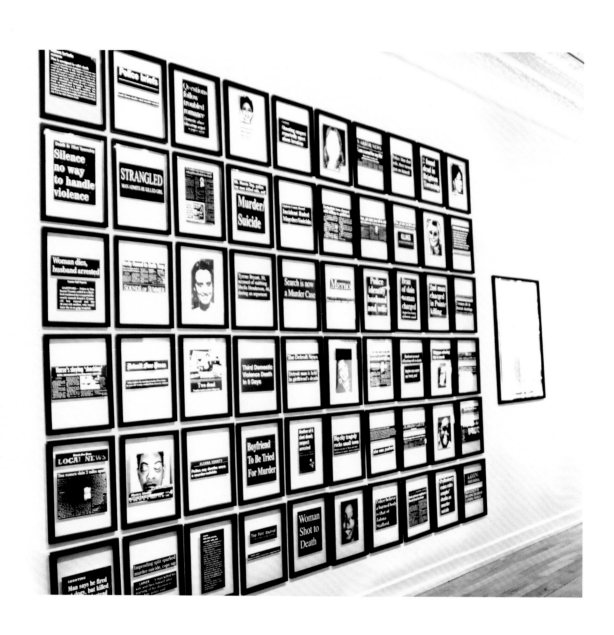

Above and right: *Michigan Murders*, installation view and detail, 2008

2005 DOMESTIC VIOLENCE MURDERS OF MICHIGAN WOMEN BY BOYFRIENDS OR HUSBANDS

Murdered Women	Abuser/Killer Sentences
1. JAMILEH ABDULLATIF, 38, beat to death by husband, 6/28, Dearborn.	25
2. CAROLYN ALKHATIB, 40, shot by husband 12/14, Detroit	Life
2. KIM ANDERSON, 40, shot by husband, 9/2, South Haven.	Suicide
3. LEILA ARMIN, 20, beat to death by boyfriend, 6/16, Troy.	Life
4. GINA BELANGER, 36, shot by ex-boyfriend, 12/12, Canton.	Suicide
5. JENNIFER BENNETT, 26, stabbed by ex-boyfriend, 9/13, Washtenaw.	45
6. TAMMY BIRCHMEIER, 38, shot by husband, 12/7, Brighton.	Suicide
7. JENNIFER BROCKERT, 53, shot by husband, 9/20, Brighton.	Suicide
8. JANIEN COBBIN, 34, shot by ex-boyfriend, 5/21, Flint.	5 mos.
9. SAMANTHA DETZLER, 12, strangled by male acquaintance, 2/19, Lansing.	Life
10. DIANE DUDLEY, 42, stabbed by boyfriend, 10/29, Grand Rapids.	15
12. JENNIFER ERNEST, 50, shot by husband, 1/9, Mt Morris.	Suicide
13. JOHNNY CAROLINE FIELDER, 63, shot by husband, 12/31, Gladwin.	Suicide
14. JULIE FISHER, 17, strangled by boyfriend, 12/8, Mt Clemens.	Life
15. MELISSA FRIAR, 27, stabbed by boyfriend, 4/24, Grand Rapids	Life
16. ALANA FRIAR, 8, stabbed by mother's boyfriend, 4/24, Grand Rapids	Life
17. SARAH GADZIEMSKI, 24, stabbed, set on fire by boyfriend, 6/7, Ludington.	40
18. HEIDI GLASS, 38, shot by husband, 7/5, Oceana.	Suicide
19. BONNIE JEAN GLISSON, 38, beat to death by husband, 7/1, Hartford.	0 (Acquitted?)
20. MICHELLE HARTMAN, 25, strangled by ex-boyfriend, 6/12, Bath.	Suicide
21. SHEILA HENDERSON, 46, stabbed by boyfriend, 6/12, Hamtramck.	20
22. MARGARET HEUSER, 44, homicide probably by ex-boyfriend, 7/5, Newaygo.	Never found her body
23. NICOLE HIRTH, 17, shot by boyfriend, 11/12, Warren.	15
24. DONNA HUSBECK, 51, shot by husband, 12/14, Menominee.	Suicide
25. KELLY IRELAND, 39, choked by boyfriend, 1/8, Lenox Township.	Acquitted
26. BARBARA ISKE, 57, shot by male friend, 6/14, Grosse Pointe.	Life
27. ANGELA JACKSON, 45, shot by boyfriend, 12/22, Detroit.	
28. MARY ANN KUYERS, 70, suffocated by male acquaintance, 9/28, Holland.	Life
29. HEAVEN LATALIER, 14, strangled by male friend, 11/1, Warren.	Life
30. CONNIE LOMPRE, 52, stabbed by husband, 2/2, Ishpeming.	Suicide
31. LISA LONCHAR, 49, shot by boyfriend, 11/20, Warren.	15
32. TYRIE LOWE, 27, shot by boyfriend, 7/26, Detroit.	Life
33. LESLIE MATEO, 23, strangled by date, 9/25, Grand Rapids.	Life
34. MARGIE MAY, 57, beat to death by husband, 10/1, Newaygo.	12
35. BECKY MCDONALD, 42, murdered by boyfriend, 10/16, Mt Pleasant.	3
36. FENECIA MCKNIGHT, 34, shot by ex-boyfriend, 2/4, Saginaw.	12
37. MYSTERY WOMAN, shot by boyfriend of Angela Jackson, 12/28, Detroit.	
38. JANET OLESEN, 66, murdered by husband, 6/22, Hubbard Lake.	Suicide
39. BRENDA ORTON, 36, shot by boyfriend, 11/11, Muskegon.	Life
40. ROBYN PAGE, 25, shot by ex-boyfriend, 5/21, Ypsilanti.	30
41. DEBORAH PINKOSKY, 52, shot by husband, 2/26, Gagetown.	Suicide
42. KAREN PLESA, 53, thrown from speeding car by boyfriend, 7/25, Lincoln Pk.	
43. MARY RIDGE, 50, shot by husband, 3/27, Kalamazoo.	Suicide
44. VELZETA RILEY, 32, stabbed by husband, 8/9, Detroit.	25
45. ANNIE SAMUELS, 42, shot by male (son?), 12/28, Detroit.	Suicide by police
46. NICOLE SAPUTO, 27, shot by boyfriend, 9/12, Detroit.	
47. LORI SCRIVER-VANMETER, 43, shot by husband, 10/23, Lapeer.	Suicide
48. PAULA SEALS, 47, shot by estranged husband, 1/28, Detroit.	Suicide
49. DOROTHY SMITH, 58, shot by boyfriend, 12/2, Flint.	12
50. DOROTHY SMITH, 58, stabbed by male friend, 9/7, Farmington.	Life
51. JALONA STAFFORD, 19, strangled by boyfriend, 2/13, Detroit.	40
52. BETH THOMPSON, 42, shot by boyfriend, 9/1, Ionia.	Suicide
53. MELISSA TOSTON, 37, beaten by john, 10/18, Detroit	Life
54. CHERYL ANN TRAN, 36, shot by husband, 4/29, Alpena.	Suicide
55. CINDY WHITCHER, 44, stabbed by boyfriend, 3/3, Redford Township.	20
56. EARLIE WHITE, 36, beat to death by male friend, 12/7, Lansing.	22
57. UNNAMED WOMAN, 26, thrown out 4th floor by boyfriend, 5/14, Detroit.	
58. UNNAMED WOMAN, 36, stabbed by date, 11/2, Detroit.	10
59. UNNAMED WOMAN, 22, murdered by male friend, 6/17, Madison Heights.	

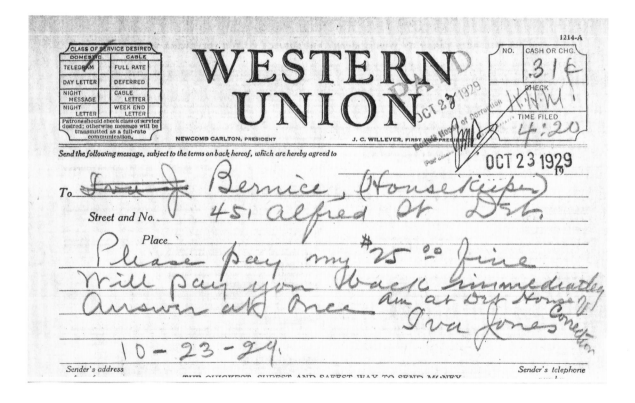

Above and right: *For Love or Money,* details and installation view, 2009

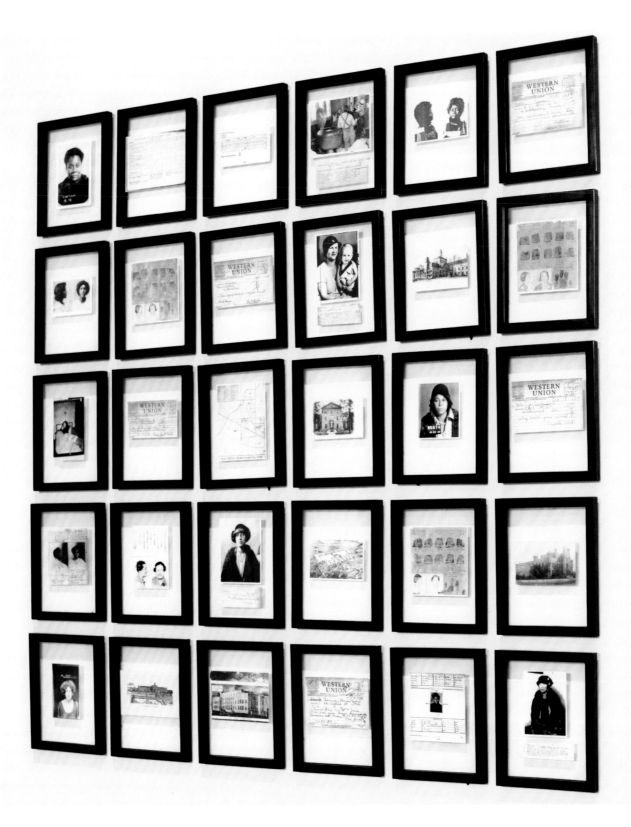

Files on the History of Justifiable Homicide

Betti-Sue Hertz

Carol Jacobsen's years of grinding work, courage, and determination on behalf of women in long-term sentences in Michigan's prisons have yielded freedom for some women and given hope for many more. However, it is with her work as an artist that she is able to sort out both the facts of the history of women, violence and the prison system as well as her feelings as a feminist who is unusually sensitive to our human vulnerabilities. In both art and activism her unique contribution has long been directed toward revealing evidentiary truths that upend conventional narratives about why women commit violent crimes while steadfastly returning to the more commonly rehearsed themes of systemic violence against women. One activity feeds the other, and each one yields incredible results. And while it may be obvious that the artwork depends on her activism, the reality is that her art and political work together constitute her creative practice. Jacobsen was a social practice artist of the highest order before the term was in common use. Jacobsen's research on women and violence has yielded a substantial trove

of historical images—photographic portraiture, mug shots and fingerprints, court sentences, Western Union communiqués, and newspaper headlines. Rather than attempt a narrative culled from these public sources, Jacobsen uses the formal characteristic grid—a rational Cartesian organizational system without boundary—to present her case. In each instance the grid cannot contain the emotional energy of violence, either as it has been perpetrated upon women who have been murdered or where a woman is forced into justifiable homicide as her life or that of her children, or both, is endangered.

Each of the installations in the **Files on the History of Justifiable Homicide** project presents a different angle on the subject. **For Love or Money** (2009) features women from the 1920s who murdered men, often someone with whom the subject has had some intimacy; **Michigan Murders** (2008) focuses on headlines denoting a woman has been murdered;the portraits would belie the criminal charges if it weren't for the accompanying labels in **Files on the History of Justifiable Homicide**

(2010); and **Nightclub Girl in a Curfew Town** (2012), about Velma West, who killed her husband in 1927, reveals the gender bias codes of the period. Jacobsen pushes up against the limits of what these records of life and tragedy offer us. Evidentiary images such as mug shots and fingerprints, portraits accompanied by captions, personal correspondence, headlines, and the like collectively tell a larger story across the many lives represented in each of these installations. Culled from various archives, they are effective feminist statements on the ugly and violent predicaments that women face in their daily lives. Jacobsen steals the grid away from its institutional authority with the intent of inversion: as a memory tool for women's history and as a critique of a repressive patriarchal American culture that allows women to be subjugated to violence or to become desperate. In art circles, the hard-edge grid is often denoted as the foundation of masculinist minimalism as in the work of Sol LeWitt. Yet it is the French artist Christian Boltanski's installations of children in school pictures, oftentimes shown with small lights illuminating each face, memorials to the Holocaust, that is a more potent comparative with Jacobsen's formulation of an irreconcilably violent history.

We are invited to imagine these women's lives, to reconstruct motives for murder, through bare-bones fragments and to eke out what we can from each frame through image and text—a beautiful portrait of a woman, a ruthless slogan, a court scene—that trigger compassion, fear, horror, sorrow. Jacobsen's use of the grid drives home the repetition of the crime of patriarchy and the state while signaling that in each case, there was an individual woman who was wronged by our culture's entrenched acceptance of sexual abuse and violence. The individual case is set among many, the crime is both specific and without end, the license to kill ingrained in the fabric of American life. At a moment when there is much attention on mass incarceration and gun violence, Jacobsen reminds us that history often leaves women behind. Her work insists on assuring we are front and center.

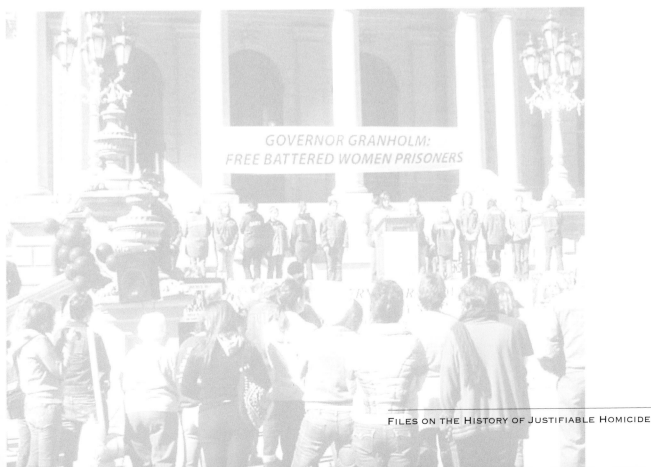

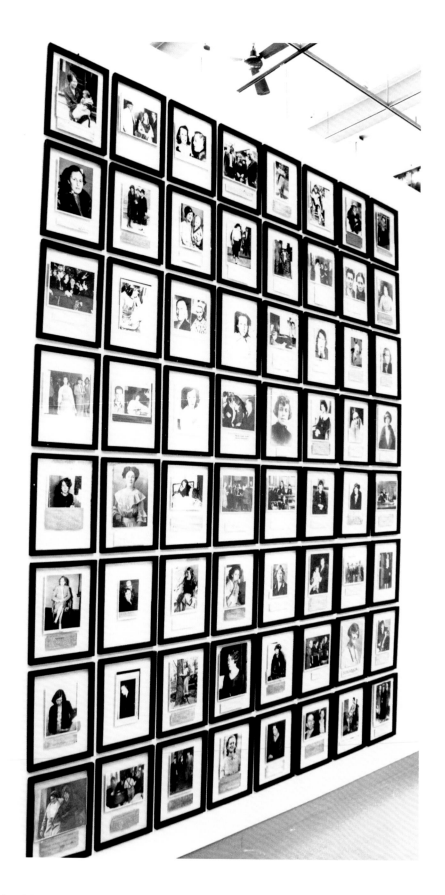

Files on the History of Justifiable Homicide, original prints, 2010

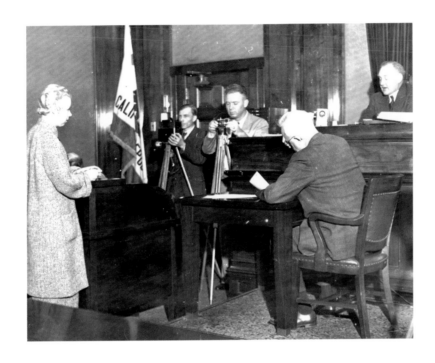

LA 5585————————————(LOS ANGELES BUREAU)

BURNAH WHITE HEARS 30-YEAR SENTENCE

 PHOTO SHOWS BURNAH WHITE AS SHE HEARD
JUDGE FLETCHER BOWRON OF LOS ANGELES SENTENCE HER TO
30 YEARS TO LIFE FOR HER SHARE IN THE ROBBERIES OF HER
SLAIN BANDIT-HUSBAND, TOM WHITE.
BUREAUS!
"YOUR CREDIT LINE MUST READ (ACME)" 11/6/33

Files on the History of Justifiable Homicide, detail, 2010

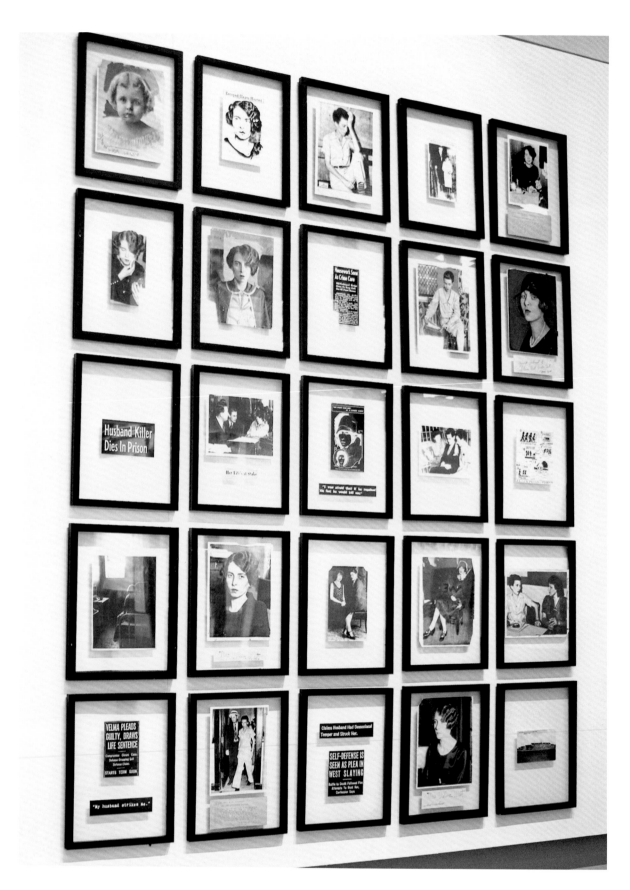

Nightclub Girl in a Curfew Town, original and archival digital prints, 2012

SELF-DEFENSE TO BE VELMA'S CHIEF PLEA

Insanity Also to Be Given as Cause of Hammer Murder of Husband; Claims Husbahd Had Demoniacal Temper and Struck Her.

NIGHTCLUB GIRL IN A CURFEW TOWN (2008–12)

In an antique fair one summer I discovered a woman selling old photographs from the archive of a Cleveland newspaper that had gone out of business. I asked if she had any photos of women being arrested or in prison. Over the next few years she sent me hundreds, many of them from the Depression era of the late 1920s and 1930s. Most were Associated Press images with captions pasted on the backs that told stories heartbreakingly similar to the contemporary women's cases I was working on at the time.

One case stood out because it captured national attention in newspapers across the United States in1927. Velma West killed her husband in self-defense during a physical struggle in their home. But because the media dubbed her "the nightclub girl" who killed her husband so she could go to a party, she was effectively convicted before the trial began. Her accounts of her husband's beatings were largely disregarded, as they too often are today in similar cases. Undoubtedly fearing Ohio's death penalty, she pled guilty and was sentenced to life in prison at Marysville Reformatory for Women.

The media circus erupted again when Velma West and a friend escaped from Marysville prison in 1939. A nationwide hunt was featured in headlines across the country. The two women were soon caught in Texas and returned to Ohio. Velma West died in prison in 1959, but the tragedy she lived continues to this day in the criminalization of women who lawfully defend themselves.

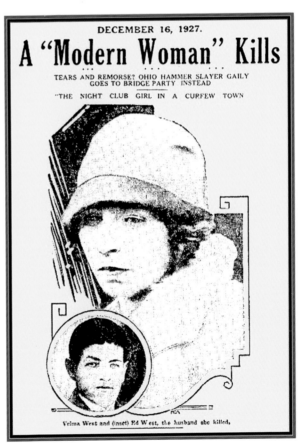

DECEMBER 16, 1927.

A "Modern Woman" Kills

TEARS AND REMORSE? OHIO HAMMER SLAYER GAILY GOES TO BRIDGE PARTY INSTEAD

"THE NIGHT CLUB GIRL IN A CURFEW TOWN"

Velma West and (inset) Ed West, the husband she killed.

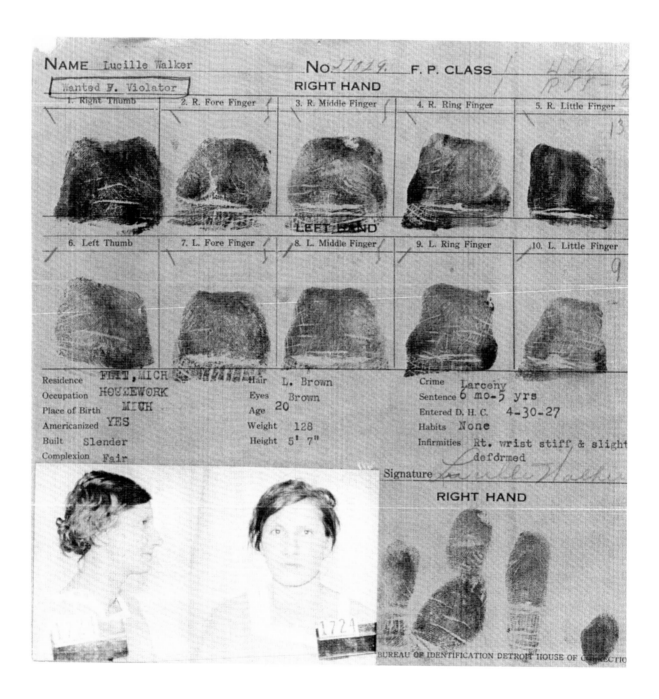

For Love or Money, detail , 2009

9-26-07

Dear Carol,

yesterday, under my door was the paper for signing 30 day notice of intent to conduct a Parole Board interview.

Also asking if anyone was coming with me. I told them you would at this point. I know you have done this before and know more than I do, on what will be ask.

I'll call you over the week-end to let you know any other news.

I'm the just 2nd degree they have seen here so far, or will see.

I'm sure this decission to see me is the results of your Commutation work.

Just wanted to inform you of the interview. Hope you can come for me.

Millie

January 11, 2008

Dear Carol,

 Namaste. I'm sorrowleden to share the news of my commutation denial. The reason given : Compelling opposition & that I remain unable to accept full culpability of for my Criminal behavior.

 I don't know what more can I do or say for them to see me more then 'A Crime'.

 I'm gathering my broken pieces so I can overcome this sorrowthat pulsates inside.

 Thank you so much for the support you have provided me throughout years.

Sincerely,

Kinnari

𝔉𝔯𝔢𝔢𝔭.com November 4, 2010

Granholm should commute prison sentences of battered women

By CAROL JACOBSEN

Carol Jacobsen is the director of Michigan Women's Justice & Clemency Project at the University of Michigan.

Michigan Gov. Jennifer Granholm can leave a powerful legacy of human rights when she leaves office if she has the courage to commute the sentences of battered women prisoners who acted to save their own lives but did not receive fair trials based on the facts of their cases.

The Michigan Women's Justice & Clemency Project represents dozens of incarcerated women who have served long sentences, many serving life, for defending their lives. The cases are carefully selected and investigated, and represent women who received neither equal protection by law enforcement nor effective trials that considered their abuse. Michigan law is seriously outdated and inadequate to address survivors of domestic violence who act in their own defense.

In Michigan, one woman is murdered by a husband or boyfriend approximately every five days. Many women in Huron Valley Women's Prison are the survivors who would very likely have been among the dead had they not fought back. In prison, they have served extraordinarily long, punitive sentences: such harsh and unfair rulings have virtually condoned sexual and physical violence against women for years.

Leaving office in 2007, Gov. Ernie Fletcher of Kentucky gave hope to women across the U.S. when he granted clemencies and early paroles to 21 battered women, stating, "Our legal system is the best in the world but it is not perfect."

He was following the example of other governors across the U.S. who also released battered women prisoners as they left office. Clemency is the last hope for justice for women who defended themselves against abusers and are in prison now. Research shows that these women do not reoffend and are perfectly safe to release back to their communities.

Granholm can leave a valuable, lasting legacy through clemency for battered women. It will send a message that women's abuse will not be tolerated in Michigan. It is her opportunity to leave a singular, humanitarian mark on the record of her years in office.

OUR FIRST CLEMENCIES (2008–10)

For two years beginning in 2008, fifty-one women prisoners (and 129 male prisoners) received public hearings for possible clemency or parole by orders of the outgoing governor, Jennifer Granholm. Our annual campaigns for the Clemency Project ramped up as we submitted clemency petitions and pressed the governor for action. Most of the clemencies and paroles that were granted went to those who had minor drug offenses or probation or else terminal medical cases. Only ten women who were convicted of major crimes (nine serving mandatory life for first-degree murder, one for conspiracy to murder) received clemency; and only five women received parole from life sentences for second-degree murder (which is a parolable offense, but the Michigan parole board refuses to parole prisoners with a parolable life sentence, in opposition to the law.) Altogether, of the fifteen women released from life sentences for major crimes, we represented six. Only three of the fifteen were black; we represented all three.

All fifteen women who were released from life sentences for major crimes were accessories; either their abuser or someone else committed the crime. I testified at eleven public hearings, and we kept up

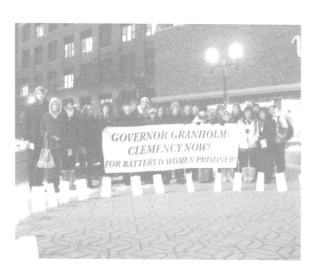

the pressure on the governor with rallies, op-ed pieces, letters, and other media coverage, but we did not publicize our successes once women were being released in order to avoid political backlash and to win as many releases as possible before the governor left office. As we celebrated those who were freed, we also felt bitterly disappointed for all the women who were just as deserving but who remained in prison, many of them for life. Doreen Washington was the first "battered woman" to be granted clemency by a governor in the state of Michigan. Doreen served over twenty years of a life sentence for the death of her violent husband. He was shot with his own gun by their foster son, who thought he was protecting Doreen and the family from further beatings. Despite Doreen's pleas to police for help, her broken bones, burned body, and trips to hospitals, she received no relief from either law enforcement or courts during her marriage. Doreen was convicted of first degree murder because she tried to protect the boy from arrest by hiding the body. I testified at her public hearing alongside her own son, who gave a graphic account of the terror his family endured at the hands of his violent father. Doreen's trial judge wrote a strong letter of support for her release, stating he was never informed of the history of abuse during the trial.

From 2008 to 2010, we celebrated Doreen's and five other releases from life sentences that we won: Linda Hamilton, Minnie Boose, Levonne Roberts, Millie Perry and Barbara Anderson. All six had families and friends who were there for them when they walked out of prison. They are rebuilding their lives and they keep in touch with us. Doreen Washington and Millie Perry remain actively involved with the Clemency Project. In 2014, Levonne Roberts died from years of medical neglect in prison. She had served twenty-five years for a murder committed by her abusive boyfriend, despite the fact that she had immediately reported him to police at the risk of her own life.

STATE OF MICHIGAN

GOVERNOR

To the Michigan Department of Corrections

Whereas, in the Circuit Court for the County of Wayne, Doreen Washington was convicted of the crime of First Degree Murder. She was sentenced on August 23, 1988 to imprisonment for life in the Michigan Department of Corrections;

And Whereas, application has been made for commutation of the sentence of Doreen Washington;

And Whereas, the Michigan Parole Board has recommended to me that her sentence be commuted and the reasons given appear to be satisfactory;

Now Therefore, I, Jennifer M. Granholm, Governor of the State of Michigan, do hereby commute the sentence of Doreen Washington to a term of seventeen years, nine months, and four days minimum to life maximum, thereby making her eligible for parole on February 1, 2008.

You are hereby required to make your records conform to this commutation.

Given under my hand, and the Great Seal of the State of Michigan this ___ day of May in the year of our Lord, two thousand eight.

Jennifer M. Granholm
Governor

By The Governor:

Secretary Of State

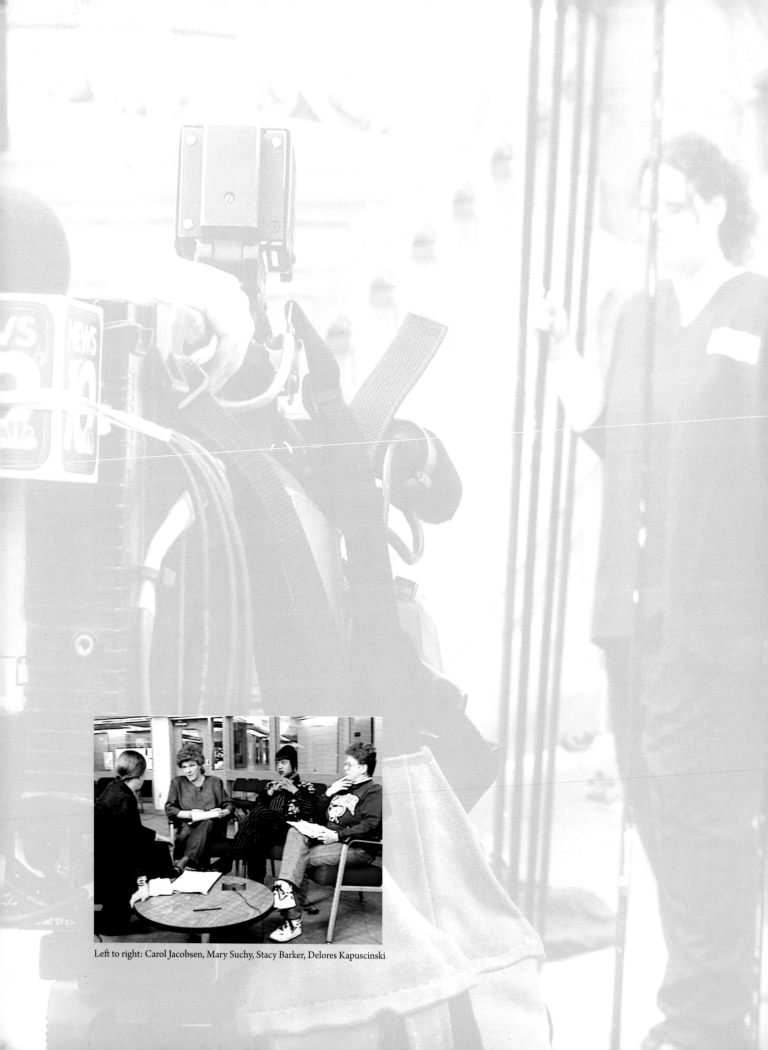

Left to right: Carol Jacobsen, Mary Suchy, Stacy Barker, Delores Kapuscinski

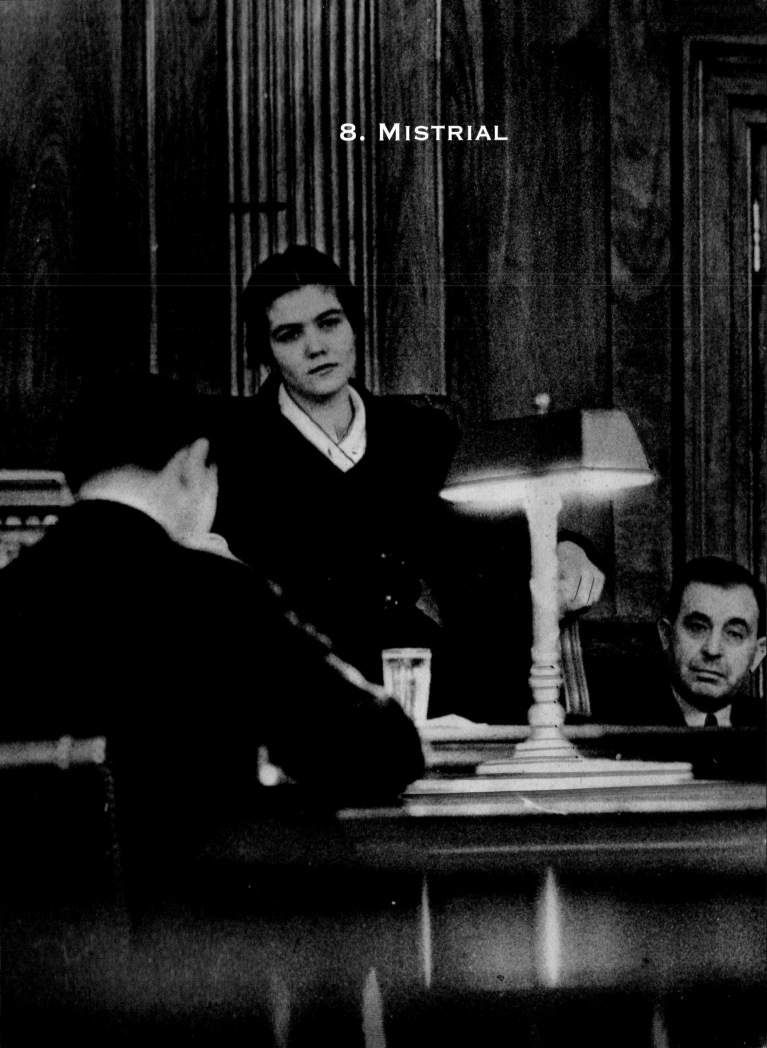

8. MISTRIAL

WATCH YOUR CREDIT
INTERNATIONAL NEWSREEL PHORO

NEW COMPLICATIONS IN HALL-MILLS MURDER CASE

THE ARREST OF CLIFFORD HAYES ON CHARGES OF IMPLICATION IN THE
MURDER OF REV. DR. EDWARD W. HALL AND MRS. ELEANOR MILLS SEEMS
TO HAVE ADDED TO THE MYSTERY AND COMPLICATIONS INSTEAD OF
SETTLING THE CASE. MISS PEARL DAHMER, XXX SEVENTEEN YEAR OLD
GIRL, WHO WITH RAYMOND SCHNEIDER, FOUND THE BODIES, HAS BEEN
TAKEN INTO CUSTODY ON CHARGES OF INCORRIGIBILTY AND IS NOW
IN THE COUNTY JAIL. WHERE THIS PHOTOGRAPH OF HER WAS MADE.
SCHNEIDER, WHOSE CONFESSION LED TO THE ARREST OF HAYES, IS
SAID TO HAVE BEEN HELD ALSO ON THE MURDER CHARGES. MISS DAHMER,
SHOWN HERE, HAS REFUSED TO SAY ANYTHING FURTHER THAN WHAT SHE HAS
ALREADY TOLD THE AUTHORITIES. 10-11-22 B.

MISTRIAL (2008–11)

Mistrial is a series of digitally enlarged archival news photographs featuring women's arrest or incarceration. The originals were taken at a time that is often linked to our own through comparisons with the crash on Wall Street and the Great Depression that followed. Many of the captions bear sexist codes that vilify the women through snide references to their appearance ("buxom matron," "blond tigress," "bobbed haired girl") and function to convict them. The photographers, however, have often captured a sense of the poignancy in these inglorious moments in the women's lives almost a century ago as they enter jail, are seated alone in a cell, or face the judge in court.

Each photograph in the series has been touched up with a crayon or dabbed with paint by a photo editor to emphasize facial features or qualities of light for newspaper reproduction, giving the images the look of unfinished paintings from the seventeenth century. The warm, fragile light that emanates from some is reminiscent of Dutch interiors that featured lone figures seated in a room while others reverberate with the dramatic tenebrism found in Italian Baroque canvases.

Each image and its caption tell only a partial story, yet there are details that mirror those in many contemporary cases, both in terms of what they say and what is left out. Finally, I appended a brass plaque to each that is engraved with a text from a contemporary trial to link questions of gender and injustice that persist across time.

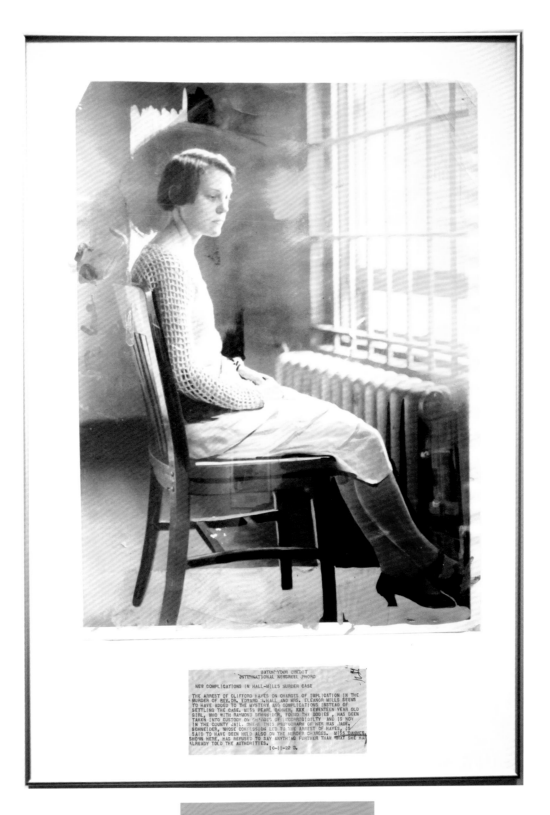

"The most tragic, troubling and saddest case

I've ever had in twelve years as a judge."

Judge John McDonald, People v. Nancy Seaman 2006

Mistrial 7, archival digital print with engraved brass plaque, 2011

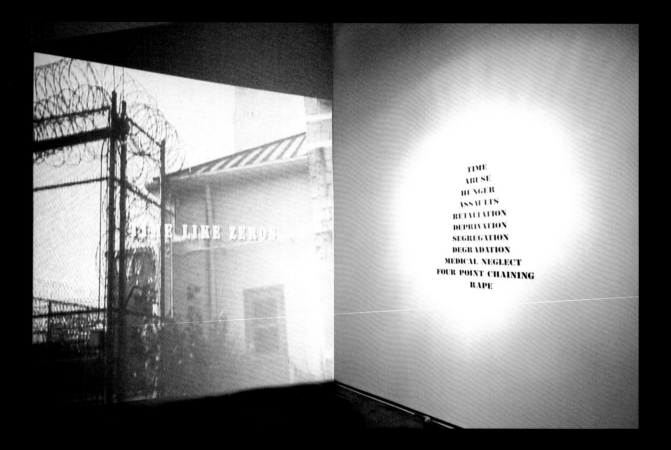

TIME
ABUSE
HUNGER
ASSAULTS
RETALIATION
DEPRIVATION
SEGREGATION
DEGRADATION
MEDICAL NEGLECT
FOUR POINT CHAINING
RAPE

"From the walls that surround you in gray to the hard bed you sleep on, to the blue uniforms that you wear, to the food that you eat, it is all a form of demeaning you socially, personally because they want to break you down. But there's no building you up. You've already been broken, so now they break you further."

Diane

Time Like Zeros, video installation, Denise Bibro Fine Art, New York, 2011

Time Like Zeros
13 min., 2011
Excerpts

D.: You're coming from the county jail wherever you are. They're loading you in a van and they're taking you to this prison. They open the gates of this prison and they drive the van in, and you're ushered out. You have your feet shackled. You have these chains wrapped around your waist, which keeps these handcuffs to your waist and your feet together. And the gate closes behind you with this guillotine wire shining everywhere. And they open up this door and they shout, "Come on, come on, get out, get out, get out!" and you don't know where you're getting out, and you're trying to get out but your legs don't stretch to get out of the van and you're shuffling and they're prodding you along and telling you, "God, slow-ass women!" After that's done, they shuffle you into this little room and you wait with all these women you've come in with.

L.: That's the first time in my life that I ever hyperventilated. I couldn't believe I was going to the penitentiary.

J.: You can't see nothing but time, like zeros, all I could see was zeros, and that was really a mental strain.

A.: I think that my hardest year was my first year having to adjust, having to accept that I was going to be there twenty years. You know, cause the sentence was twenty years, and I thought I'll never make it, I'll never make it, you know, so the only way that I could make it was for me to stop thinking about twenty years, maybe I won't wake up tomorrow.

D.: And then from there they strip you of your clothing, a piece at a time, your socks, your pants while the guard watches and instructs you to take off each piece of clothing a piece at a time. Lift up your breasts, turn around, bend over, spread your cheeks, cough. They look, examine, and prod to make sure you don't have anything inside. That's a form of degradation, but it's also–if you take the statistic of 85 percent have been molested as children, what are they going back to, what are they all of a sudden... From there you go to a shower, and you're watched as you wash, and you're instructed how to wash. Here you are being instructed by a guard, a woman, a person in authority, how you should wash your own body. "Lather up more under that arm, spread those legs, put something down there, don't be scared of a little soap down there!" You're given clothes to wear.

E.: OK, here go your blues, your underwear, you go eat at this time, and you go to the clinic at that time. It's just like throwing them out there to the wolves.

D.: Everything that you ever knew beyond that fence is now gone to you. Any type of resources, any time of family, support system, children, is gone. Now you're worthless. You're just a six-digit number.

A.: People forget you over time.

M.: I've seen so many abandoned women.

E.: And then we have that unit where they're overmedicated, they're walking around like zombies.

D.: I can't help but think, we're allowing this because we don't see beyond the fences and the walls of the prison. And because we don't see it, therefore it doesn't exist?

Framed/Reframed/Framing:
Time Like Zeroes

Patricia R. Zimmerman

Carol Jacobsen's **Time Like Zeros** graphs a disconcerting but necessary visual topography of women's incarceration as a central human rights issue. It presents a frame within which to listen to women prisoners testify to the psychic and bodily horrors inflicted on them.

A tracking shot outside the prison of a barbed wire fence suggests that any framing of women in prison requires acknowledging the relationship between inside and outside as one of danger, of blockage, frames ripped open, torture. It is a simple but disturbing image: the movement of the camera countering the immovability of the barbed wire. It marks us as outside incarcerations. In the film, voiceovers of women prisoners haunt these spaces with stories and observations. One woman testifies, "Everything you ever knew beyond that fence is now gone to you."

As feminist filmmaking practice, **Time Like Zeros** eschews individual artistic self-expression. Instead, it repositions the maker as a critical part of an urgent, life-and-death, dialogic relationship that listens.

The latter section of the film chronicles a disturbing scene: four guards restrain a woman prisoner on a bed.

Reclaiming their agency, women prisoners speak over this horrifying image. Of the other prisoners, one declares, "I see them as my family." Another explains, "You learn how to make something from nothing." Jacobsen's feminism resides in insisting on this dialogic stance, where the filmmaker bears witness through listening to the disembodied voices of the women prisoners. Thus, the film itself constitutes a form of restorative embodiment.

This witnessing extends beyond the film as artifact to reframe a dynamic chain of feminist interventions about women in prison. It transforms from listening to the demand for human rights, dignity, and even clemency.

A woman in **Time Like Zeros** describes the psychic degradation of prison, a reminder that prison is not so simply about bodies stripped of freedom but also about subjectivities pulverized: "All is a form of demeaning you… they want to break you down but there is no building up."

The video, then, functions as a reframing, focusing our attention on the most marginalized and invisible of women—the incarcerated. Jacobsen's work counters this institutionalized breaking down of women with a building

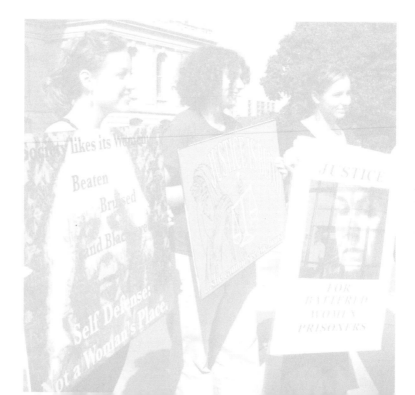

158

up of a different sort: the development of networks and organizations like the Michigan Women's Justice & Clemency Project, which she directs. Jacobsen's work, then, mobilizes beyond the frame. Her project instigates framing in the sense of construction with posts and beams that create new structures and spaces. The Michigan Women's Justice & Clemency Project works to free women who acted in self-defense but were convicted of murder. Jacobsen's films are free to those organizing on these issues.

For nearly three decades Jacobsen has chronicled women's criminalization as prostitutes and as the victims of battery through installations, videos, photography, archival work, exhibitions and other political projects. Her work refuses to stay in one zone. It enters the gallery, the museum, the classroom, activist networks, legal aid, and political organizations, finding openings to expose this issue of incarcerated women who were and are abused.

Muckraking and investigative, poetic and questioning, Jacobsen's work is resolutely region based, centered on Michigan, where she lives. This work insists on the specificity of place and the particular granularity of the state's prison politics. Since the 1990s, she has produced a compelling plethora of films on women in prison, such as **Clemency** (1999), **Sentenced** (2003), and **Prison Diary** (2006).

I can think of no other feminist documentary filmmaker who has dedicated herself so resolutely and so clearly to a lifelong project of justice for incarcerated women in a particular, specific place. Her works reframe Michigan - known more for football and blueberries than as a major part of the gendered, racialized and classed prison industrial complex.

As a result, Jacobsen's life work has recalibrated feminist documentary as moving beyond the frame and reframing, into a concrete, activist framing that builds organizations with the goal of securing clemency and human rights. And it has produced stunning, life-changing results: twelve women have been freed from life sentences.

ORD EAGLE

ERN MICHIGAN'S NEWSPAPER

he Governor for Clemency

Bill Milliken, who served as
nger than anyone in history,
lly give his successors advice
xcept on one issue. There are
ichigan prisons who, he is
g behind bars.

They are women who are of no threat to
society, mostly battered and abused women
who were either justly convicted or got
sentences far harsher than deserved. He has
joined the members of the Michigan Women's
Justice and Clemency Project in asking

THE NEW ASYLUM

Michigan closed psychiatric hospitals to save money. Now our state incarcerates the mentally ill – at three times the cost

September 24, 2010

Email to:
Governor Jennifer Granholm, PO Box 30013, Lansing, MI 48909
Director Patricia Caruso, Michigan Dept. of Corrections, PO Box 30003, Lansing, MI 48909

Dear Governor Granholm and MDOC Director Caruso,

We are alarmed by the inhumane treatment of women occurring in Level 4 and Segregation at Women's Huron Valley Prison. Many of the women in that unit, if not most, have survived terrible abuse prior to prison. Many now suffer from mental illness. Others are there because of officers' retaliation. And others are incoming prisoners. The women are locked down 22 hours a day, and have no programs. They are severely mistreated and emotionally battered by a number of the guards, several of whom are even goading prisoners toward suicide. The number of suicide attempts in the past week is evidence of this critical problem. In the past 2 years, the suicide attempts plus the actual suicides should tell us that Level 4 at Huron Valley Women's Prison is out of control because of some of the guards who are abusing prisoners. I have interviewed a number of women housed there and these women do not deserve the kind of torture they are being subjected to. They need therapy, decent programs, and positive, humane treatment. The following women attempted suicides BECAUSE OF the harassment and mistreatment:

Time Like Zeros, still, 2011

Investigators probe apparent suicide at state women's prison

Govofficesom@michigan.gov
"CARUSO PL"@michigan.gov
jgerritt@freepress.com
lynndorio@hotmail.com
mackinac44@charter.net
capps@capps-mi.org
nholbrok@afsc.org
almasmith@house.mi.gov
kbarber@legislature.mi.gov
sampso@michigan.gov
kmoss@aclumich.org
Lsager@famm.com
caroboyd@umich.edu
Bucca@aol.com
John.Conyers@mail.house.gov
SenLBrater@senate.michigan.gov
SenMSwitalski@senate.michigan.gov
djayasinghe@aiusa.org
rebekahwareen@house.mi.gov
georgecushingberry@house.mi.gov
LeisiaLiss@house.mi.gov
SenMScott@senate.michigan.gov
christinew@safehousecenter.org
barbaran@safehousecenter.org
tracyw@safehousecenter.org

October 9, 2010

Dear Governor Granholm, Director Caruso,
Another suicide at Huron Valley Women's Prison. (Name) , 25, slit
her own throat and died in her cell yesterday. Again, we ask that you install a
broader mental health program and support additional groups (thankgod for the
Domestic Violence Safehouse volunteers who are finally allowed to go in and help
the women; but more are needed), and address the problem of those officers who
are taunting and harassing women, and/or ignoring women who are in crisis and
asking for medical and psychological help.
It is our understanding that the issue of suicide attempts was raised by prisoners at
the last Warden's Forum meeting in September, but the Warden did not wish to
discuss it. It is our hope that she will begin to discuss it and consult with prisoners
themselves to see what they need to address this issue immediately and ease the
tensions and culture of cruelty and inhumanity toward the prisoners in Huron
Valley Women's Prison.
Sincerely,
Carol Jacobsen

Carol Jacobsen, John Rich Professor of Humanities
The University of Michigan

October 22, 2010

Dear Carol,

I have another girl for you to look at. It just blows my mind
when I have known these girls for many years and have no idea
they are incarcerated for killing their abusive men. This past
month, I had another one move in with me and I think she needs
to be considered from your end.

 She was convicted over 11-years
ago for killing her boyfriend. She has not told me much but
it is so obvious that she has post traumatic stress disorder
to a large degree.

I told her I would write you.

On my end, I have not been doing good at all. I got two major
misconduct tickets and served 21-days of LOP for it. I was
so devestated by it I was ready to end my own life. Now, I
am trying to focus on helping the other girls get out so I don't
think of my own woes. It is just too over-whelming to do
otherwise. Also, I am trying to get on hormones as it is either
that or psyche meds. The psyche meds they want you to walk
one mile each day to get them, maybe twice a day, and I know
I won't walk it.

I will call you eventually, I am just too depressed to talk
for now.

Hanging by the skin of my teeth...

LuAnne

Criminal Defense Newsletter

November, 2011
Volume 35, Number 2

The Commutation Process for Women

Carol Jacobsen and Lynn D'Orio

At the end of 2010, the Michigan Women's Justice & Clemency Project, a grassroots effort based at the University of Michigan, celebrated four clemencies granted by Governor Granholm to women serving nonparolable life sentences, and paroles for two women serving parolable life. The six women were convicted as aiders and abettors to murder, five of them in connection with the deaths of their abusers, and one for a murder committed by her abuser. The Project prepared clemency applications and representatives testified at public hearings for all six women.

Our celebrations for the women who were released were not without tinges of irony and disappointment at a lost opportunity for justice, however, since hundreds of other women who also petitioned for and deserved clemency - a number of them supported by the Clemency Project - remain incarcerated for crimes committed in self-defense or under duress and threat of violence to themselves or others.

In her final term in office, from January 2007 to December 2010, Governor Granholm granted a total of 28 clemencies (commutations and pardons) to women prisoners. 175 were granted to both men and women during that period, a number that was both criticized and celebrated in the media for being greater than previous governors had granted. However, the pattern of clemencies granted to women was both highly selective and politically cautious. Other than those granted for terminal medical conditions (5), excessive drug sentences (6), or erasure of probation offenses (7), only 10 were granted for women convicted of serious crimes, and all but one of those were aiders and abettors to the crime. The exception was a woman whose conviction had been previously overturned by a federal court, but then was re-instated on prosecutorial appeal. Her petition for clemency, and one other successful woman's petition were submitted and supported by the University of Michigan Law School. During the same period, the parole board released only five women who were serving parolable life, two of whom were represented by the Clemency Project.

All together, 51 public hearings were held for women: 27 for women serving life or long sentences for murder or other serious crimes; 9 for medical cases; 7 drug cases; 8 probation offenses. One or both of us attended 11 of the 27 hearings held for women who were serving life or long sentences. The hearings themselves presented enormous obstacles for incarcerated women to over-come. First, they were predicated on a gendered model of criminal processing as well as a male model of violent offending. Research has shown that women's participation in violent crime is often coerced or responding to abuse; that the relationship between victimization and offending is more closely linked in women's lives than in men's; and that women have better responses to community treatment and lower rates of recidivism than men (see Bloom et al, U.S. Justice Department 2003), yet this kind of information was ignored in favor of the state's constructions of the women as dangerous and "pathological" persons. Second, histories of abuse, and other contextual issues relevant to the women's lawbreaking, particularly in cases of aiding and abetting male co-defendants, were treated as excuses and in some cases with outright mockery by the assistant attorney general, Charles Schettler, who conducted most of the hearings. Questions such as why didn't she run away from her abuser, why didn't her family call police, why, if she was so abused, shouldn't she be considered a "monster," like psychopathic lesbian killer Aileen Wuornos, and other bullying questions that betrayed bias or ignorance of survivors' responses to domestic violence were common.

The hearings themselves established an antagonistic environment that reflected the systematic patterns of inequity that are prevalent throughout the criminal processing of women, especially women of color. White women represent 52% of the total prison population according to MDOC statistics, yet 75% of the commutations went to White women; 84% of the pardons went to White women; four of the five paroles to parolable lifers went to White women. The relatively small number of hearings that were held for women excluded far too many who deserved an opportunity for relief. Those who did receive public hearings for possible commutation or parole were denied fair and impartial reviews that are a constitutional mandate for this last redress of justice.

California has had success with a change in their habeas law allowing women whose criminal convictions were linked to their abuse to apply for paroles. At least 19 women have been released since 2002, thanks to the change. New York is considering a bill that will mitigate sentences for battered women who act against their abusers or are coerced into committing other crimes. Michigan needs to make changes in criminal processing at all levels to reflect women's experiences, particularly as they reflect women's responses to violence and acts of survival.

"Doing time in
prison is a lot
harder than dying."
Anita

"I hope everybody gets
a second chance."
Juanita

Detroit Free Press

2018

1992

1990

Life on Trial, stills, 2018

Prison hero gets a new day in court

Murderer, an inmates-rights activist, is granted a retrial

LIFE ON TRIAL (2012–18)

It was one of those days that I wait too long for when Stacy Barker called to tell me that her third and final trial for murder was over and she had accepted a plea that would free her from prison in 2004. We both screamed with joy and cried into the phone. At that point, Stacy had served twenty years of a life sentence for killing her rapist in self-defense. He was an eighty-one-year-old white Lutheran minister, and she was a twenty-year-old black aide working in the retirement center where he had his own apartment.

The parole board exacted revenge for her activism and the six lawsuits she filed against the state while she was a prisoner. They denied her parole for four more years. But in 2009, I was there when she finally walked free, and we celebrated at a wonderful party with her friends and family.

I interviewed and filmed Stacy several times in prison in the early 1990s before Governor John Engler banned all recording devices and most visitors from Michigan prisons to keep human rights investigators and reporters out. After that, I continued to visit and support her release through my role as director of and legal assistant with the Clemency Project.

When Stacy won her federal appeal she changed Michigan law. Today, a judge is required to give full instructions on self-defense to a jury, including that a person has a right to use deadly force to prevent a sexual assault. Undoubtedly because of her activism, Stacy was subjected to horrific abuse and brutalization by the guards while she was in prison. She was placed in solitary confinement, chained down naked, threatened, raped, denied visits with her daughter, and subjected to humiliating extra vaginal and anal searches by guards. These are not uncommon forms of punishment used to control, demean, and silence women prisoners.

But Stacy refused to be silenced. Through it all, she fought back by filing grievances and lawsuits against the state. It was not easy once the draconian Prison Litigation Reform Act (PLRA) was passed in 1996 that made it almost impossible for prisoners to sue the state. Nevertheless, she was a named plaintiff on such groundbreaking lawsuits as *Cain, et al v. Michigan Department of Corrections* (on prisoner classifications, access to courts, overuse of segregation units, and other issues); *Glover, et al v. Michigan Department of Corrections* (for educational opportunities in parity with male prisoners); *Bazzetta, et al v. Michigan Department of Corrections* (for visiting rights); *Nunn, et al v. Michigan Department of Corrections* (for sexual assaults of women prisoners); and *Neal, et al v. Michigan Department of Corrections* (also for sexual assaults of women prisoners). In the *Neal* case, more than five hundred women won a jury trial and were awarded damages of $100 million against the State of Michigan.

A few years after she was released from prison, Stacy and I sat down again for another filmed interview. She talked about her three trials, the class action lawsuits she was a part of, and the punishments all incarcerated women suffer inside. She is still the activist, now speaking to community groups and volunteering with girls' and women's organizations while she is rebuilding her life.

Detroit Free Press

January 4, 2009

The jury delivers surprising verdict

ABUSE WARNINGS SINCE 1990s

JUSTICE
Jury awards $15.4 million to inmates in assaults case

UNITED STATES DISTRICT COURT
EASTERN DISTRICT OF MICHIGAN
SOUTHERN DIVISION

ARY GLOVER et al,

Plaintiffs,

v

Civil No. 77-CV-71229-DT

RRY JOHNSON, et al,

HONORABLE JOHN FEIKENS

Defendants.

~~MAGISTRATE STEVEN D. PEPE~~

/

UNITED STATES DISTRICT COURT
EASTERN DISTRICT OF MICHIGAN
SOUTHERN DIVISION

Michelle Bazzetta, Stacy Barker,
Toni Bunton, Debra King, Shante Allen,
Adrienne Bronaugh, Alesia Butler,
Tamara Prude, Susan Fair, Valerie
Bunton and Arturo Zavala, through his
Next Friend Valerie Bunton, on behalf of
themselves and all others similarly situated,

Plaintiffs,

No. 95-CV-73540-DT

v.

Hon. Nancy G. Edmunds

Kenneth McGinnis, Director of Michigan
Department of Corrections, Dan Bolden,
Deputy Director of the Correctional Facilities,
Michigan Department of Corrections, Marjorie
VanOchten, Administrator of the Office of Policy
and Hearings of the Michigan Department of
Corrections, Michigan Department of Corrections,

Defendants.

STATE OF MICHIGAN

IN THE COURT OF CLAIMS

JOHN CHAPPEL CAIN, RAYMOND C.
WALEN, JR., ELTON FLOYD MIZELL,
PAUL ALLEN DYE, JOHN CHANDLER
EWING, DELBERT M. FAULKNER,
C. PEPPER MOORE, on behalf of
themselves and all others
similarly situated,

Plaintiffs,

No. 93-15000 CM
Hon. Brown

MARY GLOVER, and SERENA GORDON
on behalf of them-selves and
all others similarly situated,

Plaintiff-Intervenors,

v.

UNITED STATES DISTRICT COURT
EASTERN DISTRICT OF MICHIGAN
SOUTHERN DIVISION

LINDA NUNN, TRACY NEAL, HELEN GIBBS,
STACY BARKER, IKEMIA RUSSELL, BERTHA CLARK
and JANE DOE, on behalf of themselves and
all others similarly situated,

Plaintiffs,

Case No: 96-

vs.

MICHIGAN DEPARTMENT OF CORRECTIONS,
KENNETH McGINNIS, DIRECTOR OF MICHIGAN
DEPARTMENT OF CORRECTIONS; JOAN YUKINS,
SALLY LANGLEY, CAROL HOWES, ROBERT SALIS,
CORNELL HOWARD, OFFICER TATE, OFFICER PORTMAN,
OFFICER ELLISON, OFFICER GALLAGHER,
OFFICER ROBEY Individually and in their
official capacities, joint and severally,

STATE OF MICHIGAN

IN THE CIRCUIT COURT FOR THE COUNTY OF WASHTENAW

TRACY NEAL, HELEN GIBBS, STACY BARKER,
IKEMIA RUSSELL, BERTHA CLARK, LINDA NUNN,
JANE DOE, on behalf of themselves and all
others similarly situated,

Plaintiffs,

Case No: 96-

vs.

MICHIGAN DEPARTMENT OF CORRECTIONS,
KENNETH McGINNIS, DIRECTOR OF MICHIGAN
DEPARTMENT OF CORRECTIONS; JOAN YUKINS,
SALLY LANGLEY, CAROL HOWES, ROBERT SALIS,
CORNELL HOWARD, OFFICER TATE, OFFICER PORTMAN,
OFFICER ELLISON, OFFICER GALLAGHER,
OFFICER ROBEY Individually and in their
official capacities, joint and severally,

Defendants.

STATE OF MICHIGAN

IN THE CIRCUIT COURT FOR THE COUNTY OF WAYNE

STACY BARKER,

Plaintiff,

v

MICHIGAN DEPARTMENT OF
CORRECTIONS, et al,

Defendants.

-------------------------/

File No. 93-306063

HON. JEANNE STEMPIEN

94-15450-CM

FILED
AUG 1 - 1995

Ms. Stacy Y. Barker

December 3, 2007

Dear Carol,

Hello, I'm still alive but I'm just walking through my days in a trance... I received my 4th flop and I really don't understand. I don't even know how I'm continuing to wake up everyday and function?

I've been in this present state since July. I guess everything sort of hit me after our visit. You and Rachal brought me so much hope and faith. You and Rachal's letters were so honest and I really appreciate them.

I'm just beginning to feel like why should I keep fighting when the parole board did not hear what any of my supporters said? My friend Gerry Downey is a Professor at Columbia University. She's Vice Pro Vost and head of the psychology dept. She practically wrote them a psychiatric evaluation and I still failed to get a parole!!! Carol, what am I to do? It is not fair and I'm beginning to feel desperate!

Marlene wants to do a media blitz and start a web-site :Free Stacy Barker... I don't know what to do and I'd really like to touch base with you and maybe stratagize something!

Marlene came to visit this weekend and I feel so bad for her because she's come to all four hearings and she just believes in me so much...

Do you think you could visit me? I need it...

Peace,

Stacy

MICHIGAN
LAWYERS WEEKLY

Improper Jury Instruction Warranted Habeas Relief

Court Wrongly Concluded Error 'Harmless'

UNITED STATES COURT OF APPEALS FOR THE SIXTH CIRCUIT

199 F.3d 867; 1999 U.S. App. LEXIS 32454; 1999 FED App. 0416P (6th Cir.)

STACEY BARKER, Petitioner-Appellant

v.

JOAN YUKINS, in her official capacity as Warden, et al, Respondents-Appellees

DISPOSITION: REVERSED

In sum, we conclude that the trial court's failure to specifically instruct the jury that Petitioner Barker was entitled to use deadly force to prevent a sexual assault had a substantial and injurious influence on the jury's verdict and resulted in actual prejudice to Petitioner Barker. On that basis, we find that the Michigan Supreme Court engaged in an unreasonable application of the harmless error test under 28 U.S.C. & 2254(d). We further conclude that the Michigan Supreme Court's finding of harmless error violated Barker's consitutional rights to a trial by jury and to present a complete defense.

HUMAN
RIGHTS
WATCH

NOWHERE TO HIDE

RETALIATION AGAINST WOMEN IN MICHIGAN STATE PRISONS

"I'll never forget when the governor stopped letting the news people come in. That was one of my lowest points because it was virtual torture that was happening to us... men standing right over you, putting their penises in your face, calling you every name imaginable, telling you, 'I feel like doing this to you right now...' Too many women complaining of too many sexual acts. But that's when my second wind kicks in: 'OK, give us their number; we'll do interviews over the telephone.'"

Stacy

The Mistrial of Stacy Barker

Regina Austin

Stacy Barker, the subject of Carol Jacobsen's **Life on Trial**, was tried three times for the November 5, 1986, death of Frank Madsen. By the time she was released from prison, she had served a total of twenty-two years, three months and eighteen days for a crime that she maintained throughout was committed in self-defense. The first proceeding, in which she testified, ended with a hung jury, eleven of the twelve jurors having voted for acquittal. At the second trial, she did not testify, and she was convicted of first-degree murder and sentenced to life without the possibility of parole. In 1999, she won the right to a third trial, during which she accepted a plea to second-degree murder. The parole board took its sweet time in releasing her. She eventually left prison in 2009.

The role that mental imagery based on media mythology plays in the criminal system, especially at the appellate level, likely contributed to rejection of Stacy Barker's appeals before a federal appellate court finally granted her relief. Here is how the Michigan Court of Appeals in 1989 described the facts of her case:

> Briefly, the victim was an eighty-one year old white male and retired Lutheran minister. He suffered from various physical ailments and relied on a cane to walk. Defendant is a young, black woman who worked as a companion to another resident in the same apartment complex as the victim. Defendant and the victim were acquainted and defendant was present at the victim's apartment on the evening of his death. Defendant claims...that the victim started to make sexual advances towards her and would not stop even when she resisted... in a statement to the police during the investigation, defendant indicated that her reaction and the extent of her conduct in defending herself was in part a result of her having been previously raped and the fear of its happening again.

Ms. Barker's attorney argued that the jury instructions were erroneous in that they did not "inform the jury explicitly that, if it reasonably appeared necessary to the person assailed, she was entitled to use deadly force to repel a rapist." According to the Michigan Court of Appeals, the flaw in the charge did not matter because of the number of times Stacy stabbed the decedent. As a concurring judge put it, "Although they were not told she was entitled to use deadly force, no reasonable juror could have believed

such force was necessary to prevent rape by the enfeebled deceased." This reasoning diminished, if not nullified, the impact of Stacy Barker's own experience (a gang rape) on the reasonableness of her response to Madsen's assault. The Michigan Supreme Court subsequently agreed with this analysis in its 1991 opinion.

Eight years later, a panel of federal judges sitting in the Sixth Circuit granted Stacy Barker habeas corpus relief because of the flawed instructions. They reasoned that the instructions likely had a prejudicial impact on the jury, which was free to decide that a forcible rape would not have caused death or great bodily harm in this case and therefore grounds existed for rejecting Barker's claim of self-defense. That is not in accord with Michigan law. Moreover, the Michigan courts improperly invaded the province of the jury in stating that, as a matter of law, the amount of force Barker used was unjustified. Noted the federal court, "the conclusion that the victim was 'enfeebled' rejects testimony... which established that although the victim walked with a cane, he was 'a strong man, a big man.'"

The opinions in Barker's case cannot be read without images popping into one's head of the parties before and after the altercation, the crime scene, and the possible sequence of events. Unfortunately, what comes to the mind's eye bears the imprint of widespread, culturally fueled, culturally biased representations of black females in general and black female "deviants" in particular; aggressively and needlessly violent, sexually promiscuous, and impervious to serious bodily injury, even in the aftermath of a prior forcible rape. The depiction of the accused as a black female lawbreaker plays in our thoughts even if we have taught ourselves to repress or reject such images as stereotypes.

Artists like Carol Jacobsen educate the mind's eye as we view the women in her films. We see them not as criminals but as we see ourselves: with compassion and criticality as persons who rightly deserve fair judgment by a system of law. Lawyers need greater exposure to such critical images in order to counter the negative stereotypes and mass media misrepresentations that contaminate our criminal system and condemn women who are forced to defend themselves.

nd Press

Black jurors passed over, defense says

By STEPHEN W. HUBER
Of The Oakland Press

A-3

A second trial for a Detroit woman

Detroit Free Press

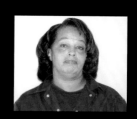

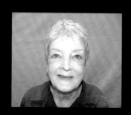

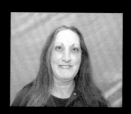

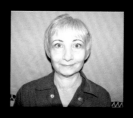

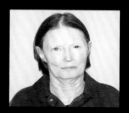

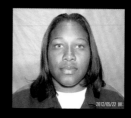

CLEMENCY FOR MICH. KILLERS?

12 women deserve to be free, group says

It claims past abuse, says there is no threat

By L.L. Brasier
Detroit Free Press Staff Writer

Ten Michigan women convicted of murder — including a former Farmington Hills fourth-grade teacher who killed her husband with a hatchet — deserve to be freed from prison because they were victims of domestic violence and didn't get fair trials, a women's clemency group argues.

The Michigan Women's Justice and Clemency Project announced this month it was filing petitions for clemency with Gov. Rick Snyder for the women, who were all convicted of first- or second-degree murder and have been behind bars for years and, in some cases, decades.

"These women are not a threat to anybody," said project director Carol Jacobsen, a University of Michigan professor in women's studies. "The whole social understanding of battery and abuse has changed since the 1980s and 1990s, when many of these women were convicted. In many of these cases, the abuse was never raised at trial."

From top: Christy Neff, Melissa Chapman, Louanne Szenay, Delores Kapuscinski, Melissa Swiney, Towanda Eppenger

From top: Machelle Pearson, Susan Farrell, Donna Debruin, Nancy Seaman, Karen Kantzler, Melanise Patterson

Group fights back against 'a war on women'
Clemency sought for domestic violence victims who acted in self-defense

FOR DEAR LIFE (2012–17)

For Dear Life is a series of large digitized prints taken from a nineteenth-century prison archive. I was struck by the beautiful faces of women and girls that emerged from the past in these long-buried documents but also struck by the details of their prison records that revealed clues to histories of abuse (left eyebrow ruptured, scars on both arms, etc.) and the harsh sentences they received for such minor crimes as "stealing a loaf of bread," "stealing an apron," or "stealing a pencil case." Their struggles as a poor "washerwoman," "laundress," or "charwoman" could be imagined from the delicate, handwritten notes next to their faded faces. Each woman was given a sentence of "hard labour" and often years in prison after that. To link these glimpses of women's histories with contemporary cases, I attached to each archival record a black metal plaque engraved with a quote from a woman's case that I am working on today.

While working on this series, I testified at a public hearing we helped to win for Karen Kantzler, a woman who killed her husband in self-defense in 1987. She is serving a life sentence for second-degree murder, which meant she has been eligible for parole since 1997 or before, with time earned for good behavior. We were certain that we would see her walk free. Her trial judge flew in from Florida to testify to his error in sentencing her to life in prison (at the time, parolable life meant serving up to ten years, but the parole board stopped releasing any prisoner with a life sentence, parolable or not, regardless of the law). She won her appeal in 1993 and was resentenced to three to ten years, which would have set her free. But the prosecutor appealed it, and her life sentence was reinstated. When her parole was denied again in 2015 (due to "inconsistent statements") despite the judge's

testimony, my testimony, and the testimony of two physicians who gave evidence of her husband's violent behavior and death threats, I could hardly contain my anger over the arrogance of the parole board, most of whom are former guards or police officers, to refuse her parole over all the evidence of self-defense, her achievements in prison, and the testimony of her judge about his "serious and tragic error" in sentencing her to life. In 2016 and again in 2017, Lynn D'Orio, legal director for the Clemency Project; Rebecca Leitman-Veidlinger, our volunteer attorney; and I met with Governor Snyder's legal counsel about Karen's and eleven other women's cases for clemency. I have stayed in close contact with the governor's office to press for clemencies before he leaves office at the end of 2018. Three women were finally granted paroles at the end of 2017: Karen Kantzler, Melanise Patterson, and Tonya Carson. We continue to fight for the other women.

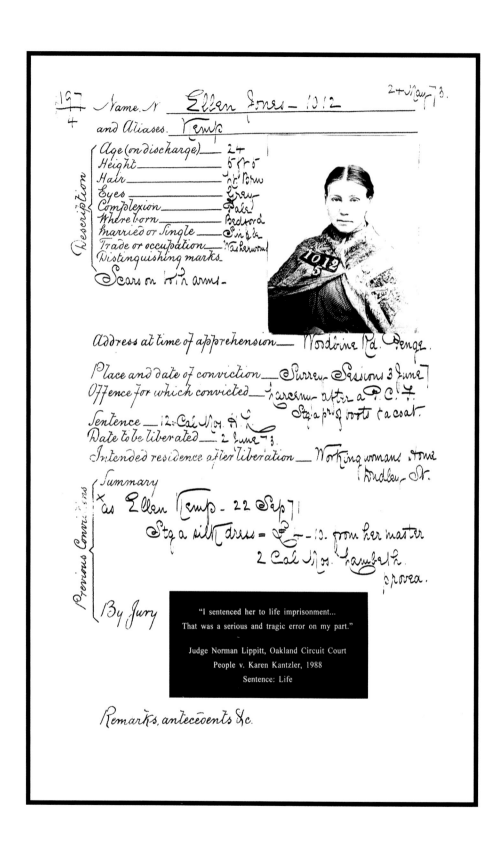

The quote within the image reads:

"I sentenced her to life imprisonment...
That was a serious and tragic error on my part."

Judge Norman Lippitt, Oakland Circuit Court
People v. Karen Kantzler, 1988
Sentence: Life

For Dear Life: Ellen and Karen, archival digital print with engraved metal plaque, 2017

April 8, 2014

Carol Jacobsen
MI. Battered Women's Clemency
 and Justice Committee/Project
1019 Maiden Lane
Ann Arbor, MI. 48105

Dear Carol,
 Last night, I received notification
from Deputy Legal Counsel Paul Smith from
Gov. Rick Snyder's office stating:

 "The Governor is in receipt of the
recommendation from the Michigan
Parole Board regarding your request
for a pardon or commutation of
sentence. Based on that recommendation,
the Governor has denied your request
at this time. Please be advised
that you may reapply two years

 from the date of receipt of your
last application."
This letter was dated April 3, 2014. I also
have a letter from the MI. Parole Board
stating they were forwarding the petition
and their recommendation to the
Governor - dated March 7th.

 Just thought I'd let you know, and another
thought - what's the use!

Karen

Huron Valley Women's Facility
3201 Bemis Road
Ypsilanti, Michigan 48197
April 8, 2013

Ms. Carol Jacobsen
Michigan Women's Justice & Clemency Project
1019 Maiden Lane
Ann Arbor, Michigan 48105

Dear Carol:

 Attached is a copy of the PSI report that you requested.
Please note that there are numerous typos in it. Kaluzny
never bothered to get it corrected, saying that it didn't
matter anyway because I had a life sentence. More bad
advice from an attorney that the courts have ruled provided
ineffective assistance of counsel on other issues.
 I'm concerned about the Judgment of Sentence (attached
to the back of the PSI). Please note that it was amended on
2/10/05 because it said that I was guilty by plea instead
of guilty by jury verdict. The Court sent me an amended copy,
but I have no way of knowing if the Parole Board has an
amended copy. Can you check on that.
 The PSI is replete with typos. Anything you can do to
get it corrected would be greatly appreciated.
 Thank you again, Carol, for everything that you are doing
to help me. I can never repay you for all the kindness that
you have shown to me. I'm scared, Carol. This is my last
chance for freedom.

 Fondly,

 Nancy

Enc.

Name, Nº _Emma Brandon 3162_ 16 Aug 73 454/4

and Aliases. _____

Age (on discharge) _32_
Height _4ft. 10._
Hair _Brown_
Eyes _Blue_
Complexion _Pale_
Where born _Midsex_
Married or Single _Married_
Trade or occupation _Laundress_
Distinguishing marks _Scar over left eyebrow. Ruptured._

Address at time of apprehension — 10 Youngs Buildings Eden Street Kingston.
Place and date of conviction — Kingston 31st July 1873
Offence for which convicted — Simple Larceny Stg a pr Socks and an apron 2/-
Sentence — 1 Cal month H. L.
Date to be liberated — 30 August 73
Intended residence after liberation — As Above.

Previous Convictions {
Summary —

By Jury —
}

"After her conviction I had many reservations about sentencing her to mandatory life in prison. She doesn't deserve to spend the rest of her life in prison."

Judge John McDonald, Oakland Circuit Court
People v. Nancy Seaman, 2004
Sentence: Life

Remarks, antecedents &c.

For Dear Life: Emma and Nancy, archival digital print with engraved metal plaque, 2017

My name is I currently reside at Women's
Huron Valley Correctional Facility. I witnessed something horrific
happen to a mentally disable woman here. I have struggled with this
for weeks now, however the last three days I have not been able to
sleep because thoughts of what they done to this woman will not
leave my mind. Please take the time to read this letter and please
help this woman

 In March 2014 I started working as a POA, "Prisoner
Observation Aid. I 'sit on' or watch prisoners that may harm themselves
or other prisoners. Within my first week I 'sat on' a prisoner named
 Room 103 Segration. She oviously is mentally
disabled. We have a lot of women in here like this because there is
no place else for them to go. So now they put mentally disabled
people in prison. In here the staff ~~all~~ not trained to care for them
like they need to be, this too is ~~evious~~. Obvious

 When I came on shift it was around 630pm. She was
yelling and begging for a shower. She became upset, stood on her
sink and started beating at the camera in the cell with her. She
was able to knock the camera off the wall. The officers, including
Sgt. Fisher took her out of the cell and put her in the shower area
while they fixed the camera and cleaned her room. Once that was
complete they put her back into her cell. Not long after that Sgt.
Fisher and three female officers showed up. One had a video camera
with her, not to mention there was a camera in the room. They asked
me to wait upstairs. When I came back she was HOG TIED, wrists
in front with handcuffs on ankles, handcuffed and connect to her
wrists with a chain. She was locked in the cell and on a bed that
is atleast three foot from the floor. She was crying, but not too
bad. A few minutes after this all the officers and the Sgt came back.
I was not told to go upstairs at this point. They again had a
video camera plus the one on the wall. They took the chain and cuffs
off, had her kneel on the bed, where she cried and cried.
They put her hands behind her back, cuffed her, hand cuffs on her
ankles and attached the cuffs together with the chain they used the
first time. So now she is in the back bend potion, naked, and on
a bed three feet from the floor. When I asked how long she had to
stay like that they said 2 hours or longer if she doesn't learn to
behave.

 I sat at the door listening helplessly to her crying,
begging them, telling them how much it hurt. Her hands behind her
back, knees bent connect to her hands naked, all for punishment.
How is this legal? How is this legal? Please tell me how this is
legal? How is this legal punishment? How come they dont have chairs
or 4 point restraint on a bed? I cannot get the image out of my
head of this mentally disabled woman that cannot fight back, that
cannot write a grievance or call family to help. So this is how
they treat the mentally disabled prisoners in here.

 Please help her. please help her. She is now in
Segragation Room 108 She is 25 years old. Prison doesn't know
how to help women like her, their only hurting her. Please dont
let them abuse her anymore.

180

Sunday, September 7, 2014

Water deprivation, hog-tying among
complaints against Huron Valley facility

ılıll

Complaint, ADA (CRT)
11:08 AM (3 hours ago)
to me
Email 4/19/14
From: US Justice Dept., Civil Rights Division, Div. of Disability Rights

The Disability Rights Section has received your email. This is an automatic
response generated by computer. Please keep a copy of this response for your
records. We will review the information you have submitted and will notify
you of any action this office will take with respect to the issues you have
raised. Please be advised that this office receives a large volume of
correspondence from the public. If you do not hear from us within 8 weeks,
you may contact us to determine the status of our review. You can check on
status either by sending a follow-up email to ADA.complaint@usdoj.gov or by
calling (202) 307-0663 (voice or TDD) or by calling the ADA Information Line
at 800-514-0301 (voice); 800-514-0383 (TDD).

To expedite processing of your status check, please include the words "status
check" in the subject line of your email and include your name, the name of
the entity that was the subject of your initial email, and the date of your
original email.

Thank you for bringing these matters to our attention.

Disability Rights Section Staff

US Dept. of Justice
Civil Rights Division
Disability Rights Section - 1425 NYAV
Washington DC 20530

Re: Abuse of Prisoner with Mental Illness at Huron Valley Women's Prison

Attached is a report I received from a prisoner about the torture of another prisoner at
Huron Valley Women's Prison in Ypsilanti, Michigan. I visited R. in 2012 and she has
been held and abused in solitary confinement most of her incarceration. She has severe
mental illness and does not deserve to be mistreated the way she has been by the prison
and the guards. Numerous other prisoners have reported abuse of R. and of other
women prisoners in solitary confinement as well. I have forwarded reports to the Justice
Department in recent years as well. Warden Millicent Warren runs a cruel ship at Huron
Valley Women's Prison and should be removed. Abuse of prisoners in solitary confinement
needs to be investigated and addressed.

Thank you for your help.

Sincerely,
Carol Jacobsen

Carol Jacobsen, Professor
The University of Michigan
Penny W. Stamps School of Art & Design, Women's Studies, Human Rights
Director, Michigan Women's Justice & Clemency Project
Denise Bibro Gallery, New York, NY
www.umich.edu/~clemency
jacobsen@umich.edu

No. 14-10218

In The
Supreme Court of the United States

◆

NANCY SEAMAN,

Petitioner,

v.

STATE OF MICHIGAN,

Respondent.

◆

**On Petition For Writ Of Certiorari
To The Michigan Court Of Appeals**

◆

**BRIEF OF *AMICI CURIAE* MICHIGAN WOMEN'S
JUSTICE AND CLEMENCY PROJECT AND THE
MICHIGAN COALITION TO END DOMESTIC AND
SEXUAL VIOLENCE IN SUPPORT OF PETITIONER**

◆

JOANNE C. BRANT
Professor of Law
OHIO NORTHERN UNIVERSITY
 CLAUDE C. PETTIT
 COLLEGE OF LAW
525 South Main Street
Ada, Ohio 45810
(419) 772-2228
j-brant@onu.edu

*Counsel of Record
 for Amici Curiae*

SARAH PROUT RENNIE
MICHIGAN COALITION TO END
 DOMESTIC AND SEXUAL
 VIOLENCE
3893 Okemos Road, Suite B2
Okemos, Michigan 48864
(517) 347-7000
sarah.proutrennie@mcedsv.org

*Attorney for Amicus Curiae
 Michigan Coalition to End
 Domestic and Sexual Violence*

REBECCA LEITMAN VEIDLINGER
2114 Londonderry Road
Ann Arbor, Michigan 48104
(734) 474-5587
rveidlinger@gmail.com

ELIZABETH K. ABDNOUR
1207 Blake Avenue
Lansing, Michigan 48912
(513) 255-1461
liz.abdnour@gmail.com

*Attorneys for Amicus Curiae
 Michigan Women's Justice
 and Clemency Project*

Amicus brief in support of petitioner Nancy Seaman to the United States Supreme Court, filed 2015
by Michigan Women's Justice & Clemency Project and Michigan Coalition to End Domestic and Sexual Violence

Nancy Seaman #520695
2B 104
Huron Valley Women's Correctional Facility
3201 Bemis Road
Ypsilanti, Michigan 48197
August 1, 2016

Dear Carol:

It is hard for anyone to imagine what it is like to be put on
trial for the homicide of your abusive husband, facing the possibility
of life in prison, only to discover that the jury deliberating your
fate will never hear the evidence that could prove that you acted in
lawful self-defense. This is the reality for me and countless other
battered women in Michigan because of severe limitations on BWS
expert witness trial testimony which has denied us the Constitutional
right to present evidence at trial that is critical to our defense.
What realistic chance does a battered woman have of defending against
the charges brought against her if she cannot present the behavioral
evidence necessary to explain state of mind and behaviors that a
jury may have found irrational or incomprehensible?

You know this issue well. Not only have you tirelessly fought
for years to urge state officials to make the necessary changes in
law to remedy this injustice, but you have supported my efforts during
twelve years of my arduous journey through the state and federal
appellate courts as I challenged the Constitutionality of these
evidentiary restrictions. Despite our diligent efforts, the
question remains unresolved and battered women in Michigan remain
a marginalized class, relegated to inferior legal status within
our judicial system.

Before this year ends, I plan to file a class action lawsuit
on the behalf of the class of all battered women in Michigan against
those state officials who have, through their actions or inactions,
acquiesced to this discriminatory practice of severely limiting
the trial testimony of BWS expert witnesses with the known
consequence of denying battered women the Constitutional right
to a complete defense, equal protection of the law, and a fair trial.

Carol, the fight has just begun and I need your help to rally
as much support as possible from domestic violence advocacy groups
to ensure the success of this lawsuit.

Thank you for all that you continue to do to improve the
plight of battered women.

Respectfully,

Nancy Seaman

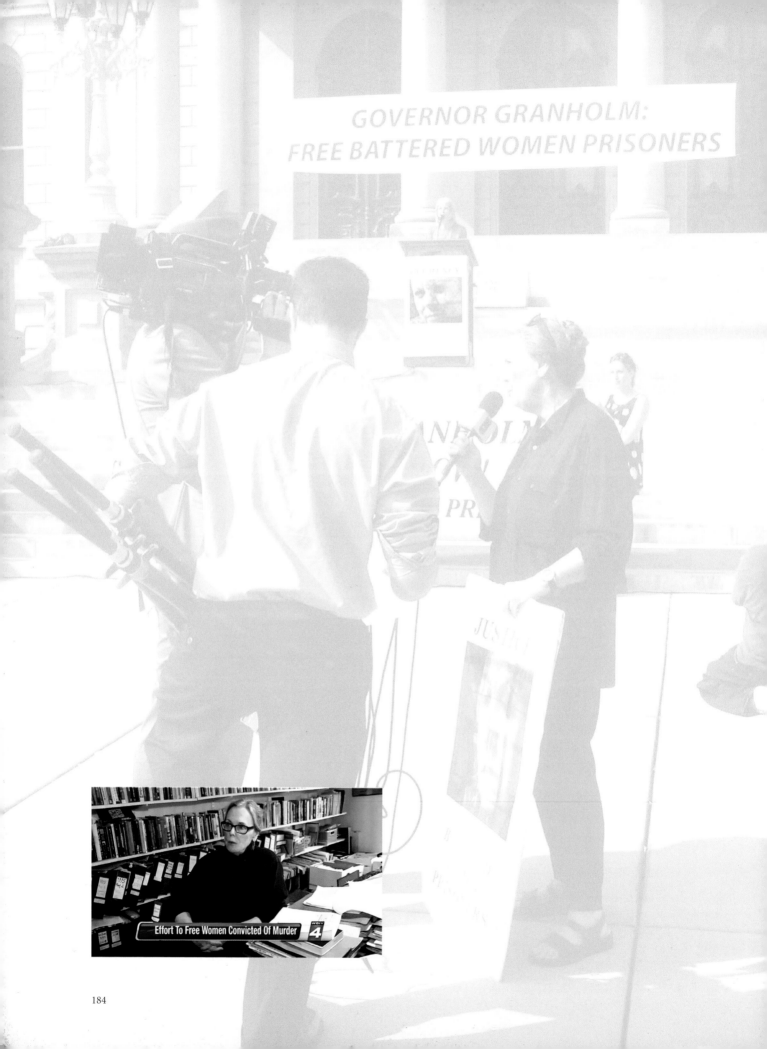

GOVERNOR GRANHOLM:
FREE BATTERED WOMEN PRISONERS

Effort To Free Women Convicted Of Murder

EPILOGUE

Left to right: Mr. Turner, Jackie Jackson, Sandy Watson, Linda DeQuinn, Doreen Washington, Montez Washington, Carol Jacobsen, 2008

FREEDOM DAYS

Each one of the twelve releases we have won with and for women who were serving life sentences for murder in the deaths of, or because of, their abusers has been a miracle, and we have celebrated every one. Each has represented years of work interviewing, investigating, poring over court files, writing, strategizing and always holding onto hope. Hope not only for individual women but for changes in the criminal-legal system itself.

Our first two releases were for Juanita Thomas (1998) and Violet Allen (1999). We succeeded through motions in court. The four clemencies we won also brought joyful celebrations on behalf of Doreen Washington (2008), Minnie Boose (2008), Linda Hamilton (2009), and Levonne Roberts (2009). And freeing Millie Perry (2008), Barbara Anderson (2009), Joyce Cousins (2013), Melanise Patterson (2017), Karen Kantzler (2017), and Tonya Carson (2018) from second-degree life sentences was just as sweet each time. We have also felt joy for the freedom of countless women we supported for successful paroles from indeterminate sentences (terms of years). We only hope to see days of freedom for many more.

Left to right: Carol Jacobsen, Linda Hamilton, Diane Engleman, Susan Fair, 2009

Left to right: Diane Engleman, Susan Fair, Millie Perry, Carol Jacobsen, 2008

Left to right: Carol Jacobsen, Juanita Thomas, Susan Fair, 1998

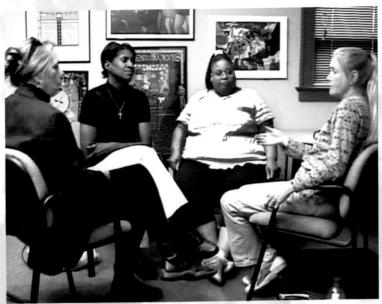

Left to right: Carol Jacobsen, Edie Clark, Serena Gordon, Susan Fair, 2004

Left to right: Sherry Savage, Carol Jacobsen, 2010

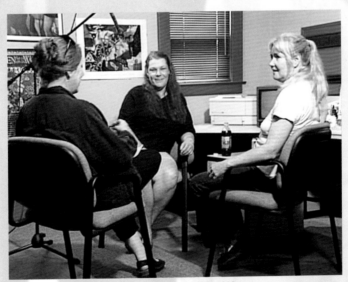

Left to right: Carol Jacobsen, Violet Allen, Susan Fair, 1999

THE ANN ARBOR NEWS

WOMEN'S

HURON VALLEY
CORRECTIONAL FACILITY
Administrative Services
West Entrance

MORE INSIDE
Inmates describe conditions in the cell they share at Huron Valley, **A5**

The ACLU is investigating reports of **abuse** at **Women's Huron Valley Correctional Facility** in Pittsfield Township. In official grievances, Huron Valley inmates described four women living in a 96-square-foot cell.

(Submitted by Michigan Department of Corrections)

"As long as it's such a closed system, it's ripe for abuse. It's been really heavy in Huron Valley over the years, the abuses (of inmates)."

CAROL JACOBSEN, DIRECTOR OF THE MICHIGAN WOMEN'S JUSTICE AND CLEMENCY PROJECT

AFTERWORD

"You learn to always look to the positive even when there's nothing but mud surrounding you because you know that to look to the positive is the only hope you have of ever seeing daylight again. You learn that you can't give up. You learn that you are your own best friend. That if you can't depend on anyone else, you can depend on yourself. You learn to love yourself and to forgive yourself and to go on."

Gerri

Cutting through the barbed wire of the prison regime is unyieldingly frustrating given the state's ever-tightening restrictions and the whims of individual guards and officials. The bureaucracy is, by design, meant to keep people out as much as it locks people in. Still, I have not always been aggressive enough in confronting power—of the governor, legislators, judges, media— to demand attention to the crisis of women's criminalization and abuses in prison. However, the failure to protect women who are being battered, the over-charging and over-sentencing of them when they are forced to defend themselves, the hiding or ignoring of exculpatory evidence, the denial of their right to present evidence of abuse and the human rights violations that are perpetrated against them by the state are all reminders that we cannot trust the state—or the corporate media—to protect women's human and civil rights at any level.

In one trial I attended at the request of the defendant's mother, the judge justified his capitulation to the prosecutor's sentencing request by saying he "didn't know about the beatings" until after the trial. But he knew before he sentenced her. Her family and I had written him with all the details her attorney left out of her defense. The judge had the power then to sentence her to a term that was low on the guidelines given the evidence including her testimony that she acted in self-defense as she was being strangled. Police took no photographs of her bruises but her mother did. The judge gave her sixteen years in prison. Certainly there are judges who make brave judgments based on education and understanding of women abuse. Several have generously worked with the Clemency Project. But as federal judge Nancy Gertner has noted, most are more worried about reversal than about right, about sentencing policy than about justice: "If there were any other social policy with the abysmal record of imprisonment we would have abandoned it long ago." Prisoners can appeal, but they rarely win relief. Appeals by prosecutors,

however, too often result in reversals. Judges rarely do anything to correct an unjust verdict or their own erroneous sentences. A few who have tried in our cases have been reversed by prosecutors' appeals.

Viewing the criminal system close up is a devastating experience. Justice is far too rare. Each case we have accepted leaves me heartsick over the appalling wreckage that is wrought by the system in so many women's and families' lives. Prison has meant for the women I know too many nights on hard bunks in cold cells; too many days of gnawing hunger with scant nutrition; too many years of chronic illness from medical neglect; and too many decades of living in cramped and crowded corners under conditions of stress, cruelty, and torture. Most of all, the cost of their survival has meant too much time without the touch of love and comfort of loved ones. The children they leave behind suffer, and they are tortured by that, too.

One question that arises at times of disappointment is whether I am adding false hope to women who cannot be saved from the hell of dying in prison. My answer comes from the women who say that hope is a gift we share and the fuel we need to stay with the struggle for justice. As an artist, I create what I love and can imagine: that has always been justice. I want my work, including this book, to encourage others to stand up to prosecutors, judges, and police who abuse their power and to redefine and create a new form of justice in our communities. I am proud to be in the company of artists, writers, scholars, lawyers, journalists, social workers, and activists who make up the women's clemency and decarceration movement and the innocence, anti-death penalty, and prison abolition movements that have awakened the nation to the need for a new system of justice. As Angela Davis defines it, the new justice will abolish prisons altogether and create instead a revitalized public education system, free health care, and an equal and compassionate justice process grounded in reconciliation and reparation.

ACKNOWLEDGMENTS

This book would not have been possible without the generous support of the University of Michigan.

I am especially grateful to Dean Guna Nadarajan of the Penny W. Stamps School of Art and Design for his early encouragement and support. I am deeply indebted to editor LeAnn Fields of the University of Michigan Press, who championed this book and guided it through the publication process. I am also grateful to the editorial and production staff at the University of Michigan Press for their enthusiastic work on this book. I owe deepest thanks to my dear friend and colleague, Abigail Stewart, the former Director of the ADVANCE Program, who has generously supported my writing and research; and to Sarah Fenstermacher, former director of the Institute for Research on Women & Gender, for her support and friendship. Special thanks also to my friends and colleagues, Sidonie Smith and Peggy McCracken, directors of The Institute for the Humanities for their generous contribution to this book; and to Lester Monts and the University of Michigan Office of Research for publication support. My gratitude also goes to the American Association of University Women for early writing support that contributed to this book.

I owe a special, lifelong debt to my dearest friend and colleague Joanne Leonard for her boundless love, fierce support, and infinite contributions to my life and work and career, as well as to this book.

I could never have produced all the visible-visual-legal-political work that is represented in this book without my fearless and indomitable partner in dissent against the broken criminal-legal system, Lynn D'Orio. Working together for almost three decades on the Clemency Project, we have shared unforgettable moments of both joy and pain and have done our best to be a thorn in the side of the Michigan parole board and Department of Corrections for their disgraceful abuses of women's human and civil rights.

I owe an enormous and lasting debt to my beloved friend Denise Bibro, who has so generously supported all my work through her love and her beautiful New York gallery. We have traveled together for art and for fun and shared personal and professional struggles for more than three decades.

I am also grateful to Amnesty International for their cosponsorship of my exhibits and screenings over the years.

My deepest love and gratitude to Shaun Bangert, who has traveled a long journey with me as my close and fabulous friend, artist, activist, educator, coproducer of several films, and designer of this book.

I owe a special debt to my dear and intrepid friend Susan Gardner, who braved the emotional, haunting, almost thirty-year journey represented in this book through her compassionate and expert camerawork.

Deepest thanks also to my friends and colleagues who contributed such eloquent and provocative essays to this book: Amanda Alexander, Regina Austin, Sally Berger, Lynn D'Orio, Nina Felshin, Betti-Sue Hertz, Marjorie Heins, Rebecca Jordan-Young, Wendy Kozol, Caitlin Mitchell, Kay Schaffer, Sidonie Smith, Ruby Tapia, Carole Vance, MaryAnn Wilkinson, and Patricia Zimmerman. And my most profound thanks to Lucy R. Lippard, whose incisive writing, activism, and endless support for artists has given me more inspiration than I can ever express.

I am truly grateful for my close friends and colleagues Peg Lourie and Vicki Patraka, especially for their careful reading of drafts of this book and their valuable insights and edits. And I thank the reviewers of the initial manuscript, who gave such thoughtful and substantive suggestions for the book.

This book represents the wish to share the undying hope and struggle for justice of the many courageous women who agreed to be interviewed on film and tape and those who contributed their images, words, letters, photographs, and documents to this book. My debt to them is enormous. It is our deepest wish that this work will contribute in some way to the struggle for social change for women caught in our biased and broken criminal-legal system. My thanks especially to those dear friends in this struggle who participated in the Clemency Project over the years. I also hold in loving memory the many women who are no longer living, especially Violet Allen, Susan Fair, Connie

Hanes, Geraldean Gordon, Kim Lundgren, Levonne Roberts, Linda K., Donna Debruin, Joyce Cousins, and Serena Gordon. You all taught me so much about love and the meaning of hope.

I am grateful to Lore Rogers for her early work on the Clemency Project and to Kary Moss, Michael Steinberg, Sofia Nelson, and the American Civil Liberties Union of Michigan for their support and guidance for the Clemency Project through the years. I also wish to thank all the attorneys and activists with whom I have worked who dedicated time and care to women's freedom and human rights. There are far too many to list, but I wish to especially thank Rebecca Leitman Veidlinger, Kammy Mizga, Bridget MacCormack, Robert Carbeck, Jeanice Dagher-Margosian, Andrea Lyon, and Arthur Spears (whose untimely death is a loss to all his friends) for their legal expertise and contributions.

A special thank you to Lora Lempert, whose friendship and fiery advocacy for women prisoners were an inspiration that transformed many unbearable losses into a deeper commitment to the struggle for a more feminist form of justice.

Also, my sincere thanks to all the domestic violence professionals and activists, especially Barbara Niess May of Safe House, Natalie Holbrook of American Friends, Sue Osthoff and Dale Grayson of the National Clearinghouse for the Defense of Battered Women, Kathy Fojtik Stroud of Michigan NOW, Debi Cain of Michigan Domestic Violence Prevention and Treatment Board, Kathy Hegenian of Michigan Coalition to End Domestic and Sexual Violence, Nels Thompson, Lois DeMott, Kelle Lynn, Pat Hardy, Marylynn Stevens and so many more for their devotion to human and civil rights and freedom for women prisoners.

A special thank you to the federal and state judges who have worked with me on the Clemency Project, especially Judge Norman Lippitt, Judge Robert Webster, Judge John McDonald, Judge Barry Howard, Judge Leonia Lloyd, and many more judges who wish to remain anonymous, who have given their time, support, and guidance on behalf of women's decarceration and justice. My very special

thanks also to former governor William Milliken and the late Helen Milliken, Joyce Braithwaite-Brickley, Jack Lessenberry, and others who gave their public support to the project. Thank you also to Governor Jennifer Granholm, who granted clemencies to women unjustly convicted. And sincerest thanks to all my terrific students and volunteers—far too many to name—with whom I have shared the work of the Clemency Project through the years.

And thank you to all my beloved artist and activist friends whose indomitable feminism and passionate work give me courage. I can only name a few here: Connie Samaras, Pi Benio, Bev and Don Shankwiler, Dianne Miller, Paula Allen, Marilyn Zimmerman, Tequila Minsky, Jane Hassinger, Kathy and Angelos Constantinides, Alice Echols, Susan Lawrence, Chris DeCorte, Ann Snitow, Beth Linn, Barb and Doug Shumard, Holly Hughes, Esther Newton, Gayle Rubin, Meg Behan, Danielle Abrams, Anne Mondro, Karen Sanders, Julie Herrada, Carol Goebel, Carol Hamoy, Kris Kurzawa, Stashu Kybartas, Janet Finn, May Stevens, Veronica Vera, Andre Wilson, Carol Boyd, Carol Leigh, Bryan Rogers, Susan Lipschutz, Sherri Smith, Gwynn Kirk, Karen Alexander, Alisa Yang, Mieko Yoshihama, Suzanne Santoro, Carol Karlsen, and so many more who have fought for justice and feminist change.

My deepest love and profound thanks to my family: my sister, Pat; my brother, Fred; and my sister-in-law, Marcia: the four of us have always stood together, propping each other up with love and encouragement through our lives and always showing up for each other in the best of times and the worst. And love to my nieces, Jennifer Bareis and Santi Bareis, and nephews, Bryan Bareis and Eric Armbrustmacher. I am most of all and forever thankful for my son, Jeff, whose love and laughter have sustained me for most of my life.

This book—and all of my work—is a nonprofit effort borne of love and anger. All revenue goes to the Michigan Women's Justice & Clemency Project.

Alexander, Michelle, *The New Jim Crow: Mass Incarceration in the Age of Colorblindness* (2010).

Alexander, Priscilla, and Frederique Delacoste, *Sex Work: Writings by Women in the Sex Industry* (1987).

Allen, Paula, and Isabelle Allende, *Flowers in the Desert* (2013).

American Friends Service Committee, *Torture in U.S. Prisons: Evidence of Human Rights Violations*, report (2011).

Amnesty International, *"Not Part of My Sentence": Violations of the Human Rights of Women in Custody*, report (1999).

Atwood, Jane Evelyn, *Too Much Time: Women in Prison* (1989).

Belknap, Joanne, *The Invisible Woman: Gender, Crime and Justice* (2007).

Bloom, Barbara, Barbara Owen, and Stephanie Covington, *Gender-Responsive Strategies: Research, Practice, Guiding Principles for Women Offenders*, National Institute of Corrections (2002).

Browne, Angela, *When Battered Women Kill* (1987).

Buel, Sarah, "Effective Assistance of Counsel for Battered Women Defendants: A Normative Construct," *Harvard Women's Law Journal* (2003).

Campbell, Jacquelyn C., "Assessing Risk Factors for Intimate Partner Homicide," *National Institute of Justice Journal* (2007).

Catalano, Shannon, "Intimate Partner Violence in the United States," U.S. Department of Justice, Bureau of Justice Statistics (2007).

Chesney-Lind, Meda, and Lisa Pasko, *The Female Offender: Girls, Women, and Crime* (1997).

Coker, Donna, "Crime Control and Feminist Law Reform in Domestic Violence Law: A Critical Review," *Buffalo Criminal Law Review* (2001).

Cotton, Charlotte, and Lisa Bloom, *Connie Samaras: Tales of Tomorrow* (2013).

Davis, Angela J., *Arbitrary Justice: The Power of the American Prosecutor* (2007).

Davis, Angela Y., *Are Prisons Obsolete?* (2003).

Davis, Angela Y., *Abolition Democracy* (2005).

D'Orio, Lynn, "Battered Women's Clemency Project Issues Call for Justice," *Ann Arbor News* (April 4, 1996).

Ensler, Eve, *What I Want My Words to Do to You,* film (2003).

Faith, Karlene, *Unruly Women: The Politics of Confinement & Resistance* (1993).

Felshin, Nina, *But Is It Art?* (1995).

Foucault, Michel, *Discipline and Punish* (1978).

Frost, Natasha, Judith Greene, and Kevin Pranis, *The Punitiveness Report: Hard Hit: The Growth in the Imprisonment of Women, 1977–2004*, Institute of Women and Criminal Justice, Women in Prison Association (2006).

Gagne, Patricia, *Battered Women's Justice: The Movement for Clemency and the Politics of Self-Defense* (1998).

Gertner, Nancy, "Women, Justice and Authority: How Justice Affects Women," *Yale Journal of Law & Feminism* (2002) .

Gillespie, Cynthia, *Justifiable Homicide: Battered Women, Self-Defense and the Law* (1989).

Harris-Perry, Melissa, *Sister Citizen: Shame, Stereotypes and Black Women in America* (2011).

Heins, Marjorie, *Sex, Sin and Blasphemy: A Guide to America's Censorship Wars* (1993).

Human Rights Watch, *International Film Festival*, Film Society of Lincoln Center, catalog (1995).

Human Rights Watch, *All Too Familiar: Sexual Abuse of Women in U.S. State Prisons* (1996).

Human Rights Watch, *Nowhere to Hide: Retaliation against Women in Michigan State Prisons*, report (1998).

Jacobsen, Carol, Archive, Special Collections Research Center, Joseph A. Labadie Collection, Hatcher Graduate Library, University of Michigan.

Jacobsen, Carol, and Lynn D'Orio, "Defending Survivors: Case Studies of the Michigan Women's Justice & Clemency Project," *University of Pennsylvania Journal of Law and Social Change* (2015).

Jacobsen, Carol, and Lora Bex Lempert, "Institutional Disparities: Considerations of Gender in the Commutation Process for Incarcerated Women," *Signs: Journal of Women, Culture & Society* (2013).

Jacobsen, Carol, Kammy Mizga, and Lynn D'Orio, "Battered Women, Homicide Convictions and Sentencing," *Hastings Women's Law Journal* (2002)

Jones, Ann, *Women Who Kill* (1980).

Jordan-Young, Rebecca, "Convicted: A Prison Diary," *S&F Online* (2007).

Kajstura, Aleks, and Russ Immarigeon, "States of Women's Incarceration: The Global Context," Prison Policy Initiative.

Karlsen, Carol, *The Devil in the Shape of a Woman* (1987).

Kozol, Wendy, and Wendy Hesford, *Just Advocacy? Women's Human Rights, Transnational Feminisms, and the Politics of Representation* (2005).

Kozol, Wendy, and Wendy Hesford, eds., *Haunting Violations: Feminist Criticism and the Crisis of the "Real,"* (2001).

Lazarus, Margaret, and Renner Wunderlich, *Defending Our Lives*, film (1994).

Lempert, Lora Bex, *Women Doing Life: Gender, Punishment, and the Struggle for Identity* (2016).

Leonard, Elizabeth, *Convicted Survivors: The Imprisonment of Battered Women Who Kill* (2002).

Leonard, Joanne, *Being in Pictures: An Intimate Photo Memoir* (2008).

Lippard, Lucy, *Get the Message? A Decade of Art for Social Change* (1984).

Louisell, Paul, "Parole Board Interpretation of Lifer Law Unfair, Unwise, Unconstitutional," *Michigan Criminal Law Journal* (2003).

Lyon, Andrea, Emily Hughes, Juanita Thomas, "People v. Juanita Thomas: A Battered Woman's Journey to Freedom," *Women & Criminal Justice* (2002).

Maguigan, Holly, "Battered Women and Self-Defense: Myths and Misconceptions in Current Reform Proposals," *University of Pennsylvania Law Review* (1991).

McNulty, Faith, *The Burning Bed: The True Story of an Abused Wife* (1989).

Michigan Supreme Court, *Final Report of the Michigan Supreme Court Task Force on Gender Issues in the Courts* (1989).

Michigan Women's Justice & Clemency Project, www.umich.edu/~clemency

National Clearing House for the Defense of Battered Women, https://www.ncdbw.org

Pearl, Julie, "The Highest Paying Customers: America's Cities and the Costs of Prostitution Control," *Hastings Women's Law Journal* (1987).

Pheterson, Gail, *A Vindication of the Rights of Whores* (1989).

Rathbone, Christina, *Women, Prison, and Life Behind Bars* (2005).

Richie, Beth, *Arrested Justice: Black Women, Violence and America's Prison Nation* (2012).

Rosenberg, Susan, *An American Radical: Political Prisoner in My Own Country* (2011).

Rutdovsky, David, Alvin Bronstein, Edward Koren, and Julia Cade, *The Rights of Prisoners: The Basic ACLU Guide to Prisoner's Rights* (1988).

Scarry, Elaine, *The Body in Pain: The Making and Unmaking of the World* (1985).

Schneider, Elizabeth, *Battered Women and Feminist Lawmaking* (2000).

Scholder, Amy, ed., *Critical Condition: Women on the Edge of Violence* (1993).

Smart, Carol, *Feminism and the Power of Law* (1989).

Smith, Sidonie, and Kay Schaffer, *Human Rights and Narrated Lives*, (2004),

Sollinger, Rickie, Paula C. Johnson, Martha L. Raimon, Tina Reynolds, and Ruby C. Tapia, *Interrupted Life: Experiences of Incarcerated Women in the United States* (2010).

Sontag, Susan, *Regarding the Pain of Others* (2004).

Stevenson, Bryan, *Just Mercy: A Story of Justice* (2014).

Strossen, Nadine, *Defending Pornography: Free Speech, Sex, and the Fight for Women's Rights* (2000).

Talvi, Silja J. A., *Women Behind Bars: The Crisis of Women in the U.S. Prison System* (2007).

VanCleve, Nicole Gonzales, *Crook County: Racism and Injustice in America's Largest Criminal Court* (2016).

Walker, Lenore, *The Battered Woman* (1979).

Walsh, Marie, *A Tale of Two Lives: The Susan Lefevre Fugitive Story* (2011).

Woolf, Virginia, *Three Guineas* (1938) (1977).

Zimmerman, Patricia, *States of Emergency: Documentaries, Wars, Democracy* (2000).

ESSAY AND DESIGN CONTRIBUTORS

Amanda Alexander is an assistant professor and postdoctoral scholar in law and Afro-American studies at the University of Michigan. As a 2013-2015 Soros Justice Fellow, she founded the Prison and Family Justice Project at Michigan Law School, which serves families divided by incarceration and the foster care system using a combination of direct representation, know-your-rights education, targeted litigation, and advocacy. She serves on the steering committee of Law for Black Lives, a national network of lawyers committed to building the power of the Black Lives Matter movement. Her writing has been published in The Globe and Mail, Mail & Guardian, the Michigan Journal of Race & Law, the Journal of Asian and African Studies, Review of African Political Economy, and more.

Regina Austin is professor of law and director of the Penn Program on Documentaries & the Law at the University of Pennsylvania Law School. Her research analyzes law-genre documentary films and filmmaking as well as the overlapping burdens of race, gender, and class oppression in the law of intentional civil wrongs. Her writings have appeared in *Gender Equality: Dimensions of Women's Equal Citizenship* (ed. Linda C. McClain and Joanna L. Grossman, 2009); *Race and Real Estate: Transgressing Boundaries: Studies in Black Politics and Black Communities* (ed. Adrienne Brown and Valerie Smith, 2015), and in many legal scholarly journals.

Shaun Bangert is a professor of art at Saginaw Valley State University, where she teaches filmmaking and graphic design. Her work in photography and film has been exhibited both in the United States and abroad.

Sally Berger is an independent curator and writer on film whose research has focused on Maya Deren and early women filmmakers. She is a former curator of film at the Museum of Modern Art in New York.

Lynn D'Orio is a criminal defense and family attorney in Ann Arbor, Michigan. She is the legal director of the Michigan Women's Justice & Clemency Project. Her writings have appeared in Hastings Women's Law Journal, University of Pennsylvania Journal of Law and Social Change, Michigan Criminal Defense Newsletter, and other publications.

Nina Felshin is an independent curator, writer, and activist and a former curator at Wesleyan University's Ezra and Cecile Zilkha Gallery, the Contemporary Art Center in Cincinnati, and the Corcoran Gallery of Art in Washington, DC. She is the author of *But Is It Art? The Spirit of Art as Activism* and has written numerous articles and essays on contemporary art.

Marjorie Heins is a civil liberties lawyer, writer, educator and the founding director of the Free Expression Policy Project. She served as director of the ACLU Art Censorship Project during the height of the culture wars in the art world. More recently, she has taught at the University of California, San Diego, and the American University in Paris. Her most recent book, *Priests of Our Democracy: The Supreme Court, Academic Freedom and the Anti-Communist Purge* traces the history and fortunes of academic freedom on campus and in the courts.

Betti-Sue Hertz is an independent curator and educator whose research centers on the intersection of critical visual culture and socially relevant issues. Recent curated exhibitions include *Public Intimacy: Art and Other Ordinary Acts in South Africa* (2014), *Dissident Futures* (2013), and *Audience as Subject* (2010-2012). She is former director of visual arts at Yerba Buena Center for the Arts, curator of contemporary art at San Diego Museum of Art, and director of the Longwood Art Project in the Bronx, New York. She has taught at San Francisco Art Institute, Stanford University, and California College of the Arts.

Rebecca Jordan-Young is associate professor and chair of Women's, Gender and Sexuality Studies at Barnard College. Jordan-Young's work explores the reciprocal relations between science and human social hierarchies. She is the author of *Brain Storm: The Flaws in the Science of Sex Differences* (2010), as well as numerous critical articles on research methods, policies and ethics related to scientific claims about gender, sexuality, class, and race.

Wendy Kozol is professor of Comparative American Studies at Oberlin College. Her research brings a feminist and human rights perspective to questions about conflict photography and visual advocacy. In addition to numerous articles, her books include *Life's America: Family and Nation in Postwar Photojournalism* (1994) and two edited collections with Wendy Hesford: *Haunting Violations: Feminist Criticism and the Crisis of the Real* (2000) and *Just Advocacy? Human Rights, Transnational Feminism and the Politics of Representation* (2005). Her most recent book, *Distant Wars Visible: The Ambivalence of Witnessing* (2014), examines visual cultures that depict twenty-first century U.S. military conflicts to consider the politics of witnessing.

Lucy R. Lippard is a writer, art critic, activist, and curator. She is the author of twenty-one books on feminism, art, and politics, has curated more than fifty exhibitions, and was a cofounder of the Art Workers Coalition, Political Artists Documentation and Distribution (PAD/D), Printed Matter, the Heresies Collective, and others.

Caitlin Mitchell is a staff attorney at Youth, Rights & Justice in Portland, Oregon. She represents children and parents in trial-level and appellate juvenile dependency proceedings, with a focus on families separated by incarceration.

Kay Schaffer is professor emerita of Gender Studies and Social Inquiry at the University of Adelaide. Her most recent book, *Women Writers in Postsocialist China* (coauthored with Sianlin Song, 2014), introduces Western readers to contemporary Chinese women writers. She coauthored *Human Rights and Narrated Lives: The Ethics of Recognition*, with Sidonie Smith in 2004. She has been on the staff of the Institute for the Study of Law, Literature and Culture at the University of Osnabrueck, Germany, since 2010.

Sidonie Smith is the Mary Fair Croushore Professor of the Humanities and professor of English and Women's Studies, in the College of Literature, Science, and the Arts at the University of Michigan. She was the 2010 president of the Modern Language Association. She has written extensively on autobiography studies, feminist theory, and human rights and literature. Her most recent book, *A Manifesto for the Humanities: Transforming Doctoral Education in 'Good Enough' Times* (2015), calls for a new vision of graduate studies in the humanities and the new everyday life of academic humanists.

Ruby Tapia is associate professor of English and director of undergraduate studies in Women's Studies at the University of Michigan. Her scholarly research addresses the interdisciplines of visual culture, comparative ethnic studies, gender, and sexuality studies. She is the author of *American Pietas: Visions of Race, Death and the Maternal* (2011), coeditor of *Interrupted Life: Experiences of Incarcerated Women in the United States* (2010), and author of numerous articles and essays. Her current book project is on gender in/and carceral visualities.

Carole S. Vance has written widely on sexuality, science, gender, and policy; policy controversies about sexual expression and imagery; and sexuality theory and research methods. She coordinated the landmark Barnard Conference on Sexuality and edited the collection, *Pleasure and Danger: Exploring Female Sexuality*. Vance has received the Kessler Award and the Simon and Gagnon Award for contributions to sexuality studies. Her recent work focuses on trafficking into forced prostitution, issues of consent and state regulation, and the current initiatives to stop sexual violence on U.S. campuses. She is a professor of anthropology at Columbia University.

Maryann Wilkinson is exhibitions director of the Alfred Taubman School of Architecture and Urban Planning and adjunct curator at The Museum of Art at The University of Michigan. She is former curator of Modern and Contemporary Art at the Detroit Institute of Arts. She has organized such exhibitions as "Artists Take on Detroit," in 2001, and 'The 30th Anniversary of the Heidelberg Project," in 2015. She is currently working on several projects about art in Detroit.

Patricia R. Zimmerman is professor of Screen Studies in the Roy H. Park School of Communications at Ithaca College. She is also codirector of the Finger Lakes Environmental Film Festival. Her research explores the relationships between historiography, political engagements, and documentary practices across platforms and modes. Her books include *States of Emergency: Documentaries, Wars, Democracies* (2000), *Thinking Through Digital Media: Transnational Environments and Locative Places* (2015), and *Open Spaces: Openings, Closings and Thresholds of Independent Public Media* (2016), and she has authored numerous critical and scholarly articles and essays on film history and documentary and experimental film/video, and digital arts practices.

SELECTED FILMOGRAPHY

All films are distributed free. Films and screenings are cosponsored by Denise Bibro Fine Art and Amnesty International.

Courtroom, 15 min., 2019
By Carol Jacobsen and Shaun Bangert
Documents the drug and prostitution courtroom, 36th District Court, Detroit, Michigan, through the experiences of sex workers in Detroit.

Life on Trial, 20 min., 2018
Narrated by a courageous former prisoner who fought the criminal, legal, and penal systems for the human and civil rights of women prisoners.

Time Like Zeros, 13 min., 2011
Eight women prisoners give chilling accounts of their prison experiences as the camera encircles the prison and moves inside.

Prison Diary, 10 min., 2006
Shocking excerpts from a woman prisoner's letters to the artist are narrated over aerial and exterior views of the women's prison.

Censorious, 34 min., 2005
Coproduced with Shaun Bangert and Marilyn Zimmerman
Explosively funny, feminist view of the culture wars narrated by artists Carolee Schneemann, Holly Hughes, Martha Wilson, Renee Cox, and others who fought major battles against censorship of their politically charged works.

Beyond the Fence, 15 min., 2004
Three prisoner activists recall the brutal conditions of their incarceration and their acts of resistance inside.

Sentenced, 6 min., 2003
Moving account of the failure of the criminal-legal-penal system narrated by Connie Hanes, who later committed suicide in prison.

Segregation Unit, 30 min., 2000
A rare look at the everyday torture that occurs in solitary confinement. Narrated by Jamie Whitcomb, who filed a successful lawsuit for torture against the State of Michigan.

Barred and Gagged, 8 min., 1999
Despite audible warnings by the deputy warden, women prisoners courageously tell what they are not allowed to speak about in prison: painful assaults and rape by guards, lack of medical care, rotten food, and other atrocities.

Clemency, 15 min., 1999
Narrated by eleven women prisoners who are serving life sentences for murder, the piece is a collective indictment of a gender-biased criminal-legal system.

3 on a Life Sentence, 30 min., 1998
A conversation about the failures of the criminal-legal system by three women serving life sentences for murder of their abusers.

Violet & Judith, 40 min., 1995
Video installation commissioned by the Detroit Institute of Arts.
A contemporary video portrait narrated by Violet Allen is installed with the seventeenth century painting, *"Judith with the Head of Holofernes"* by Artemisia Gentileschi. Wall texts give evidence of the injustice of two women's court trials across time and space.

From One Prison..., 70 min. 1995
Narrated by four women serving life or near-life sentences in Michigan prisons, their accounts give scathing and heartbreaking critiques of the criminal, legal, and penal systems from the domestic to the public spheres.

Night Voices, 15 min., 1991
Video installation
Voices of street workers are heard over night views of Detroit streets where they were arrested.

Street Sex, 30 min., 1989
Video installation
Sex workers critique the arrest process, sexual abuse and jail conditions of Detroit police officers and police department.

For Dear Life chronicles feminist and artist Carol Jacobsen's deep commitment to the causes of justice and human rights, and focuses a critical lens on an American criminal-legal regime that imparts racist, gendered, and classist modes of punishment to women lawbreakers. Jacobsen's tireless work with and for women prisoners is charted in this rich assemblage of images and texts that reveal the collective strategies she and the prisoners have employed to receive justice. The book gives evidence that women's lawbreaking is often an effort to survive gender-based violence. The faces, letters, and testimonies of dozens of incarcerated women with whom Jacobsen has worked present a visceral yet politicized chorus of voices against the criminal-legal systems that fail us all. Their voices are joined by those of leading feminist scholars in essays that illuminate the arduous methods of dissent that Jacobsen and the others have employed to win freedom for more than a dozen women sentenced to life imprisonment, and to free many more from torturous prison conditions. The book is a document to Jacobsen's love and lifelong commitment to creating feminist justice and freedom, and to the efficacy of her artistic, legal, and extralegal political actions on behalf of women. *For Dear Life* will appeal to scholars in gender studies, criminal justice, art and cinema studies, as well as to activists, lawyers, social workers, prisoners, former prisoners and survivors.

Carol Jacobsen is Professor of Art, Women's Studies, and Human Rights at the University of Michigan and Director of the Michigan Women's Justice and Clemency Project.

Also available as an e-book.

University of Michigan Press
Ann Arbor • www.press.umich.edu

"To grasp fully the horror of our nation's prisons and the injustices of its justice system, and yet still be awed by the truly stunning extent to which the women who endure this horror refuse to be lessened and erased, one must read this book. Its essays and renderings of women's lives on the inside both haunt and inspire."
—Heather Ann Thompson, Pulitzer Prize-winning author of *Blood in the Water: The Attica Prison Uprising of 1971 and Its Legacy*

"An extremely powerful book that not only documents Jacobsen's career but itself functions as an artistic project that challenges the silencing measures inflicted by social forces upon marginalized women such as prisoners and sex workers."
—Wendy Kozol, Oberlin College

"Truly a case in which a picture is worth more than a thousand words—this richly illustrated book's mixture of photos of incarcerated women juxtaposed with reproductions of bureaucratic documents is spot on, and the women's voices compelling."
—Susan Sered, Suffolk University

"Sheds a searing light on the misogyny of the criminal-legal system and the dark, abusive world of women's jails and prisons. This passionate book illuminates not only a sobering close-up view inside but also a feminist path through the fence where human rights and justice may enter."
—Nadine Strossen, New York Law School and former President of the ACLU

"Carol Jacobsen's exhibition 'Street Sex' was shown at Franklin Furnace in New York in 1991, with no censorship. Her decades-long concern for the criminalization of women, beginning with those sex workers in Detroit, led to this wonderful book.... Now that the #MeToo movement has gained public traction, it is my hope that the widespread criminalization of women may come to broad notice—and that justice may be gained."
—Martha Wilson, Artist and Founding Director of Franklin Furnace Archive, Inc.

ISBN 978-0-472-05392-6

90000

9 780472 053926